D

Books are to be returned on or before
the last date below.

LIBREX·

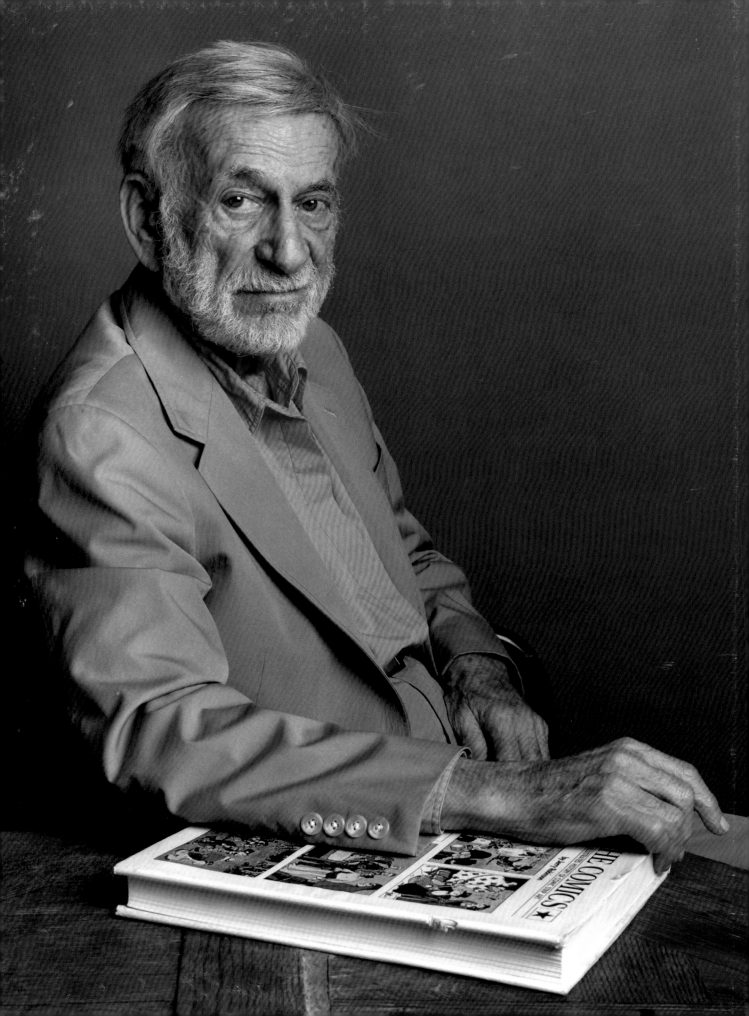

JERRY ROBINSON

Ambassador of Comics

N. C. Christopher Couch

INTRODUCTION BY
Pete Hamill

FOREWORD BY
Dennis O'Neil

Abrams ComicArts, New York

Acknowledgments

I was most fortunate to work on this book with special people who have earned my deep respect for their talent and professionalism: Charles Kochman, executive editor of Abrams ComicArts; Sheila Keenan, senior editor; and Mike Essl and Alexander Tochilovsky, who created the handsome design. Charlie believed in the book from the beginning. Sheila is a brilliant editor and was a joy to work with. I am grateful to Chris Couch for telling my life story. It is an honor to have the contributions of two great literary talents, Pete Hamill and Dennis O'Neil. I am indebted to my friend Paul Levitz, former president of DC Comics; Michael Uslan, executive producer of the Batman films; and my agent, Denis Kitchen, for their invaluable help and continued support. This book could not have been possible without my son, Jens Robinson, editor of CartoonArts International, whose knowledge of the field and whose special contributions to the project were invaluable. My assistant, Kevin Miller, was essential throughout. Many thanks also to my cousin and family historian, Jay Robinson. I value my many rewarding collaborations with the United Nations, the Breman Museum in Atlanta, and the Comic-Con International in San Diego. Thanks also to Metropolis Collectibles and Dr. Michael J. Vassallo for making available their vintage comics collections. And, most important, thanks to my wife, Gro, who has been my collaborator and love for fifty-four years and counting.

— Jerry Robinson

Thanks to the ambassador himself, Jerry Robinson, for cheerfully answering my eternal question, "What would you like to talk about today?"; to Kevin Miller, for grace, good cheer, and mastery of the Robinson archives; to Charles Kochman for faith, patience, and making the world take comics seriously. Sheila Keenan's diplomatic skills would make her a top ambassador, but then we'd lose her wonderful editorial pencil and her fine eye for book design. Special thanks to Professor John Lent, Temple University, for insight into Jerry's role in international comics; to Jens Robinson, for sharing the history of CWS and many stories about his father; to Gro Bagn, for her hospitality and insight; to Dr. Michael J. Vassallo for timely instruction in Atlas Comics; to comics historians Tom Andrae, Steve Weiner, Jim Amash, Bill Black, and Michael Uslan; to Denis Kitchen, artist, agent, author, and curator; to my dear sister Lesleigh Luttrell; to Dr. Donna Gilman for her wise advice; and deepest appreciation to my wife, Jackie Southern, who always cuts to the heart of the matter—everything I write is infused with her subtle understandings.

—N. C. Christopher Couch

CONTENTS

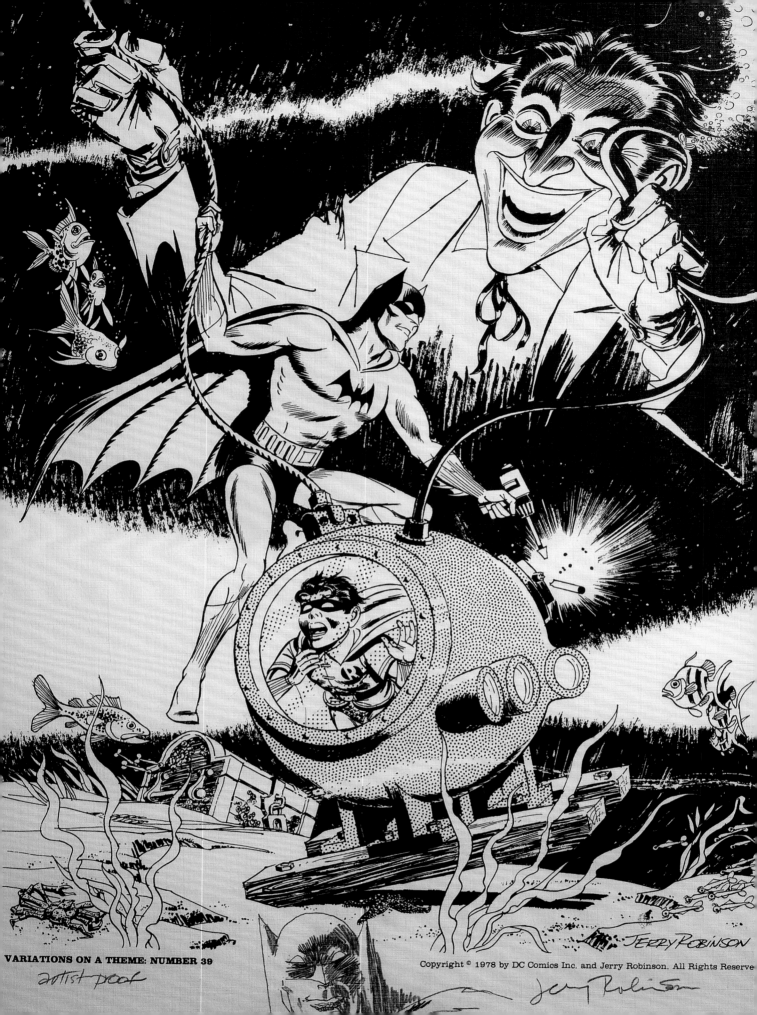

VARIATIONS ON A THEME: NUMBER 39

artist proof

JERRY ROBINSON

Jerry Robinson

INTRODUCTION

I first traveled into the world of Jerry Robinson in 1943. The occasion of my journey was opening a copy of *Batman*. I was eight years old, living with my parents, my younger brother, and my little sister in a cold-water tenement flat in Brooklyn. For months, I'd been reading newspaper comic strips in the *New York Daily News* and the *Brooklyn Eagle*, and so was familiar with the form. My mother's favorite strip was *Terry and the Pirates*, and I loved looking at it, but couldn't really understand it. I loved *Dick Tracy*, too, with its scary villains and beautiful snowstorms, and wished I knew Punjab and the Asp from *Little Orphan Annie*, or could have the powers of Invisible Scarlet O'Neill. But they all moved through distant, exotic worlds: mysterious caves, the battlefields of China, bases in the South Pacific.

When I started reading that first *Batman* comic book, I saw the world where I lived. A right-angled vertical world of deep shadows, sinister warehouses, tall buildings that scraped the sky, and a brooding sense of menace. I had read a few copies of *Superman* by then, but his Metropolis had no shadows in it, no real menace or even peril for the hero, since Superman was bulletproof. Captain Marvel was more fun, but he was pretty dumb. My friends and I agreed with Doctor Sivana that the Cap really was a "big red cheese." And Captain Marvel's city was about as scary as *Mutt and Jeff*.

Batman's Gotham was New York.

Including Brooklyn.

I started searching for old copies of *Batman* in a used bookstore a few blocks from where we lived. I devoured them. We had no backyard so we often played on our tar-papered roof, which extended an entire city block. It was full of chimneys, air vents, clotheslines, small structures where the interior staircases ended, and one pigeon coop. A rooftop in Gotham. Wandering through the cobblestoned alley in the factory across from our

PREVIOUS: *Portrait of Jerry Robinson by Holger Keifel (2008)*

OPPOSITE: Variations on a Theme: Number 39, *lithograph, signed artist proof with pencil remarque (1978)*

tenement, with its deep shadows and windows made blank by thick mesh, I could swear I sometimes heard laughter from within the redbrick walls. Mad, berserk laughter. The laughter of the Joker.

The newspaper comics had taught me that living men actually wrote and drew the comics. Milton Caniff wrote and drew Terry. Harold Gray gave us Annie. Chester Gould signed Dick Tracy. And Batman came from someone named Bob Kane. I was certain he must be from Brooklyn. Years later, I learned he was from the Bronx. I also learned that most of the writing was done by a man named Bill Finger. And that the first image of the Joker was drawn by Jerry Robinson, inspired by a playing card that Robinson turned evil. This marvelous book tells that story, and much more.

Robinson was part of an extraordinary band of very young men who were inventing a genre that went far beyond the newspaper strips. They created a graphic language that adjusted their narrative art to the vertical pages of the books themselves. The splash page was born, introducing each story with a logo and an often surrealistic sample of what was to come. Robinson led the way in creating pages of great variety: Small panels strung in a row, vertical panels, immense culminating panels. This range of panels was impossible in the rigid, horizontal newspaper strips.

Jerry and crew also aimed their creations directly at kids. (Caniff once said that he wrote *Terry* for "the guy that buys the paper.") Many comic book heroes added young sidekicks to get the young audience more involved. Robinson, Finger, and Kane created Robin, the Boy Wonder, to work at the side of Batman (and to provide him someone to talk to). Captain America had Bucky. The Human Torch had Toro. Kids who felt small and weak in a world of tough people (men and women shaped by Prohibition and the Great Depression) could imagine themselves into the great dramas. Kids living at home while older guys from their neighborhoods were off fighting a ferocious war could battle Hitler and Tojo, too. In our imaginations, of course. No small thing.

We didn't call these comic book characters "super heroes" then. And part of the appeal of Batman and Robin was that they had no super powers. They were humans named Bruce Wayne and Dick Grayson, wearing costumes that made them special and heroic. Bullets didn't bounce off them. They couldn't fly, and so depended upon a convenient cable to swing through the air, or a fire escape or a crane. They weren't from a distant planet. They had no magic words to utter, or secret potions to throw down their gullets. They were human. Like us. Super or not, millions of us looked at this dynamic duo in capes and masks and suspended our disbelief.

Batman grabbed us because its creators understood one other important truth in popular narrative art: To have great heroes, you must have great villains. And so it wasn't only the Joker who challenged Batman. It could be the Penguin, or Two-Face, or Clayface, or the Scarecrow or, a bit later, Catwoman. Robinson was inspired too by certain examples of expressionist cinema: F. W. Murnau's *Nosferatu* (a brilliant but blatant rip-off of Bram

Stoker's *Dracula*), Fritz Lang's *M* and *Metropolis,* and Orson Welles's *Citizen Kane.* Along with some other artists (most important, Will Eisner), Robinson and his peers were making frozen movies. Film noir on paper, long before that label was invented for movies. No surprise that many decades later, when cinematic technology was fully developed, their youthful ideas were unfrozen into sometimes brilliant movies. The comics came first.

But Jerry Robinson is more than the young man who worked with such exuberant verve and imagination in the streets of Gotham. He worked on other comic books, in those years before television arrived in full force.

The Korean War, with its ambiguities, its lack of a Pearl Harbor–like attack that must be avenged, changed comic books. Harvey Kurtzman and his crew gave us stories of combat in which nobody wore masks or capes. Love comics came along, often as insipid as Doris Day movies (but providing subject matter a decade later for the pop artist Roy Lichtenstein). Robinson did more straight illustration. And he began teaching at the Cartoonists and Illustrators School, later to become the School of Visual Arts. His subject was the art of the comic book and he was a perfect teacher. Jerry knew how to explain the gathering power of narration, the sense of surprise, the graphic language of expressing character, the visual syntax, and the joy of working in comics. After all, he helped invent the form.

In the years that followed, Robinson continued to teach us all, through his books about comics, through his activism on behalf of cartoonists imprisoned by dictatorships, by his decency as a man and his fidelity to the power of the human imagination. He began drawing the brilliant *Still Life* panels for the men and women who bought the papers. I was privileged to meet him during those years, and always came away from our encounters smarter than when we met.

At the same time, Jerry was inspiring several generations of apprentice graphic artists, through his books and classes, and through the example of his work. During those years the newspaper narrative strip virtually disappeared, slain by television, and the comics pages shrunk to the visual equivalent of stamp collections. Super heroes made several comebacks for new generations of readers, but looked increasingly like paralyzed figures on steroids. But underground comics showed other directions to the young, wilder, and more anarchic, filled with sex, drugs, and rock 'n' roll; and soon the graphic novel was born. In 1986, Frank Miller went back to the origins of Batman, when Jerry Robinson and Bill Finger and Bob Kane and the character they created were young, and brought new life to the pulsing darkness of the streets of Gotham. All great art survives its creators, including great popular art.

As a master of graphic creation, as teacher, historian, and roving ambassador of comics, Jerry Robinson has ensured that future generations of talented kids will continue to imagine, and then put marks on paper. Some of those marks will be his.

Pete Hamill
New York, New York
January 2010

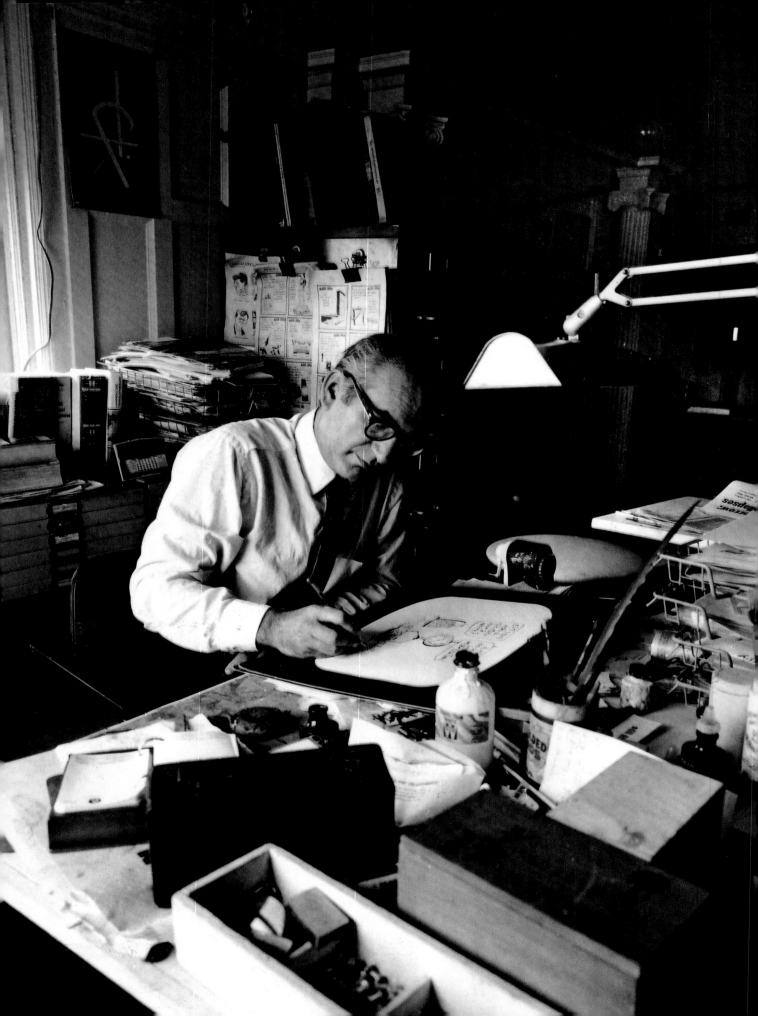

FOREWORD

The Jerry Robinson I've known for about thirty years probably hasn't spent ten minutes in all that time thinking of himself in weighty terms. I very much doubt that he considers himself in an historic context or mulls his sociological significance or wonders what place in the history of popular culture future chroniclers will accord him. He's probably too busy doing all the things he's been doing so well since 1939: writing, drawing, socializing, and helping his fellow human beings. Jerry's gregarious—I don't know of a better person to share a lunch table with—and he's knowledgeable enough to talk intelligently and engagingly about a lot of topics. But he's not a boaster; while Jerry'll tell stories that involve him as a character, it's never to emphasize his own importance or prowess. *He* won't be the one to tell you who created Batman's trickster foe, the Joker, or who got Superman's creators some of what was due them. Jerry's had an interesting life, and he knows it, and, with a little urging, he'll talk about it. But he'll be discussing what he's seen, what he's been a part of, rather than focusing his narrative on himself.

So let us do for him what he would never do for himself: proclaim that he is a pretty darn thorough example of an archetype. The archetype we have in mind may not yet be recognized by people who concern themselves with identifying archetypes, but it should be. The archetype Jerry exemplifies is the Modern American Artist.

First of all, let's remember that ours is a nation of immigrants, and so our Modern American Artist can't have generations of forebears who lived on this continent. As you'll learn in the following pages, Jerry's father, Benjamin, came from Russia as a teenager with empty pockets and no English; therefore Jerry is first-generation American and qualifies as immigrant stock.

OPPOSITE: *Jerry Robinson in his studio in New York City (1970s)*

Next, our Modern American Artist must be self-reliant, a person largely self-educated, someone Walt Whitman might have rhapsodized, and again, Jerry qualifies. Although his formal education may have been a bit better than that of some of his colleagues—he attended a good high school—it did not include any time at an art academy or a university degree. Jerry was, for all intents and purposes, an autodidact who, like Mark Twain, got his education in museums and libraries and *used what he learned*. The books he read, the paintings he looked at weren't just curiosities to be crammed into some cranial storage bin and left to molder; they were to be enjoyed, sure, but they were also to be applied to whatever was on Jerry's board. Our most identifiable homegrown American philosophy is William James's pragmatism, which insists that an idea's validity is measured by its usefulness: Does it work in real life? Does it accomplish anything? From here it's an easy leap—really, just a small step—to using whatever you happen to learn, anywhere, anytime, in what you're doing to put food on the table.

Jerry applied his learning to a medium that was, like Benjamin Robinson's citizenship, something new. Some of the earlier generation of newcomers, particularly Jews, had sought fame and fortune in vaudeville, which certainly had old-world predecessors—all those music halls in Merry Olde London—but was fresh-minted for a new century and a new world; and in an odd entertainment just beginning to be popular in New York in which photographs were projected onto a white screen and *moved*! These newcomers, these refugees, couldn't afford art for art's sake—they were James's pragmatists—and they wanted opportunities; they wanted something that would pay. It's not hard to imagine young Jerry, had his life shuffled itself a bit differently, making his way in the movie biz; his father, Benjamin, after all had operated Trenton's first movie theater, and Jerry admits to liking movies and being influenced by them. But instead, Jerry happened into another new form of amusement: comic books.

Comics were a congenial place for him. He liked to write—he still does, and he's good at it—but his most salable skill was his self-taught ability to draw. Jerry was a natural storyteller and a natural graphic artist, and comics are about using drawings in the service of narrative. The timing of Jerry's introduction to what would become a major part of his life's work could hardly have been better. Comic *strips*, carried by virtually every urban newspaper, had been around for almost a half century, but comic *books*, pulpy, flimsy magazines that used the word-picture narrative tools of the strips to tell original stories, were just beginning to exist. It was a new medium so anyone entering it would be, by definition, a pioneer, and nothing is more central to the American mythos than pioneering. We fancy ourselves a nation of innovators, of brave souls not afraid to broach the unknown! So our archetypical artist could not laze in some pre-upholstered niche, obeying rules; he'd have to stride forward.

Anyone seeking work in the comics industry of the late 1930s and early 1940s was certainly not interested in staying with the known. What these kids—Jerry; his mentor, Bill Finger; Bob Kane; as well as Stan Lee and Joe Kubert and Will Eisner and all the other first-generation comics guys—were doing was extraordinary. At tender ages, with few resources and no help from any establishment, they were, on deadline, creating an art form and refining a language, a means of using images and words in conjunction to tell stories. And they were very seldom admired for it—in fact they were often scorned. Everyone seemed to know that comics were for semiliterate dumb clucks . . . everyone except the few who actually *looked* at what was being belittled and saw an original American art form. But, hey! Pioneers aren't bothered by a few slings and arrows.

Although Jerry and the other young comics pioneers may not have venerated art—make that Art—the way it's venerated by today's culturati, that isn't to imply that they did not value it nor that they slighted their involvement in it. Let's posit that our Modern American Artist must have a workman's pride in what's being produced, by himself and others, and a willingness to work as hard as necessary to make the thing as good as it can be. Evidence? Look at the comics produced by Jerry and his contemporaries and imagine the effort and thought that went into creating those entertainments. They may have been working on deadline for pay, but the pioneers of comics wanted to produce quality stuff. They cared.

Finally, our archetype, our Modern American Artist, has to be a Good Samaritan. We cherish the self-image of us Americans as a generous folk, always willing to help. And here Jerry Robinson improves the archetype. With no hope of personal gain, often without any significant credit, Jerry has given time, money, and enormous effort to rescuing, rewarding, and gaining recognition for fellow artists who have been badly treated. He is the most benevolent man I have ever known, in or out of comics, and one of the most decent.

So can there be any question? We have our archetype. Behold and celebrate! The Modern American Artist! His name is Jerry Robinson. Read this book and be convinced.

Dennis O'Neil
Nyack, New York
October 2009

PREFACE

Few modern American artists can claim to have worked in as many media as Jerry Robinson and with such success in all of them. Like a Renaissance master, he has been a visual artist and author, a teacher of other artists, and a spokesman to the world for the arts he loves. Robinson began his career in comics art and has remained true to this medium throughout the years, exploring it from all sides: from comic books, where he created some of the world's best-known characters; to his aesthetically innovative editorial cartoons, which captured the spirit of their times; to comic strips, where he was one of the few artists who succeeded with both adventure and humor strips. Robinson taught several generations of cartoonists at New York's School of Visual Arts and founded the first worldwide cartoon syndicate, sharing the work of colleagues from more than forty countries with readers everywhere. And he fought for the rights of cartoonists, leading campaigns to preserve freedom of expression, to free a jailed cartoonist, and to guarantee recognition of the rights of comic book creators.

A strictly biographical or chronological rendering of Robinson's career would be more likely to obscure rather than illuminate his work and influence. Instead, this book explores Robinson's artistic work, his historical and critical writings, and his social impact by looking at all the different media he has worked in. In order to paint a fully rounded picture of the artist, the text also includes extensive quotes drawn from my interviews with Jerry Robinson recorded over a period of two years (2006–2008). The unity of Robinson's diverse career can best be understood by looking at the media he's worked and innovated in, as well as his role as a cultural spokesman for the history, aesthetics, and importance of comics.

N. C. Christopher Couch
Florence, Massachusetts
September 2009

OPPOSITE: *Robinson's pencil drawing of his New York City studio (early 1980s)*

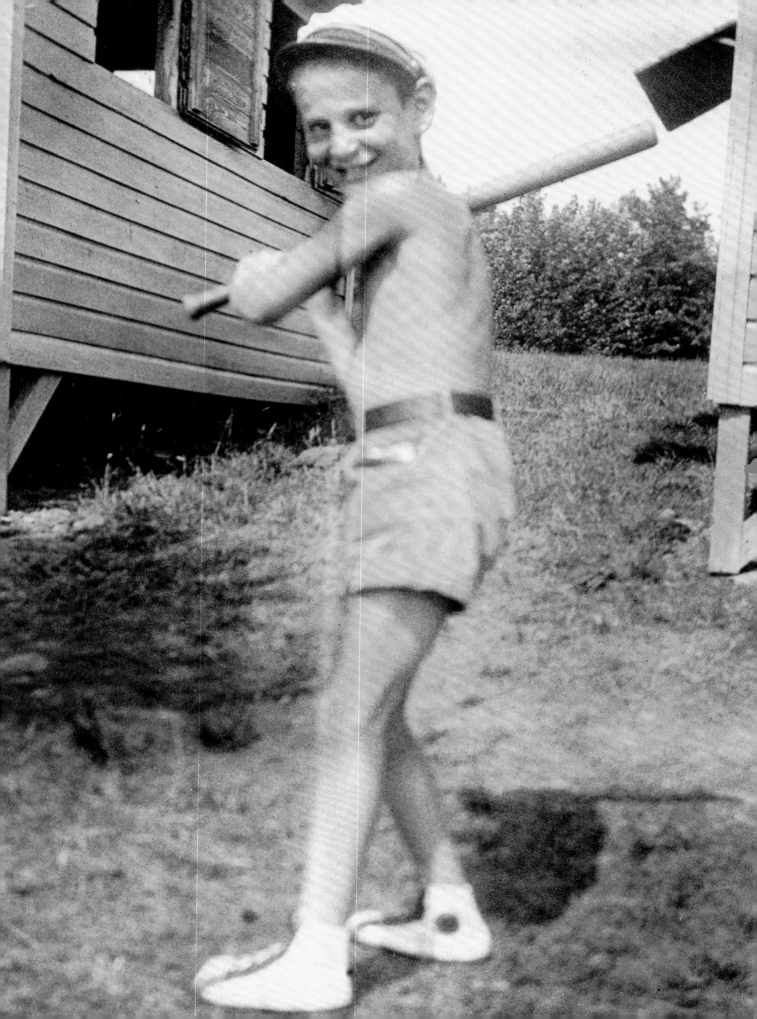

BOYHOOD TO BATMAN

A glowing sign on a bridge in Jerry Robinson's hometown in New Jersey reads TRENTON MAKES, THE WORLD TAKES. Although its stature is faded now, Trenton was one of America's great manufacturing cities, and its boast was entirely true when the sign was erected—goods from Trenton's factories were shipped everywhere—and expressive of a kind of down-to-earth, practical, and businesslike attitude, but one that was also always aware of the larger context. Jerry Robinson's career has some of the same qualities: His creations have had worldwide influence, and he's produced things that were enjoyed by untold millions of readers and viewers. At the same time, he's used his skills as an artist and entrepreneur to bring recognition to other artists, and to the mediums of comic art and cartoons.

Jerry Robinson was born to Benjamin and Mae Robinson at the family home in Trenton, New Jersey, on January 1, 1922. He was a true New Year's baby, born at the stroke of midnight as Trenton's church bells were ringing in the New Year.

Jerry was the Robinsons' fifth and last child, much younger than his three older brothers, Harold, Avner, and Maury, and his sister, Edythe. Jerry and his brothers grew up loving the outdoors; they biked and played baseball and football. Jerry joined the junior high school track team, and especially loved tennis, the family sport.

The Robinsons were also big card players. Jerry's mother was an expert bridge player, while his father was more a poker man. One of his brothers was a champion contract bridge player; Jerry also liked bridge and played it a lot in high school. When he moved to New York as a teenager, he had little time to play, but always kept a deck of cards in his apartment. This turned

OPPOSITE: *A young Jerry Robinson at summer camp, where he learned to box and began a lifelong love of comics through reading reprints of popular newspaper strips (1930)*

ABOVE: *Robinson's grandparents, Max and Sarah Mendelsohn, with Jerry's mother, Mae (standing), and his uncle, Harry (seated) (c. 1880)*

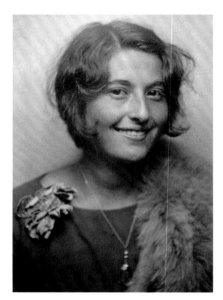

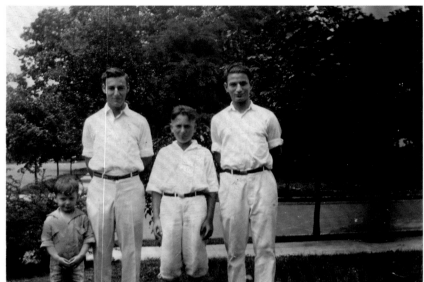

ABOVE LEFT: *Jerry's sister-in-law, Silvia Robinson, encouraged Jerry's interest in art. (c. 1930s)*

ABOVE RIGHT: *Jerry (far left) and his three older brothers, Harold, Maury, and Avner, in tennis outfits (c. 1925)*

out to be fortunate one night when he was devising a new character for a comic book story.

Jerry Robinson never thought about a career as an artist when he was growing up, but he drew constantly. He still remembers one of his first pictures from kindergarten: "I had a big piece of paper on the floor and on it I drew a mountain, which came to a peak, and perched on the top was an elephant—which *didn't* predict my future political leanings!"

Robinson didn't take formal art lessons; rather, he began to draw from life. He wasn't the only one in the family who showed artistic talent; his sister, Edythe, was a photographer, and his brother Harold drew cartoons for his college magazine at Penn. But Jerry was clearly passionate about drawing. By the time he was nine or ten years old, he was doing portraits of his family and friends. "I used to lie on the floor and draw my grandfather's picture," Robinson recalled, speaking of his mother's father. "He was a very dear man. I loved him. I remember when he died. I think I was thirteen. I had a diary in which I only ever made two entries and one of them was about him. I wrote it on George Washington's birthday: 'The two greatest men who ever lived were born or died today, one was my grandfather.'"

More predictive of his future were Jerry's instincts to preserve his own art. As a first- or second-grader, he was given a colorful pressed-tin candy box. He filled it with his own drawings and was heartbroken when it was mistakenly thrown away.

In high school, Robinson shared his artistic interest with another member of the family: his sister-in-law Silvia, Harold's wife. "She was beautiful. I would travel all the way across town after school, just to spend a couple of hours painting with her. She had one room in their house devoted to her studio," said Robinson. "I painted still lifes and outdoor scenes in watercolor.

THE YOUNGEST MEMBERS

I didn't like oil because it took too long; you had to wait until it dried. I liked to try to do drawings in one or two sittings. I'd usually finish a drawing in the afternoon that I'd spend with her." Sadly, Silvia died at an early age, leaving Jerry's brother Harold with their three very young sons, Marty, Lee, and Richard. "I've thought of them as my kids ever since. We're still very close," Robinson said.

Jerry's father, Ben Robinson, an immigrant from Russia, had a distinctive sense of design, and one of his early businesses in America reflected that. "My father came to the United States when he was about eighteen or nineteen, penniless, without a cent, not knowing the language, and somehow he had to get along," said Robinson. "In those days, you thought of it as making a living, nowadays you'd call him an entrepreneur.

"Trenton was the center of pottery at the time," Robinson continued. "It was the home of a famous brand of pottery, Lenox. So my father opened his own small pottery." Ben Robinson bought carloads of unfinished pottery,

ABOVE LEFT: *Four-year-old Jerry with his sister, Edythe, who became a photographer (1926)*

ABOVE RIGHT: *A signed sketch of Jerry's beloved grandfather, Max Mendelsohn (1935)*

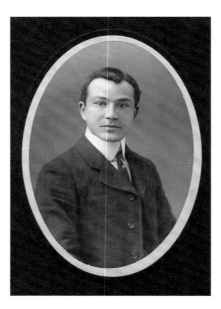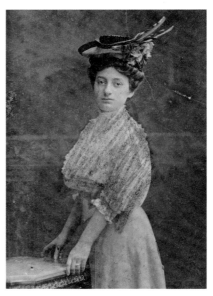

to which he would add decorations of his own design. Robinson's pottery also made its own ceramics, shaping and firing them. Jerry recalls watching the process: "I remember visiting the pottery as a very young kid and watching my father work: The plates spun on a wheel and he decorated them with gilt edges and designs."

Robinson's mother, Mae, came up with the idea for his father's next endeavor. "My mother, who was born in New York, on the Lower East Side, saw a novel entertainment—nickelodeons. Nickelodeons showed rented films in empty storefronts with some benches in them. That's how the early film entrepreneurs started," Robinson said. "Anybody reputable wouldn't go into them. But it was a novelty—pictures that moved—and it only cost you a nickel! The so-called middle class or decent people wouldn't enter a nickelodeon, but my mother felt they could become hugely popular with a wider audience."

His mother's idea was prescient. Before World War I, the first theaters built exclusively for showing motion pictures appeared in New York City. The era of movie palaces with orchestras, uniformed ushers, and elaborate house lighting began there. In urban centers, where increasing one's income and moving up in social status were part of the American dream, the lower classes and immigrants sought ways to move themselves up culturally, and the new theaters, instead of losing the working masses, managed to bring several strata of society together in these temples of what was to become the dominant medium of the nation's popular culture.

"My mother convinced my father that there was a real place for a theater in Trenton, and that it could be a success," Robinson recalled. "My father knew nothing about the film industry, but he wasn't deterred. He went to the bank and got a loan for one hundred thousand dollars, a lot of money at that

ABOVE: *Pre-marriage photos of Jerry's parents, Ben Robinson and Mae Mendelsohn (c. 1900)*

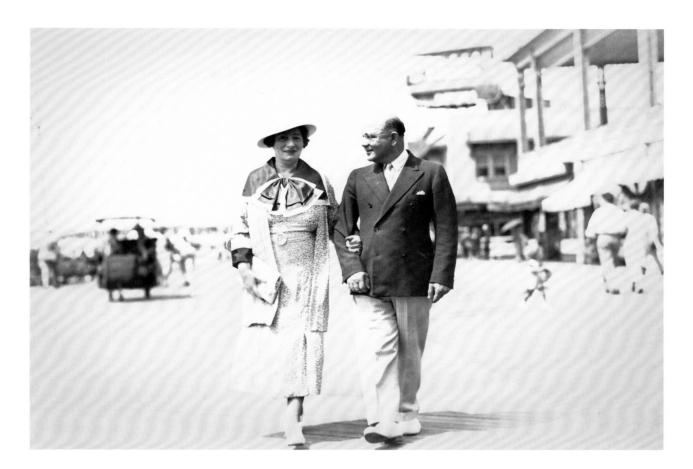

time, to build the first moving picture theater in Trenton. He had no collateral. They just knew him as a hardworking, honest man."

Ben Robinson's Garden Theatre was built in the mid-teens (it appears in the 1917 Trenton city directory) at 148-150 North Broad Street. Robinson's mother and her sister Frieda decided what kind of theater it would be. "My aunt Frieda and my mother decorated the theater lobby with a lot of plants and flowers," said Robinson. "It was inviting and safe, so that the so-called upper class would patronize it. They had to, because admission was twenty-five cents, which was a lot for a movie for most people at that time."

The Garden Theatre was where Robinson spent time with his extended family: "My aunt Frieda played the piano, and she became the accompanist for the movies. One of my earliest memories is sitting on the piano bench, next to my aunt, straining to look up at the screen—it was almost directly above us—while my aunt watched the picture and played the background music."

Robinson's beloved maternal grandfather also worked in the theater. "My grandfather was the cashier," Robinson recalled, "and when someone once asked him what movie was coming next, he said, 'Oh, the next picture is *Tixy, Tixy*.' The name of the movie was *Taxi! Taxi!* but that was as close as he could come to it; his English was limited. This became kind of a family joke."

ABOVE: *Ben and Mae Robinson stroll along the boardwalk in Atlantic City, New Jersey (c. 1920)*

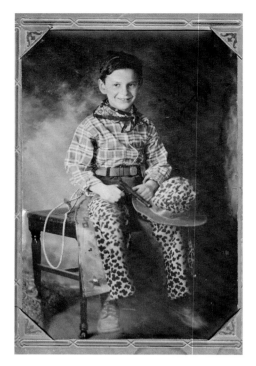

ABOVE: *Jerry at six years old in his cowboy suit (c. 1928). Robinson would later go on to draw Western comics, including* Bat Masterson.

Robinson's love of movies was born in the family-run Garden Theatre, which still stands, but is now closed down. "I remember [Charlie] Chaplin, Buster Keaton, and Harold Lloyd, and all the cowboy stars: Ken Maynard, Hoot Gibson, Bob Steele, Buck Jones, Tom Tyler, but most of all Tom Mix. He was my favorite cowboy star. I once had the exciting experience of seeing Tom Mix in person when he came to Trenton on the vaudeville circuit."

Robinson and his family were not immune to the ravages of the Great Depression. When Jerry was in first grade, his father lost the theater and everything else in the stock market crash. The Robinsons had to move to a different, rougher neighborhood in the center of Trenton, where they lived in a tenement, the only thing that his father still owned.

Jerry was a small kid, but wiry, and as he remembers: "I was initiated into my new neighborhood with a fight." Jerry already had some experience as a fighter. He had gone to a Boy Scout summer camp where he learned to box. (At the time, of course, no one knew that Robinson would be drawing and creating some of America's greatest battling heroes and villains before too long.)

On his first day in the new neighborhood, when Jerry went out to see if there were any friends to be made, and what there was to do, he found himself surrounded by a gang of fifteen or so kids. They grabbed him, took him to an empty lot, and surrounded him in a circle. They pushed one kid forward, to start a fight, and began yelling things like, "Coward!" as Robinson stood there and took the punches. He was frightened, but he soon realized he had to fight—and he knew how. The other kids began to take Jerry's side and, when his opponent got frustrated and started throwing stones at him, the tables turned: "Even in their language, that was not fair." The kids pulled their former champion away from Jerry, and then welcomed him into the gang. He was now part of his new neighborhood. Robinson described it as being "almost like an *Our Gang* comedy."

Financially, Ben Robinson wasn't down for long. He turned the difficult times to his advantage by opening a clothing store, which he stocked by buying the entire inventories of distressed stores, and selling suits that were originally one hundred dollars for twelve dollars and fifty cents. According to Jerry, the Depression helped make the store successful: "People came from all over south Jersey when they could afford a suit of any kind to make a decent presentation to get a job." It also led to one of Jerry Robinson's first public art jobs. After his aunt came up with a clever name for the store— Thrifty Twelve-Fifty—she and Jerry collaborated on a logo.

A few years later, after his father's fortunes improved, Robinson and his family moved to the suburbs, on the western end of Trenton. But like some of the other kids who would later create the comics—for example Jack Kirby, who was growing up on the tough Lower East Side—Robinson brought some urban grit to the fights and criminals he would depict in *Batman* and the tough crime stories he would draw later.

In addition to boxing, Robinson also learned to love the comics at summer camp, when his parents brought him books that are now seen as the predecessors of modern comic books. Long before all-color comic books appeared on newsstands in the 1930s, Sunday and daily newspaper comic strips were reprinted in cheap books on low-quality paper, usually with pasteboard covers. The covers might be in color, but the interiors were black and white. The titles were all reprints of newspaper humor strips: Bud Fisher's slapstick classic, *Mutt and Jeff;* George McManus's beautiful Art Nouveau masterpiece about Maggie and Jiggs, *Bringing Up Father;* and a special favorite, Rube Goldberg's *Life's Little Jokes.* Robinson still has these books. Years after those summer camp days, when he was president of the National Cartoonists Society, Jerry brought his childhood treasure to Goldberg to have him sign it. "That's what I grew up with, the humor, and it left a lasting impression," Robinson believes. The foundations for his later success with humorous and satirical cartoons and comic strips were laid reading these strip reprint books.

ABOVE: *Jerry's favorite childhood house, on Bellevue Avenue in Trenton, New Jersey (c. 1920)*

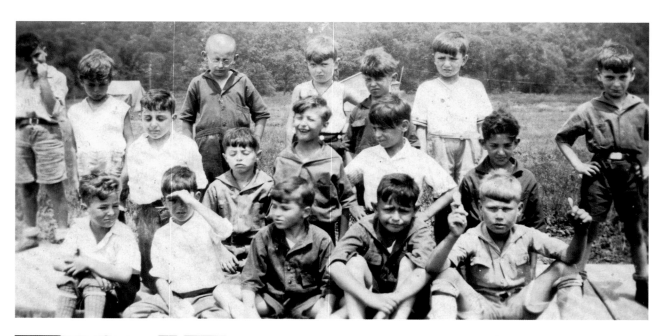

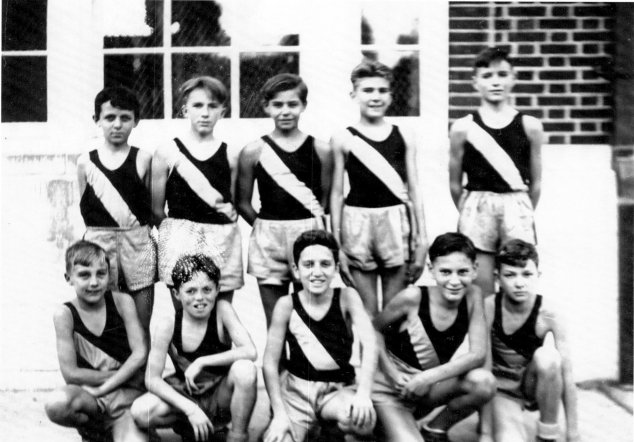

Education was very important in the Robinson family. Not only did all of Jerry's brothers and his sister go to college, most continued to grad school or dental or medical school. Robinson's mother had only been able to attend school through the sixth grade. Despite this, Robinson said, "she loved education, she adored culture. We discussed everything in the house: politics, literature. My mother admired good diction and good speech. She had excellent diction herself, and beautiful handwriting. She had a beautiful mind." As he further recalled, "She took any opportunity to educate herself. My mother started working full time before she was even high school age, and taught herself bookkeeping. She became so professionally accomplished that she eventually became the head bookkeeper for a business that employed some thirty bookkeepers. Later, she was proud to say that the owner's daughter was a bookkeeper under her," said Robinson. When Jerry's father had his business reversals, his mother enrolled in secretarial school and learned shorthand so she could find a job and help support the family during the 1930s. "She knew things instinctively," said Robinson. "I think that if my mother had been able to go to high school, college, she could have done anything. She really would have been remarkable." Mae Robinson passed along her love of learning and respect for education to all her children. When Jerry finished high school, he applied to several colleges and was accepted, giving him a choice of top schools: Penn, Syracuse, and Columbia.

Robinson's parents had a huge influence on him: His father was an inventive and resourceful businessman who found creative ways to make a living, and his mother embraced literature, culture, and the spirited exchange of ideas. Robinson's father also taught Jerry to stand up for himself when necessary. Ben Robinson was not very tall, but he was strong and broad-shouldered. One day in his clothing store, a couple of muscular, tough-looking customers were trying on suits, and one of them made an anti-Semitic remark. Jerry's father didn't say anything, didn't challenge him to a fight. He just picked up the customer bodily, lifting him up by the collar of his suit and the waistband of his pants, and deposited him on the sidewalk in front of the store. The other tough guy was so amazed, he just stood there gaping until he was ejected in the same way.

Jerry loved to have his father tell him the story of how he escaped from Russia. "My father and grandfather—who I never met, he died in an accident—were respected in the village. The people in the village called each of them 'mayor.' They knew how to do anything that needed to be done, from shoeing a horse to writing a letter." Like many young Jewish men, Ben Robinson wanted to escape compulsory military service, which in Czarist Russia lasted for twenty-five years, as well as the rampant anti-Semitism, which could break out into pogroms. "My father came from northwestern Russia, near the Polish border and the Baltic states," Robinson remembered. "He had to escape through the woods."

OPPOSITE TOP: *Jerry Robinson (standing, far right) was a boxing champion at summer camp. (c. 1930)*

OPPOSITE BOTTOM: *Jerry (front row, second from right), like his brothers, was athletic; he was a member of his junior high track team. (c. 1935)*

ABOVE: *Jerry's great-grandfather, Moses Robinson, followed his son Ben to America and was reputed to be the oldest man in the state when he died at age 116. (c. 1900)*

There was an extensive forest along the Polish border that provided the best way to escape Russia. The night Robinson's father began his flight, he rendezvoused with a group of other fugitives. "They made up a small party, and traveled by horse and sled through the woods." Robinson recalled his father's story. "It was a very snowy night, and the snow continued for a couple of days, which I guess was fortunate; they couldn't see well, but neither could their pursuers! They crossed the border to Poland, and then my father made his way up to the Baltic," Robinson recounts. His father had saved up some money, and there he took passage on a ship, his first step toward America.

In addition to familial influences, Jerry Robinson was exposed to art and writing through a job he had as a boy: selling magazine subscriptions, picking up each week's magazines at the distributor, and then delivering them by bicycle. He did this for several years through grammar school and middle school. "I remember each and every day I would carry these magazines, large magazines like *Life*," said Robinson. He remembers when the first issue of *Life* came out, with its iconic cover photograph by Margaret Bourke-White. "There was also a magazine called *Scandal*, it was a tall magazine like *Life,* but it was much more sensational," he recalled. He would also pick up sample magazines at the distributor to show to potential customers to get more subscriptions. "*Collier's* and the *Saturday Evening Post* were popular," according to Robinson, who noted that he was drawn to the illustrations in the magazines: "I remember the work of popular illustrators of the day. I knew the ones I liked, and I could identify them: J. C. Leyendecker, Norman Rockwell, Charles Dana Gibson, and others."

Another kind of magazine was available in a local candy store or newsstand: the pulps. "I spent a lot of time there looking through these magazines, and if I had any money, purchasing them, too," said Robinson. Like a lot of boys—and men—at the time, Jerry read these oversize magazines, printed on the cheapest paper with untrimmed pages, with their exciting stories and fantastic, sometimes transgressive covers. Unlike many of the pulp readers, however, Robinson paid close attention to the art. "I remember looking at the full-color art of the covers of the pulps. Then I would also look through the pulps for all of the illustrations, like the spot illustrations in *The Shadow*. Edd Cartier's work, especially his artwork in *The Shadow*, was a major influence for me," he recalled. "I began to pick up some science-fiction magazines like *Astounding* and *Weird Tales*. I don't think they carried *Spicy Mystery*. I would have been intrigued by that!" he said, referring to that pulp's famous covers of ladies *en deshabille*. "I read whatever Western pulps they had, and I liked Tarzan. I was more apt to pick up or buy a magazine or book if it was illustrated."

"I read pulps, but I read a lot of books, too," Robinson added. "At that time, I went to the library a lot. I read *Tom Sawyer*, all of Mark Twain's works. I used to read compilations of short stories by different authors." Eventually,

Robinson tried to get published himself, submitting a short story to the *Saturday Evening Post:* "I got a nice rejection slip. I was pleased that they acknowledged my existence."

Much as he loved art as he was growing up, Jerry Robinson's real interest was in writing. He was drawn to journalism, but he also had a deep love for literature. In high school, he went down both paths. He wrote more short stories and read even more widely. He was inspired by many different writers, Americans such as Edgar Allan Poe and O. Henry, Europeans such as Guy de Maupassant, and the Russian masters Fyodor Dostoyevsky, Nikolai Gogol, and Ivan Turgenev. But he also explored journalism, and became an editor and writer for his high school paper, *The Spectator*. It just seemed natural to contribute drawings to the newspaper as well.

Robinson's facility and dexterity in drawing made him the exclusive cartoonist for his high school newspaper for an odd technical reason. To print the cartoons, metal plates coated with chalk were used instead of photographic plates. Incising the thin layer of chalk with a burin transferred the image. Robinson excelled at this. "It wasn't a very thick layer of chalk. If you got two lines close together, a piece would often break off," he remembered. Eventually, his reputation reached the plate manufacturer: "I suddenly had a visit from Mr. Guido T. James from Philadelphia, offering me a job when I finished high school, doing drawings on his chalk plate."

The strong creative and theatrical atmosphere at his high school stood Robinson in good stead later, when he helped to create and expand the new dramatic medium of the comic book. Strikingly, the high school experiences of a number of the other young men he found working in comics in New York were parallel to his own in Trenton. For example, the artists Will Eisner and Bob Kane and the writer Bill Finger all went to DeWitt Clinton High School in the Bronx, which also offered an atmosphere that combined solid academics with an appreciation for the arts and literature.

When it came time for college, Robinson had pretty much settled on a career in journalism, and had applied to several colleges and universities that had good journalism departments or strong reputations in this field. However, it was still the Depression and, while Robinson's family had some financial resources available for him—particularly since he was the youngest, and his siblings had already finished or would soon finish their studies—Jerry still needed to earn as much money as he could before starting college in the fall. So during the summer of 1939, he began selling ice cream.

Jerry didn't luck into selling from an ice-cream stand, and jingle-blasting trucks hadn't yet been invented. He was given a bicycle with a freezer, and had to pedal from neighborhood to neighborhood, ringing a bike bell and calling for customers. The only way to really make the job pay enough to save for college was to put in long hours of biking and selling. Already slender, Robinson lost more and more weight as the summer months went by. Finally, in the middle of August, his mother hit on a solution: Jerry would

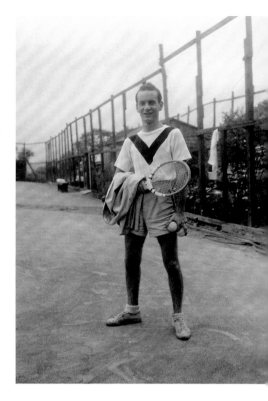

ABOVE: *Tennis was the Robinson family sport; Jerry was a member of his high school tennis team and played in tournaments across New Jersey. (c. 1938)*

spend the last week before school started at a resort in Pennsylvania's Pocono Mountains.

"My mother sent me off to fatten up. She never thought I'd survive the first semester at college. I was down to skin and bones, really, eighty-nine pounds or so," Robinson remembered. "My mother had to persuade me to go to the Poconos, because I didn't want to be a burden to my family. They had just put three brothers through college ahead of me," he said. "I think the resort cost twenty-five dollars for a week in the country with meals. I was loath to spend that twenty-five dollars. I wanted to be independent and I was determined to do whatever I could do to help, even though by then my folks were a little better off."

Of course, eating wasn't going to keep Jerry from playing tennis. He took along his racquet and tennis whites, and a jacket that he had decorated himself, which he used as a warm-up jacket. He wore it to and from tennis. This was a college-age fad. "I was in Princeton from time to time. I loved track-and-field, and went to meets there; and I also played tennis there," he remembered about his visits. When he saw that college students were wearing painter's jackets that they'd decorated themselves, Jerry went out and got one. He covered his painter's jacket with his own drawings.

The jackets all the college Joes wore were sold in painters' supply stores and had plenty of pockets for brushes, tools, and equipment. As Robinson described it, "The painter's jacket was very cool. It was kind of like a light, linen sort of thing. Many other people, workmen, used it, too. But it was called a painter's jacket." These jackets inverted class messages: Ivy League kids (or high schoolers imitating them) were now wearing a working man's garment. Robinson observed, "It was a fad, taken up because we saw it on college students. But it was also functional."

The off-white, absorbent jackets were perfect for drawing on, and Robinson did just that. He no longer remembers exactly what he drew, though. "I just drew various stuff all over it. The only thing that I specifically remember, there was a side pocket, and I drew a comb coming out of it!"

His first day at the resort, Jerry threw on his painter's jacket and headed for the tennis court. As he was looking for a partner to play, someone tapped him on the shoulder and asked, "Who did the cartoons?"

"I spoke hesitantly," said Robinson. "'I did,' I said, thinking I might be about to be arrested or something."

But a job, not jail, was in the offing. The questioner turned out to be Bob Kane. Kane had just created a new character as the lead feature for a comic only some months before. He asked seventeen-year-old Jerry if he'd be interested in working on Kane's comic book stories—*Batman*.

"Obviously he must have been attracted by some drawings on the jacket," Robinson explained. Kane needed an art assistant, and a teenager might be just the thing if, as Robinson speculated, "He was looking for some inexpensive help!"

Robinson said he might be interested; after all, he loved art, he loved to draw. But he also had to admit that he'd never seen, or even heard of Batman or even comic books. Kane took him down to the village, where they found a newsstand and purchased a copy of *Detective Comics,* in which Batman was the lead feature. Jerry was definitely interested in working as Kane's assistant. . . . But he was unimpressed by the comic book!

ABOVE: *Jerry Robinson, around the time that he met Bob Kane in the summer of 1939*

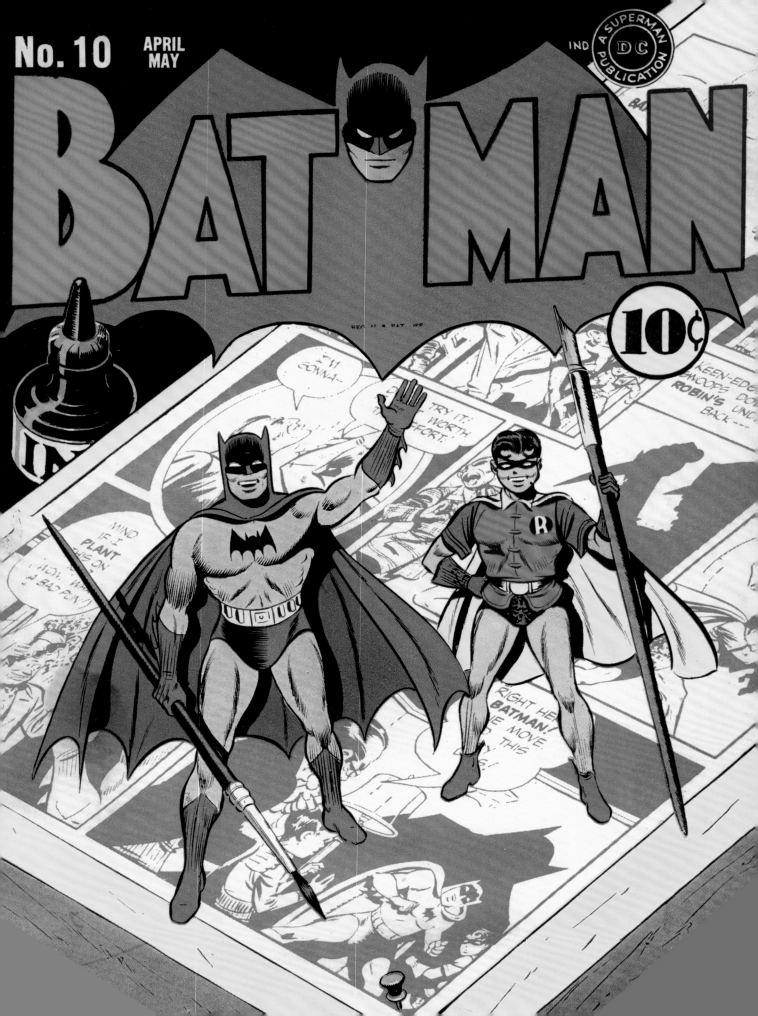

BATMAN BEGINS

Bob Kane was a cartoonist who specialized in humor and funny animal comic book features such as "Peter Pup." He was a Bronx native and still lived there with his parents. One day in 1938, Vin Sullivan, Kane's editor at DC Comics, asked Bob if he could come up with a character to replicate the success of Jerry Siegel and Joe Shuster's popular costumed hero, Superman. After drawing some basic character sketches, Bob contacted his colleague, the writer Bill Finger, to work with him. When Kane spotted Robinson in his cartoon-decorated jacket in the Poconos and invited him to come to the Bronx and work on *Batman*, the comic book character and his mythos began.

Seventeen years old at the time, Robinson was a combination of tough street kid, budding intellectual, and innocent teenager. When Kane offered him a job, Robinson decided he was not even going to go back home to Trenton before starting his new life. He had been accepted to several universities, but had put off making a final choice, which turned out to be fortunate. Jerry quickly called Columbia University in New York City, found that the offer of admission to the college was still open, and accepted it.

Robinson planned to head directly to New York from the Poconos—but he'd never been to the city and had no idea how to get there. He asked the resort's desk clerk for directions, but was dismayed to hear that the only route was on the bus, with several confusing connections. Luckily the clerk had another idea. The tenor Jan Peerce had been performing at the resort that weekend: "Mr. Peerce is driving back to New York this afternoon," the clerk told Robinson. "Maybe he might give you a lift."

Peerce was perhaps the most famous operatic tenor in America at the time, thanks to his radio broadcasts with the Radio City Music Hall company.

OPPOSITE: Batman *no. 10 (April–May 1942)*
DC Comics
Layouts: Fred Ray; pencils, inks, and colors: Jerry Robinson

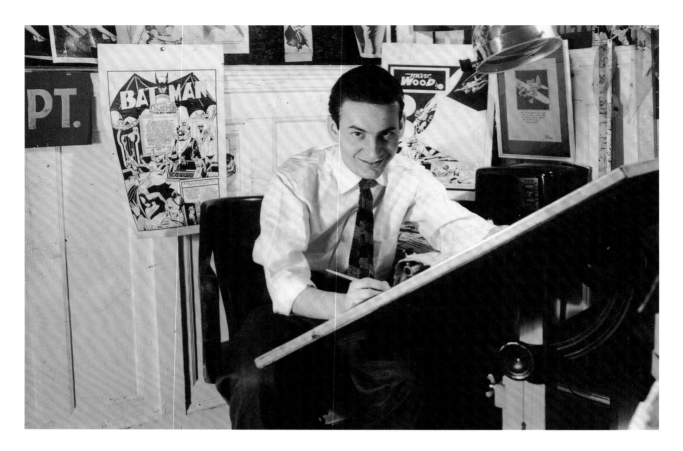

ABOVE: *Jerry Robinson at the drawing board in the* New York Times *building, Times Square (1940)*

Robinson shyly approached the singer, explained that he'd just been admitted to Columbia, and asked if he might get a ride. Turns out, Peerce had gone to Columbia, too. He answered: "Sure, kid!" Robinson soon found himself in Peerce's car . . . a chauffeured limousine! "He left me off somewhere in the Bronx with my battered suitcase and tennis racquet," Robinson recalls, "but I arrived in style!"

Robinson had relatives in the Bronx and, to save money, he was able to move in with an aunt, Virginia Fairfax. "Aunt Virginia was a tall, elegant, former actress who was as dramatic at home as she was on the stage. I loved hearing all her stories about being on Broadway and on tour. She had been married to my mother's brother, my late uncle Harry, who had also been a great storyteller and raconteur and had had his own radio show," Robinson said. Jerry was happy living with his aunt and, since she was quite poor, having him there offered her some much-needed help with the rent. Sadly, Virginia Fairfax passed away within a year after her nephew moved in, and Robinson had to find his own place. By that time, he'd gotten used to the neighborhood and didn't move far away. It was a real commute from the Bronx, New York's northernmost borough, to Columbia's campus at 116th Street and Broadway. But living there meant Robinson could walk to the Kane family apartment, which doubled as Bob's studio.

New York City played a large role in Robinson's overall artistic career, as well as in the creation of the *Batman* comics. As a young man, Jerry was inspired by the Bronx. It was so different from his hometown. Trenton offered an industrial landscape and the gritty, working-class area filled with empty lots where Jerry had proved his mettle as a boxer. For the most part, his life had revolved around Trenton's commercial districts, where his father's businesses were located, and the suburban residential areas with houses and small apartment buildings where the Robinson family had lived.

The Bronx was different. The borough had grown explosively in the teens and twenties as immigrant families began to achieve the American dream and moved from crowded neighborhoods such as Manhattan's Lower East Side to the new and more spacious apartment buildings that marched mile after mile along the tree-lined avenues of the Bronx. By 1939, when Robinson moved there, the Depression was really taking a toll on the social fabric of the city. Construction had stopped, and a darker mood had settled over the borough's neighborhoods. The endless rows of Bronx apartment houses, filled with families from various ethnic groups, provided the urban background in the works Robinson, Kane, and Finger were creating. All the city's characters—families and children, cops and deliverymen, hustlers and con men—populated the borough. The gallery of city types that the young creators of *Batman* would depict in their comics passed in review before them on the streets of the Bronx every day. Jerry particularly enjoyed drawing what and who he saw framed by his apartment window; eventually some of these same characters appeared in the stories he wrote for his studies at Columbia.

Jerry Robinson had been drawing since childhood, and now he was going to start an actual job as an artist. However, as he recalled, "I had absolutely no training whatsoever in art, had never taken an art class. I was due to start with Bob as a cartoonist, and I thought, 'Jeez, I better learn something about cartooning!'" So he decided to look for an art school. He found one, at the top of the famous Flatiron Building, the pioneering skyscraper at Fifth Avenue and Twenty-third Street, and signed up for a month's instruction. "I found out they didn't have any classes in cartooning," Robinson said, but he still felt he needed some training, and took an art course that the school did offer. It was like something out of the nineteenth century. The instruction emphasized following classical models and making drawings of Greek and Roman sculptures. "They had me drawing plaster casts of figures and reliefs," Robinson said. "I got frustrated, and thought, 'I'm not going to learn anything here.'" He stuck it out for a week and then, "I taught myself just by observing and doing."

Kane was learning, too. He had decided to concentrate less on humorous comic book features, and start developing action and adventure stories. He drew *Rusty and His Pals,* a kid adventure modeled on Milton Caniff's *Terry and the Pirates* comic strip, and *Clip Carson,* featuring a world-traveling

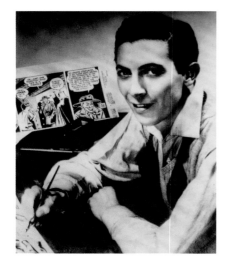

TOP: *Bob Kane in the 1940s. Twenty-five-year-old Kane seemed much older and more sophisticated to the seventeen-year-old Robinson when the two met.*

BOTTOM: *An ink-and-wash drawing of Bill Finger by Jerry Robinson (2005). This is engraved on the Bill Finger Award created by Robinson to honor his colleague; the award is given annually at Comic-Con International in San Diego.*

action hero. (Robinson would work on *Clip Carson* and *Rusty and His Pals* as well as on *Batman*.) Kane worked with Bill Finger on these earlier features before the two turned to *Batman*. Finger was two years Kane's senior; the Depression had kept Finger from attending college and following his dreams.

Bill Finger was an autodidact, a true self-taught intellectual like many of the best comics creators, such as Will Eisner and Harvey Pekar. He was widely read in adventure fiction and literature, from Theodore Dreiser to Edgar Allan Poe to Robert Louis Stevenson. He also avidly read the pulps in all different genres, from science fiction (*Amazing Stories*) to horror (*Weird Tales,* which published writers such as H. P. Lovecraft) to detective and mystery fiction (*Black Mask,* which first published Dashiell Hammett and Raymond Chandler). Among Finger's favorites were the hero pulps, the magazines that featured the escapades of a single adventurous and resourceful character, such as the Shadow or Doc Savage. The format of the pulps— colorful, lurid covers and sparsely illustrated, all-fiction interiors—had paved the way for comics on newsstands and in the hearts of readers. All the creators of the comics were voracious pulp readers, like science-fiction fans Jerry Siegel and Jack Kirby. Bill Finger was one of the few comics creators who immersed himself completely in pop culture *and* the "high culture" of literature, art, and cinema. He would have a profound impact on the younger Jerry Robinson.

When they were working on *Batman*, Robinson and Finger would go over to Kane's apartment. Robinson recalled, "We worked in Bob's room, his bedroom, which was fairly large. He had a drawing table set up in there." Robinson said the meetings in Kane's apartment focused on discussing the scripts and stories: "I didn't do any drawing, we just met there. We usually did character sketches, working out the concepts of the characters, or maybe diagrams of something that happened in the story that we wanted to iron out. We went over the work, or brought in the finished work, and that was it. Bob's father, or Bob himself, would bring the work down to the DC offices."

More free-flowing, inspired conversations among the three took place when they went out to dinner at one of the down-to-earth Grand Concourse restaurants or to lunch at a classic American soda fountain–candy store, the kind with a counter and stools. "We would discuss ideas," says Robinson. "We were really, totally absorbed. Lunchtime, or dinner, whenever we would go out, the topic of conversation wasn't Bill's girlfriend, Portia, or one of Bob's many girlfriends, or my own romances. It was about *Batman*. We literally dreamed and talked about *Batman*: visuals and story ideas and so on." They were part of the first generation of comics-smitten kids who talked more about super heroes than girls.

Not far from their apartments was a piece of Bronx history and a part of American literary history: the Edgar Allan Poe Cottage and Poe Park. The small house, now a museum and National Trust for Historic Preservation

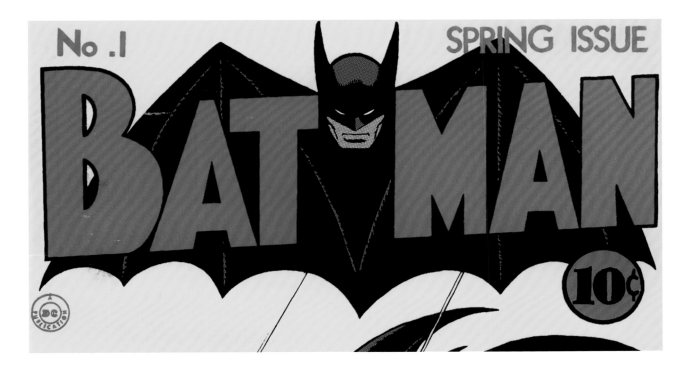

property, had been inhabited by Poe during the lowest part of his life. Over the winter of 1846–47, Poe was unemployed and desperately poor. He made little money selling his writing, and his beloved wife, Virginia, was desperately ill with tuberculosis. Hungry and cold, Poe watched his wife fail and finally die that January.

Robinson often walked over to Poe Park, imbibing the dark, tragic atmosphere in the cottage. Jerry was a huge fan of Edgar Allan Poe; for his tenth birthday Jerry had received what became a beloved volume of Poe's *Tales of Mystery and Imagination* illustrated by the Irish artist Harry Clarke. Clarke is often identified as an Art Nouveau artist who was powerfully influenced by Aubrey Beardsley; his work clearly owes as much or more to Expressionism, as well as to symbolism. Clarke's *Tales of Mystery and Imagination* is generally recognized as the finest illustrated version of Poe ever produced, and Jerry read his copy over and over; in fact, he memorized Poe's story "The Tell-Tale Heart" from it for an oratorical contest. Poe has remained part of the very fiber of Robinson's being and a continuous inspiration to his creative work: "The design elements Clarke used, the color, captured so much of Poe: The mystery, the suspense, the drama, the horror," Robinson said. Poe, Clarke's book, and Poe Park and the Bronx neighborhood surrounding it all entered Robinson's work on *Batman*.

Once Robinson had settled into his aunt's apartment and registered for classes at Columbia University, his work on *Batman* really began. Kane handled all contact with the publisher, but the working relationship quickly became quite collaborative. Kane, Finger, and Robinson knew they were

ABOVE: *Detail from* Batman *no. 1 (Spring 1940) DC Comics. Jerry Robinson designed this Art Deco–inspired logo, which became the official logo for Batman in comic books and elsewhere for decades.*

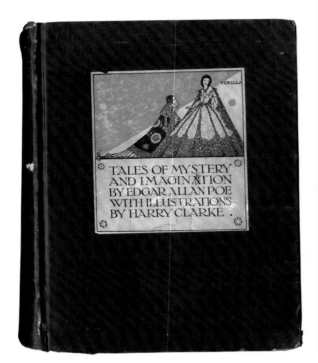

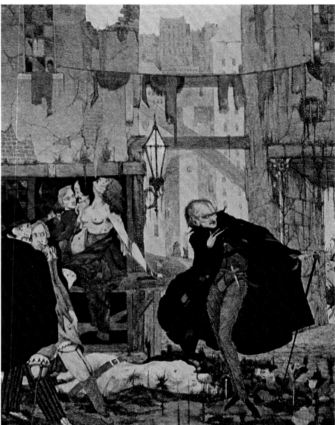

ABOVE LEFT: *Jerry Robinson's original copy of Edgar Allan Poe's* Tales of Mystery and Imagination, *illustrated by Harry Clarke (Tudor Publishing, 1933)*

ABOVE RIGHT: *"It was the most noisome quarter of London." Harry Clarke's pen-and-ink and watercolor illustration for "The Man of the Crowd," from* Tales of Mystery and Imagination

doing something very new, and the possibilities excited all of them. The words *super hero* didn't even exist. When the artists and writers and editors of these new comic books talked about the heroic figures they were creating, they called them "characters." The term *super hero* only began to be used widely in the mid-1940s.

Robinson was truly burning the candle at both ends. He tried to take most of his college courses at night so that he would be free to work on comic books during the day. His schedule was not an easy one; he was trying to prepare himself for a career in journalism, but he also wanted to study literature. Columbia College's Core Curriculum, required of all undergraduates, is based on a great books approach, reading works of literature from classical to contemporary. Robinson wasn't satisfied with just analyzing literary works; he wanted to write as well, and signed up for creative writing courses. His academic work would have a surprising impact on his contributions to *Batman*.

As Robinson expanded his academic education, he gained a second kind of education from Finger. Bill loved art and was an inveterate museumgoer. He took Jerry to New York's famous Metropolitan Museum of Art on Fifth Avenue, where they studied the vast sweep of the history of art together, as

well as to the Museum of Modern Art. And they went to movie after movie. Robinson had developed a love of movies in his father's theater; now Finger introduced him to a whole new world of cinema: foreign films.

"I often went to the movies with Bill," Robinson recalls. "He took me to European movies by directors like Josef von Sternberg, Fritz Lang, and Robert Wiene. We went to see *The Blue Angel, The Cabinet of Dr. Caligari,* and Murnau's *Nosferatu.* Bill loved German Expressionist movies, and I fell for them, too. I think partly that was because I was familiar with European Expressionism through the illustrations in my favorite book of Poe, those beautiful color plates and black-and-white drawings by Harry Clarke." In the 1920s and 1930s, German Expressionist cinema was an important and internationally influential medium, and many of the films featured powerful but clearly artificial painted sets, which frequently ignored or reversed perspective, and camerawork that embraced extreme angles. Expressionist cinema derived much of its aesthetic from the visual arts, including works such as Edvard Munch's *The Scream* (1893) and James Ensor's *Entry of Christ into Brussels* (1888). And its influence circled back into the visual art of comics through the work of artists such as Jerry Robinson.

Robinson and Finger often headed to Times Square, the mecca for young moviegoers then because Forty-second Street was lined with theaters. As Robinson notes: "The only places I knew were Columbia University and the Bronx. Going to Midtown was like going to Siam! I vividly remember the big smoking sign for Camel cigarettes. During the war [World War II], they painted the sign to make the smoking character a soldier or sailor." Jerry ate at the Horn and Hardart's Automat in Times Square, and once saw Frank Sinatra mobbed by girls at the theater across from the *New York Times* building.

Robinson was also learning more about how to be a comic book artist. He developed his own style, drawing dramatic and adventure-filled stories. Originally hired as an art assistant—the traditional apprentice role of letter-ing and inking backgrounds—Robinson quickly became a fluid and talented inker. He also took over more and more of the penciling as the popularity of *Batman* grew and the workload increased. Sometimes the speed of the work enabled Robinson to experiment with viewpoints and angles. Kane was rushing to pencil the stories, and his quickly drawn dramatic figures in settings that were merely suggested forced Robinson to "devise a way to make Bob's concepts work," as he put it. Jerry took this as a challenge.

Another challenge arose when it was time to add a second major charac-ter to *Batman.* "Bill Finger came up with the idea of the boy," Robinson re-calls. Since the first comic books contained reprints of Sunday newspaper comic strips that were for readers of all ages, it seemed important to make sure that the *Batman* stories appealed to this same broad range of adults and children. Adding a boy to the *Batman* comic would give younger readers a character to identify with. "He was the first aide-de-camp, the first protégé. After that, every strip had a boy, every hero had a young sidekick," Robinson

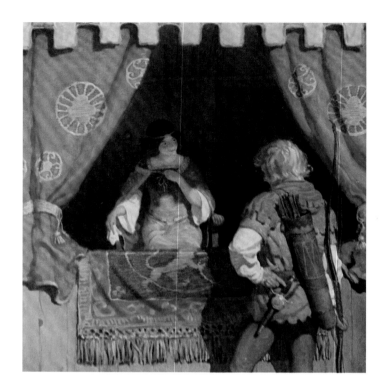

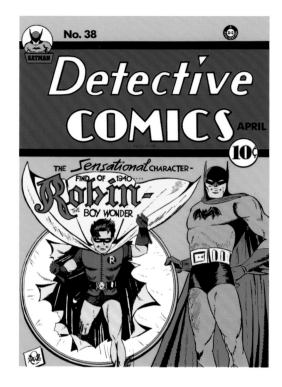

ABOVE LEFT: *N. C. Wyeth's oil-on-canvas illustration, "Robin Meets Maid Marian," from* Robin Hood, *by Paul Creswick (David McKay Co., 1917). The book was Robinson's inspiration for both Robin's name and his costume.*

ABOVE RIGHT: *Cover,* Detective Comics *no. 38 (April 1940) DC Comics Pencils: Bob Kane and Jerry Robinson; inks and lettering: Jerry Robinson Robinson designed the Old English–style lettering for Robin's logo as homage to the source of the character's name, Robin Hood. A reference to Robin's parents, who were circus aerialists, can be seen in the paper-covered hoop that Robin jumps through, as if a performer under the big top.*

explained. But the idea needed to be fleshed out: "After Finger suggested a boy, we were kicking around the name and the idea." Kane, Finger, and Robinson developed a long list of potential names, from various sources. One of them was Mercury, the Roman god who served as the other gods' messenger; however, that name was discarded when Jerry suggested Robin, from *Robin Hood*. Robinson wanted to emphasize the humanity that's at the heart of Batman's appeal, as opposed to the more-than-human qualities of characters like Superman. As Jerry recalls: "Robin was more human, a real boy's name, rather than one that implied some powers."

Children love to imagine themselves the heroes of adventure stories, and illustrated books are a perfect medium for helping young readers visualize themselves in exotic surroundings and exciting and dangerous situations. Perhaps the greatest illustrator of America's Golden Age of Illustration (usually identified as the 1880s to the 1920s) was N. C. Wyeth, father of the realist painter Andrew Wyeth. N. C. Wyeth was part of every American's childhood for decades through his Scribner's Illustrated Classics, a series of great adventure books, each containing a dozen or so color plates from Wyeth's paintings. His *Treasure Island* illustrations are perhaps the finest ever done for that magical volume. Jerry Robinson particularly loved Wyeth's version of *Robin Hood* and, growing up, spent hours poring over Wyeth's illustrations in it. This gave Robinson the idea for Robin's name and costume. Drawing from memory, Robinson sketched out a medieval costume. Looking at his copy of Wyeth's *Robin Hood* today, Robinson notes the close

parallel with the image of Robin in the illustration "Robin Meets Maid Marian": "If you recall this [Wyeth illustration], you just recall the tights, the shorts, the belt, the jacket, and the shoes." But Robinson didn't remember all the details from the original: "I forgot about these scalloped sleeves on the tunic. Perhaps it's just as well," he joked.

Robin debuted in *Detective Comics* no. 38 (April 1940). Robinson had begun designing logos almost as soon as he started inking the book, and had already designed a logo with BATMAN in receding block lettering. Later, for the first issue of *Batman*, he would design a classic logo featuring Batman's head with bat wings, a bold block BATMAN, and with ROBIN, THE BOY WONDER underneath. For Robin's first appearance, Robinson designed distinctive lettering that would remain associated with the character. "I made up my own Old English for the logo," he recalled. Because the character was based on Wyeth's Robin Hood, Robinson thought it was appropriate to choose something medieval: "I tried to get something to relate to Robin, visually as well as the style."

ABOVE: *Detail, cover,* Detective Comics *no. 70 (December 1942) DC Comics Pencils and inks: Jerry Robinson Robin's costume features a doublet and gloves, perfect for an action hero, whether one of Robin Hood's Merry Men or a comic book sidekick.*

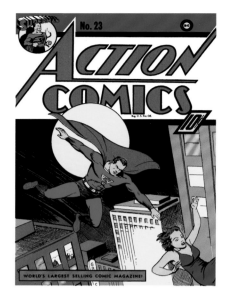

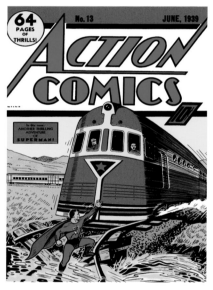

TOP: *Cover,* Action Comics *no. 23
(April 1940) DC Comics
Pencils: Joe Shuster; inks: Paul Cassidy*

BOTTOM: *Cover,* Action Comics *no. 13
(June 1939) DC Comics
Pencils and inks: Joe Shuster*

*As the Depression deepened, Art Deco–
style murals by artists of the New Deal's
Works Progress Administration (WPA)
inspired hope for the future and glorified
the American worker. Jerry Siegel and
Joe Shuster's* Superman *expressed the
same hope and optimism.*

The last touch was the *R* in a circle on Robin's vest. Robinson's job as assistant included lettering the dialogue, which appeared in word balloons, and the captions, or legends, which usually appeared in boxes at the top or side of a panel. For Robin's emblem, he adopted a simple design he had developed for the first letter of the first word of each legend or caption. Robinson explained, "and so when drawing the symbol for Robin, I just adapted the R as a counterpoint to the bat design on Batman's chest."

There weren't any models for what Robinson and Kane were doing with their artwork for Batman. Batman was the world's second costumed super hero, but he was completely different from the character that had led to his creation—Superman. The Man of Steel secured the financial success and future of the comic book medium.

Superman was a beacon of hope in the dark Depression, both in terms of the first stories and the spare, clean art. Jerry Siegel, the writer, loved science fiction and brought its sense of limitless inventiveness and resourcefulness to his Superman stories. Joe Shuster matched this with his style; the power of the technological future sweeps across the page in Shuster's streamlined buildings and trains. His finest, most heroic creation is Superman himself, whose angular body and beautiful Art Deco monogrammed *S* embodies both the people and their protector in a single powerful symbol.

Expressionism is perhaps the aesthetic and psychological opposite of Art Deco. Film historian S. S. Prawer has pointed out the importance of the "disruptive stranger" in post–World War I German films, particularly in the Expressionist films that influenced Bill Finger and Jerry Robinson. Dr. Caligari and his psychic somnambulist disrupt the life of a small town, Murnau's vampire and Fritz Lang's Hans Beckert are murderous strangers. The Bat-Man (as his name was originally written) is a stranger as well in the community. Certainly the creation of Batman was inspired in part by pulp heroes like Lamont Cranston (the secret identity of the Shadow), and the bat imagery frequently found in pulp mystery and horror. But perhaps its most profound emotional resonance comes from the adoption of this central theme of German Expressionism, in which the nature of the central character is reversed—good for evil—but remains alienated from the community, forever dark and mysterious.

When Robinson and Finger were brought together in Kane's studio, they each brought sensibilities related to the psychologically charged and aesthetically innovative Expressionist movement. The Dark Knight's Expressionist lineage revealed itself in the chiaroscuro of its pages, so much like the German films, and in the wild angles, distorted figures, and the villains who populated the comic book. In one of the most unlikely developments in the bumpy history of comics, a single publisher, DC Comics, ended up with two of the most successful heroes of all time—Superman and Batman—drawn in styles that were socially meaningful in completely opposite ways.

With the success of the Batman stories in *Detective Comics,* the publisher decided it was time to give Batman his own comic book. When Superman got his own book in the summer of 1939, some of the material was reprinted from *Action Comics.* But when Bob Kane came back to the studio and told Robinson and Finger there was going to be a *Batman* title, it looked like they were going to have to create four *new* stories very quickly, in addition to their ongoing work for *Detective Comics.* "Although we were working hard, in retrospect it was a very leisurely pace, doing one *Batman* story a month," Robinson recalled. "Suddenly we were confronted with doing four stories for *Batman* no. 1 and one story for *Detective.* Bob and I were still doing *Clip Carson* and *Rusty and His Pals,* though those would end shortly, as well as the *World's Fair* comic, which was a quarterly. None of us was geared to do that much work in that short a time." As it turned out, the Kane/Finger/Robinson team wasn't able to produce four new stories; the second story they used in *Batman* no. 1, "Dr. Hugo Strange and the Monsters," was a story for *Detective Comics* that hadn't run yet.

To take some of the pressure off, particularly on Bill Finger, who was a superb but not always a fast writer, Robinson had a suggestion. "I volunteered to do one story, which Bob and Bill were very happy about." Robinson, too, was delighted; he wanted to write, but the art took too much of his time, particularly since he was still a student at Columbia. He was taking a creative writing class there, and knew he could turn in a Batman story as one of his assignments. It seemed like an ideal solution to both the comics deadline and college homework problems, plus he'd get paid for it.

Jerry went back to his room in his aunt's apartment and started thinking about a hook for the story. One of the topics in his creative writing classes at Columbia was conflict in fiction, and Robinson thought that a really outstanding villain was something that was missing from the early Batman stories. Jerry was also determined to do something original, something that wasn't found in other comics. He recalled "there were no supervillains in the comics at that time. In the 1930s, the villains were the gangsters—Pretty Boy Floyd, Dillinger, Machine Gun Kelly, and so forth. They were the models for the comic books' racketeers, hijackers, anonymous gangsters, and thugs." Robinson was aware of just how limited this repertoire of bad guys was: "I was not going to do another stereotypical villain, a gangster." Batman deserved a worthy opponent, a Moriarty to his Holmes, a Goliath to his David. Jerry's creative writing classes also examined the construction of character and the richness that internal contradiction could impart. Robinson decided to give his new master criminal a sense of humor, in contrast to his dark personality. Robinson felt that "a villain with a sense of humor would be the kind of contradiction that would make this character memorable."

While Jerry was mulling over the attributes of his new character, he started thinking about names. As in any literary form, names are extremely important in establishing a character in comics. Robinson needed to come up

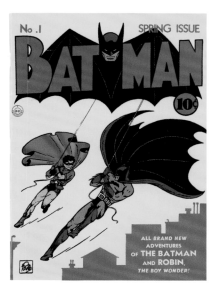

ABOVE: Batman *no. 1 (Spring 1940) DC Comics Pencils: Bob Kane and Jerry Robinson; inks: Jerry Robinson and Bob Kane*

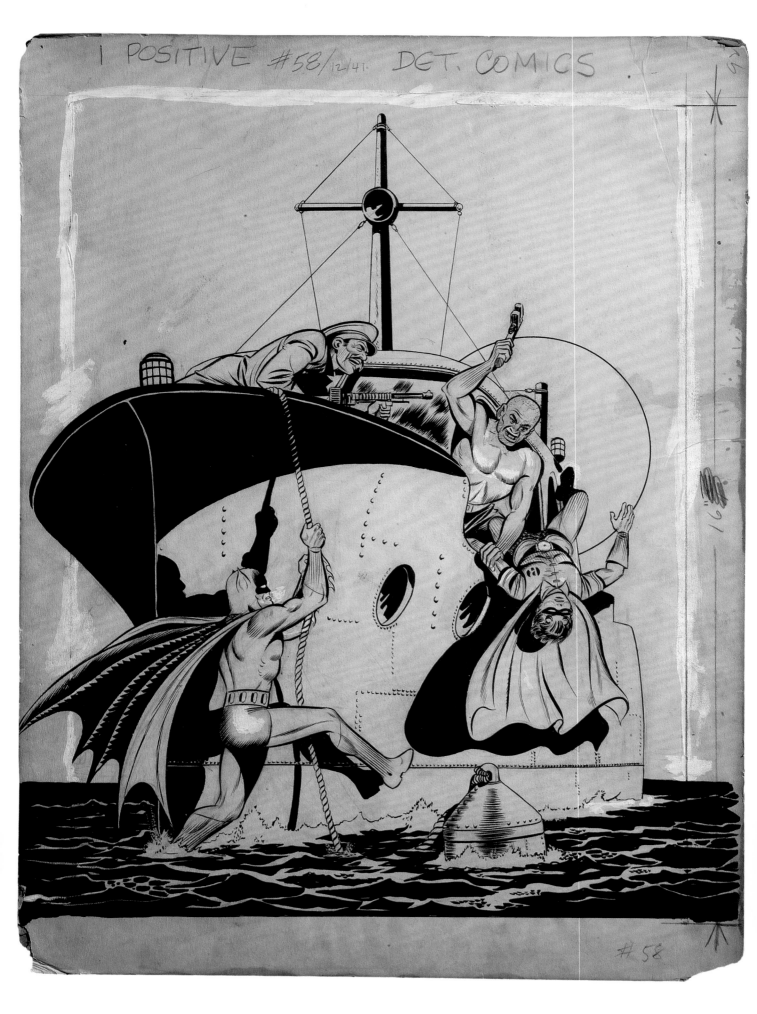

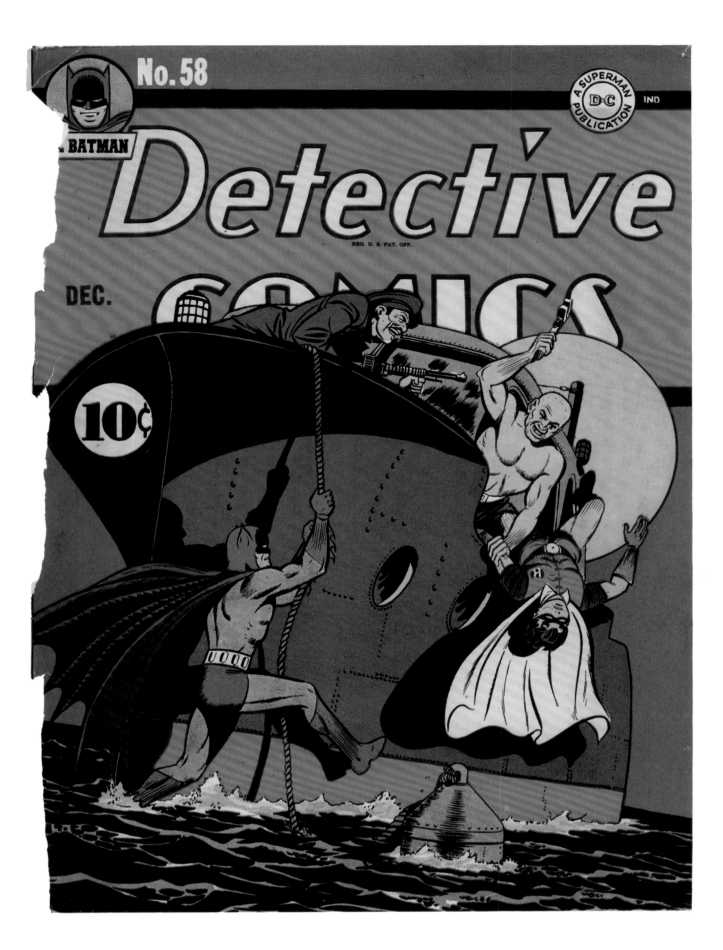

with just the right name, one that truly reflected the contradictory duality of his comic villain / his villainous comedian. Suddenly one came to mind:

"Joker."

Playing cards evoked strong associations for Jerry because card games were a popular activity with the Robinson family. He thought he might find a visual key to his character in a pack of cards and searched his room, turning everything upside down looking for one. When he finally found a deck, he quickly thumbed through the cards and pulled out a joker. It became the basis for his famous character. Robinson studied the figure on the card and got to work sketching. He emphasized the jester's distorted features and gave his new character the teeth-baring rictus of a sinister clown.

Robinson had just created one of the most memorable characters in comics—and in all of literature.

In the Joker, Robinson brought together the mystery and sadness of Poe's work, the dark psychological forces of Expressionism, and the vagaries of fate, expressed in the turning of the cards as a metaphor for our lives. It's no wonder that this complex and resonant figure has been such a durable and mercurial character in the history of comics, and that the Joker has been portrayed by some of the finest film actors.

At first, however, Jerry didn't get to write his own story, the Joker origin. "When I came in with my Joker idea, Bob and Bill loved it so much they persuaded me to let Bill write the story because time was of the essence and this would be my first script," Robinson recalls. "They both literally begged me to relinquish the idea and let Bill do the finished script, using my premise. I reluctantly agreed, though I must admit I had tears in my eyes. I was eighteen at the time. If it had been at a later point, I might have had second thoughts."

Robinson described the Joker's character, his persona, and the whole story idea to Finger. His friendship with and respect for Finger made losing the chance to write his own story a bit easier: "Bill was such a sweet guy, and I knew he would do a great job with it," Robinson explained.

The opening splash page of the first Joker story, published in *Batman* no. 1 (Spring 1940), features the Joker holding three cards, each bearing a different image: Batman, Robin, and the Joker himself. Each time the Joker robs and murders in the story, he leaves a playing card with his own portrait at the crime scene. Robinson produced the image on the Joker's calling cards in this debut story from his own first sketch, done as he was feverishly creating the character on that winter night at the end of 1939. The original script had called for the Joker to be killed at the end of the story, after a dramatic fight with Batman. But the Joker was saved at the last minute—by the book's editor. DC's Whitney Ellsworth, who had worked in newspapers and the pulps before he came over to comic books, knew a good thing when he saw it. A quick change before going to press shows a cop discovering that a knife wound to the Joker had not, in fact, been fatal. The grinning villain

PREVIOUS SPREAD: *Cover,* Detective Comics *no. 58 (December 1944) DC Comics Rough layout: Fred Ray; pencils, inks, and colors: Jerry Robinson*

OPPOSITE: *Robinson's concept drawing for the Joker (1940) pencil and red grease pencil on paper*

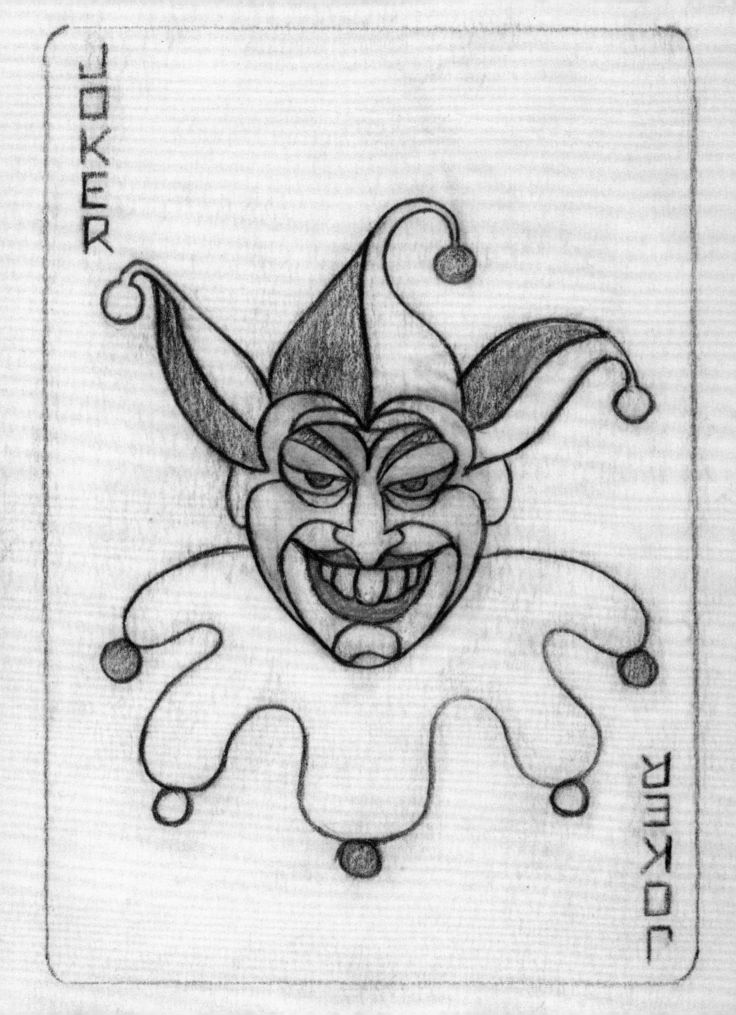

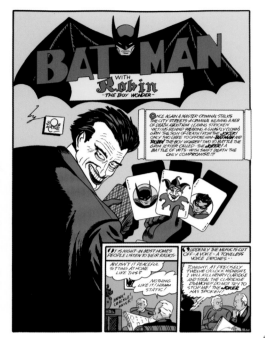

would live on to commit more crimes and threaten Batman, Robin, and the peace of Gotham City time and time again.

The Joker was an important force behind the new energy that flowed in *Batman*—and the first supervillain launched a thousand others in his wake. Other comic book editors and writers took notice of the character, as Robinson recalled: "The Joker did quite well. After he appeared, all the other books tried to come up with supervillains of their own: the Clown, the Jester. The whole supervillain concept took off, as had the super-hero idea before that."

Robinson deployed the two sides of his artistic personality in contributing to the images of the villains that followed in the footsteps of the Joker. His sharply honed sense of humor and his youthful immersion in the dark side of Art Nouveau and German Expressionism made him the ideal collaborator for Bill Finger and Bob Kane on the *Batman* stories featuring the Penguin, Scarecrow, Alfred the butler, and others. Robinson's Expressionist-influenced brushwork became the perfect medium for inking and enhancing the characterizations of the psychotically angry Clayface, the haunting, magical Scarecrow, and the schizophrenic Two-Face. As new villains came to life in sketches and scripts for the *Batman* series, the young creators—"We were boys ourselves," Robinson has said—shared the excitement of going from concept to finished creation. As with the Joker, each new villainous character was featured on a comics cover. Robinson recalls that it was like a thrill ride as he drew the first sketches to explore the appearances and personalities of the new villains, and then the full realization of these characters for the images that would introduce them on the newsstands. Comics covers on coated stock often had to be done in advance for printing and promotion, which meant they were where the first visuals and designs for a character appeared; covers helped establish new comics characters, and Robinson did the first covers for the Joker, Penguin, and Two-Face.

He was also able to include humorous cartoons in one of his *Batman* stories, recalling his high school drawings and foreshadowing his future career. In the classic Joker story "A Crime a Day," *Detective Comics* no. 71 (January 1943), the rivalry of Batman and the Joker is followed in the *Gotham Gazette,* the city's newspaper, with headlines and three editorial cartoons. Robinson drew the cartoons within the comics story with a grease pencil, mimicking the look of genuine editorial cartoons. One of these mock editorial cartoons, captioned IS BATMAN SLIPPING? shows the Joker literally pulling the rug out from under the super hero. (Robinson became a professional editorial cartoonist twenty years later, at first for New York City newspapers and then syndicated around the world. Of course, as he recalled, "At that time, I had no idea I'd ever be a political cartoonist.")

Robinson and Finger were the perfect complements to each other. Deeply immersed in popular culture, the pulps, the Shadow, radio drama, and the Sunday comics, Bill and Jerry also brought with them excellent educations from urban high schools and a love of reading that took them

ABOVE LEFT: *Heath Ledger as the Joker in* The Dark Knight *(2008)*

ABOVE RIGHT: *Jerry Robinson and Christian Bale at* The Dark Knight *premiere in New York, 2008*
In 1943, Jerry Robinson went to Hollywood to watch the filming of the first Batman serial. During his visit, he sat in on a writers' story conference. He was not impressed: "I remember thinking, 'these writers can't write their way out of a paper bag. If only Bill Finger were out here to take over!'" (Bill Finger did co-write two episodes of the Adam West Batman television show: "The Clock King's Crazy Crimes" and "The Clock King Gets Crowned," which aired in 1966.)
More than sixty years passed before Robinson visited any of the ensuing film and television shoots of the characters he had done so much to create. In the summer of 2007, he flew to England to visit the set of The Dark Knight. *He met director Christopher Nolan, Christian Bale (Batman), and other cast and crew of the film, and shared his memories of the creation of the Batman mythos. Unfortunately, Robinson didn't get to meet Heath Ledger (the Joker), the young actor who was bringing his darkest creation to life. Ledger had wrapped his scenes before Jerry arrived and died tragically a few months before the release of the film.* The Dark Knight *is the fifth film to gross over one billion dollars worldwide, and it's become perhaps the best-reviewed super-hero film ever made.*

far beyond the adventure and mystery stories they both loved. Finger delighted in creating comic book scripts filled with action and crime-solving, but he and Robinson also loved short stories with psychological depth, like those of the great Russian writers, or masters like Poe, who sustained a feeling and a tone with a level of artistic intensity possible only in a short story. Comic book stories *are* short stories, and there was no reason why the whole aesthetic universe of that literary form couldn't be part of the tales they were telling. When the German Expressionist films that Finger introduced to Robinson were added to this mix, the stage was set for something new in comics, something that fulfilled the best aspirations of popular culture: stories that were entertaining *and* socially relevant. And the new comics villains proved to be the nexus in which this psychologically charged and disturbing blend of literary and artistic influences would find its strongest expression.

Introducing the Joker into the world they were creating for *Batman* seemed to liberate Bill Finger's imagination, and he delighted in creating more bizarre and resonant villains. Through conversations and character sketches, Finger, Robinson, and Kane brought these villains to complex life. Batman's enemy the Scarecrow is clearly the cousin of the somnambulist in *The Cabinet of Dr. Caligari;* Robinson deployed his most startlingly Expressionist brushwork in limning this inhuman character. His early Scarecrows are worthy of a canvas by James Ensor.

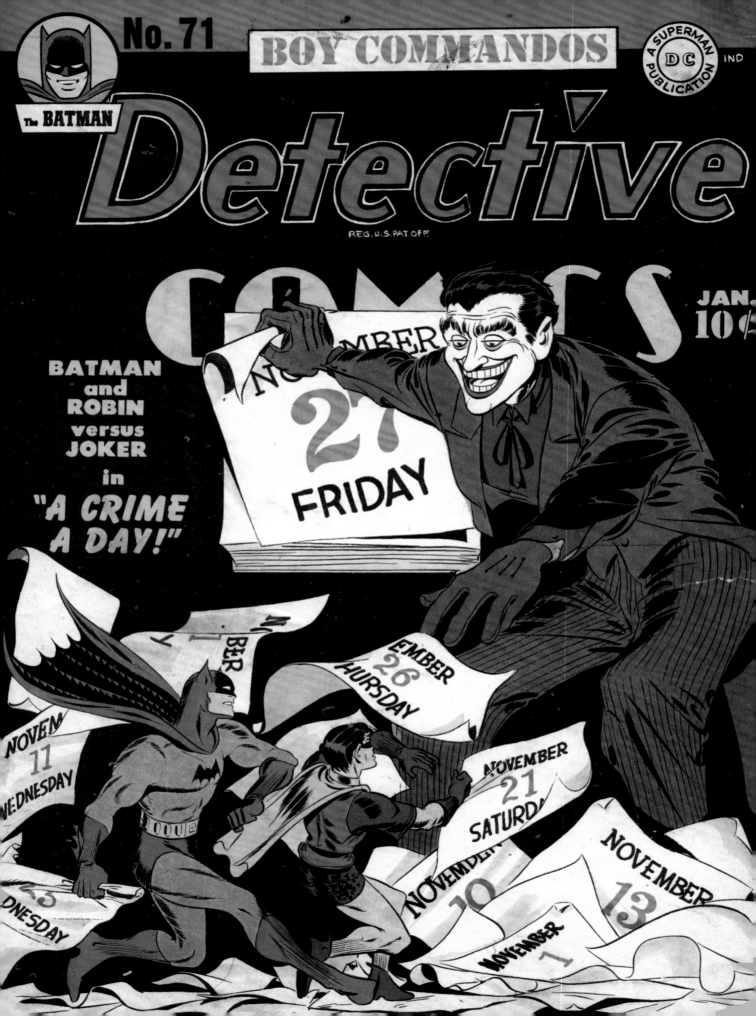

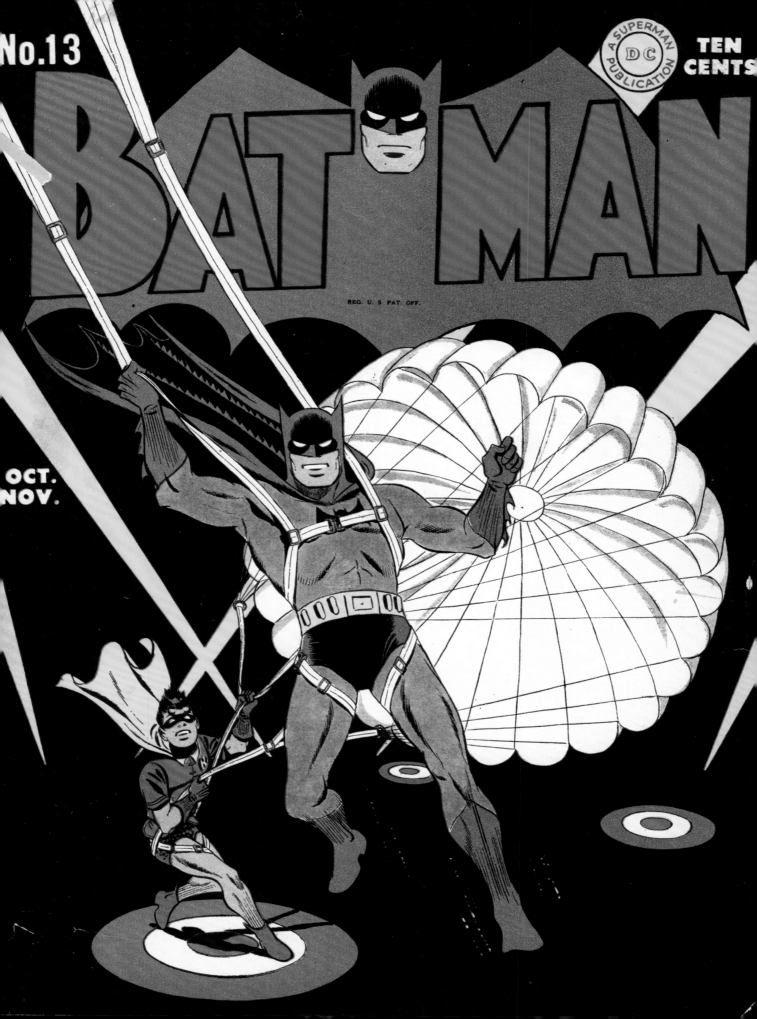

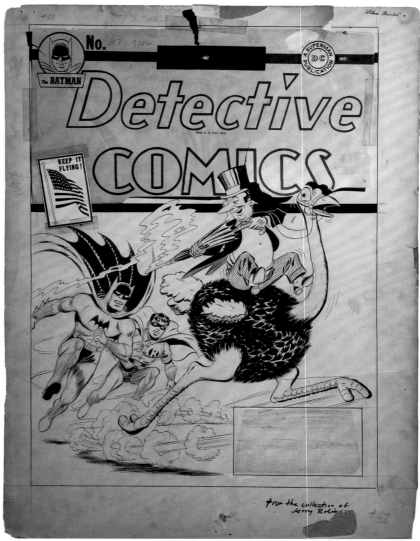

The complexity of human psychology appears again in Two-Face, whose divided personality echoes the dual, warring protagonists of Poe's "William Wilson." The bizarre angles and distorted, obviously artificial, painted sets of German Expressionist film echo through the charged and angular spaces of Robinson's *Batman,* and the exaggerated nature of the characters in these films inspired the young creators to bring to life a distorted, carnivalesque villain like the Penguin, a character who would not have been out of place in the classic Tod Browning film *Freaks* (1932).

Robinson appreciated the fact that these comics villains, when considered together, incarnated different aspects of human personality. "I think they're very striking and memorable characters. The Penguin was great because he had a lot of humor. He looked kind of comical, Chaplinesque in a way," Robinson reflected. "The Penguin was fun to draw. I think he added a new kind of villain to the mix, coming after the Joker. Two-Face of course is

the opposite. There's a lot of horror and drama in his concept." And the effect of these new villains was cumulative, in Robinson's opinion: "All those characters, one coming after another in quick succession, really made *Batman*. After the first series with the Joker, the other characters, the sum total, had a great deal to do with *Batman*'s success."

Batman has been reinvented numerous times in his long career. As comic books lost adult readers in the 1950s, he became a less threatening, more surreal character. This is the Batman that was translated into the campy 1960s television series starring Adam West. Batman became more serious in the 1970s, when comics embraced cultural relevance, and again in the 1980s, when greater freedom in comics allowed darker and more violent stories. These reinventions, which appealed to adult readers and featured more psychologically complex stories, might be most accurately described as revivals of the complex and Expressionist Batman of Robinson, Finger, and Kane. The darkness of the Dark Knight was rediscovered by writer Dennis O'Neil and artist Neal Adams in the super-hero comics which appeared against the background of the social upheavals of the late sixties and seventies. When Frank Miller created the graphic novel *Batman: The Dark Knight Returns* in 1986, the spirit of the crazy and disturbing Batman of the 1940s returned.

Jerry Robinson worked with Kane for a little over a year. With *Batman* a huge success, everybody wanted Robinson to freelance for them. "Everybody wanted to hire the guys who did *Batman*," he recalled. "Bob had the contract with DC, but Bill Finger and I got many calls." The publisher of Quality Comics, Everett "Busy" Arnold, took Robinson to lunch several times to offer him a position as editor of the company. (Quality later launched a number of successful super heroes, including Jack Cole's Plastic Man, and heroes such as Doll Man and Uncle Sam created by Will Eisner; Will Eisner later partnered with Arnold on a comic book newspaper supplement for which he created his revolutionary hero, the Spirit.)

Robinson wasn't really sure he wanted to take on the editor's job at Quality Comics. "It would have been a little heady for someone who was just nineteen years old, to run a whole comics division," he said. "Part of the enticement was I'd get to do my own stories and covers, and do the lead story for a magazine and whatever else I wanted to do." Robinson was conflicted about the idea of leaving *Batman*, but was flattered to have Arnold wining and dining him. In any case, Arnold's offer led DC to propose to Jerry Robinson and Bill Finger that they work directly for the company. Working for DC meant Robinson would be able to do stories of his own and to do both complete pencils and inks. This would also get Finger and Robinson out of Kane's studio and get them paid a good deal more.

In 1940, Jerry began to work directly for DC. With the success of Batman, more artists worked independently on *Batman* stories, and Robinson began to completely pencil and ink his own stories in *Batman* and *Detective Comics*. Inking over Kane's pencils, Robinson had made the characters of Batman and

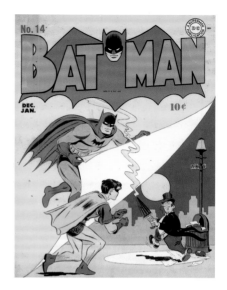

TOP: *Cover,* Batman *no. 14 (December 1942–January 1943) DC Comics Pencils, inks, and colors: Jerry Robinson*

BOTTOM: *Cover,* Detective Comics *no. 74 (April 1943) DC Comics Pencils, inks, and colors: Jerry Robinson The roly-poly villains Tweedledum and Tweedledee were appropriated from Lewis Carroll's* Alice in Wonderland. *Bill Finger's scripts usually emphasized the comic character of their villainy.*

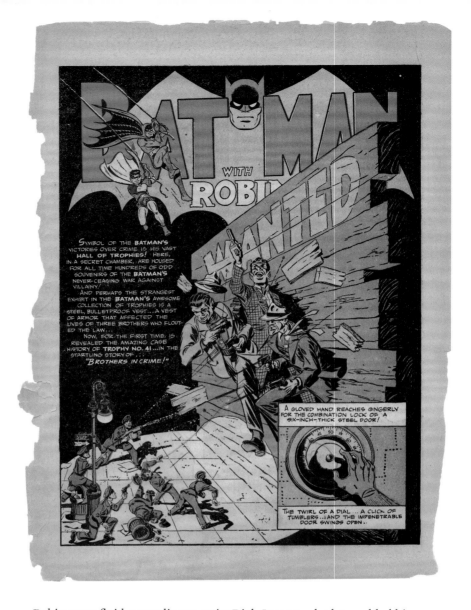

Robin more fluid, according to artist Dick Sprang, who later added his own extraordinary contributions to the look of Batman and his world. When Robinson moved into the DC bullpen, he had the opportunity to do covers exactly as he visualized them in both concept and design. In his collaborations with Kane, Robinson had been introducing more and more distorted angles, shifts of scale, and forced perspective into the stories and the covers. These experiments brought to the page his own ceaselessly inquiring visual sense and some of the imagery he had been absorbing in New York.

The *Batman* covers that Bob Kane had been penciling and that Robinson had been inking (sometimes with help from George Roussos on the backgrounds) had been created without prior approval from the editors at DC, and this continued after Robinson began working directly for DC. Penciling, inking, and occasionally coloring when his busy schedule allowed it, Robinson created cover images that were commercially successful—they *sold* the comics—and innovative in their effects of scale, depth, and proportion.

ROBIN, I CAN SEE YOU'VE BEEN SHIRKING YOUR CRIMINOLOGY STUDIES. WHY, EVERYONE KNOWS DANA DRYE, DEAN OF DETECTIVES, GREATEST OF THEM ALL!

"HERE'S A PICTURE OF DRYE IN 1880. SINGLE-HANDED HE ROUNDED UP THE NOTORIOUS GRAVES GANG!..."

"HERE'S DRYE IN 1910 WHEN HE CRACKED THE CONEY POISONING CASE. DRYE WORKED ON OVER A THOUSAND MURDERS AND NEVER FAILED!

AND NOW YOU'LL GET A CHANCE TO SEE WHAT HE LOOKS LIKE TODAY!

I BET WE COULD LEARN A LOT FROM DRYE, BATMAN.. I'D LIKE TO TALK TO HIM!

AND AS A BRILLIANT NOVEMBER SUN STREAKS THRU SPARK-LING WINDOWS AT RIVER HOUSE, THE GREAT DETECTIVES OF THE WORLD ASSEMBLE...

HONORABLE MISS SEERS HAS GREAT REPUTATION IN 'FRISCO!

I THINK WE'D BETTER SIT DOWN. DRYE IS COMING UP TO SPEAK!

I'LL BE GOLDARNED! BATMAN! H'ARE YA!

GLAD TO SEE YOU, SHERIFF PLUNKETT.

YIPPEE! GOOD OLE DRYE!

BRAVO! BRAVO!

GOOD TO SEE YOU, DRYE!

FELLOW DETECTIVES, YOU ARE TRUE FRIENDS INDEED, VISITING ME THIS LAST TIME, WHEN I'M ABOUT TO RETIRE!

3

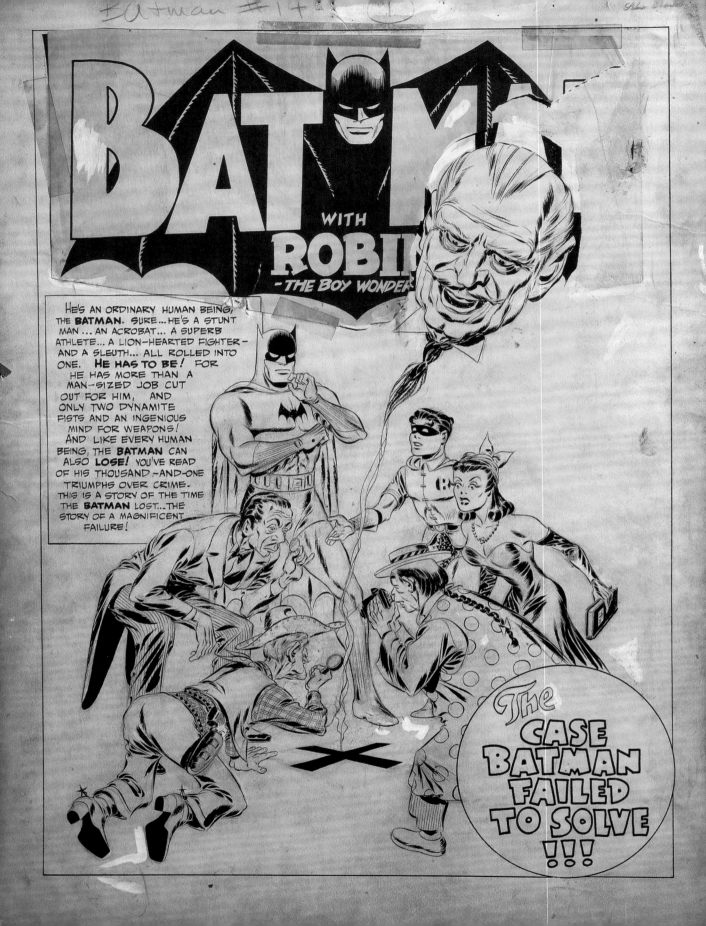

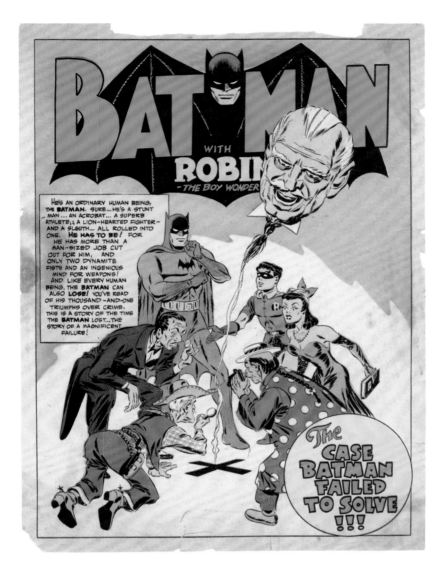

One of the best and most famous of Robinson's *Batman* covers is an image from the Bill Finger Joker story "A Crime a Day!" in *Detective Comics* no. 71 (January 1943). The cover is one of Jerry's Joker masterpieces. The theme of the story is reversals—the world turned upside down—and Robinson carries this out in an effective, Expressionist way, making Batman and Robin tiny, lost in a pile of calendar pages being ripped off and thrown down by a Joker four times their size. This reversal of scale echoes the multiple reversals in Finger's story, and the conceit of the flying calendar pages on the cover creates a powerful single image that packs the same punch as a calendar montage in a film to show the passing of time.

Robinson used a similar composition in a way that's almost more symbolically expressive in the cover for "Slay 'Em with Flowers," *Detective Comics* no. 76 (June 1943). "That cover was an adaptation of an interior splash page," Robinson explained. "In the story, the Joker had a front for his

OPPOSITE AND ABOVE: *Splash page, "The Case Batman Failed to Solve!!!"* Batman *no. 14*

ABOVE LEFT: *Cover,* Detective Comics
no. 68 (October 1942) DC Comics
Pencils, inks, and colors: Jerry Robinson
First cover of Two-Face

ABOVE RIGHT: *Another Robinson cover
using symbolism: "Slay 'Em with Flowers,"*
Detective Comics *no. 76 (June 1943)
DC Comics*
*Script: Horace L. Gold; pencils, inks,
and colors: Jerry Robinson; lettering:
George Roussos*

nefarious deeds—posing as a florist—so here I have the Joker symbolically growing out of a large flower and spraying insecticide on Batman and Robin, the small figures, who are fighting back. Batman and Robin are wielding huge scissors and cutting the stem out of which the Joker's flower grows; this provides the movement in the design," Robinson explained. The "Slay 'Em with Flowers" cover image had an interesting afterlife. Robinson was one of the founding professors in the comics program at New York's famous School of Visual Arts. He used the basic idea of this story to teach his students how to use symbolism to convey a concept.

Robinson's best covers were arguably those that feature the Joker, perhaps because of his deep understanding of the character. For "The Harlequin's Hoax," *Detective Comics* no. 69 (November 1942), Robinson turned the Joker into a huge genie coming out of a magic lamp, again threatening the diminutive figures of Batman and Robin. The menace is increased by the contrast of the gleaming, modern angular handguns with the magical, fairy-tale lamp from which the villain emerges. The carnivalesque qualities of the Joker are front and center in a cover from *Detective Comics* no. 62 (April 1942), where he holds a mass of balloons on strings, each decorated with his face. The background is an abstract urban skyline that could be the set for a German Expressionist film.

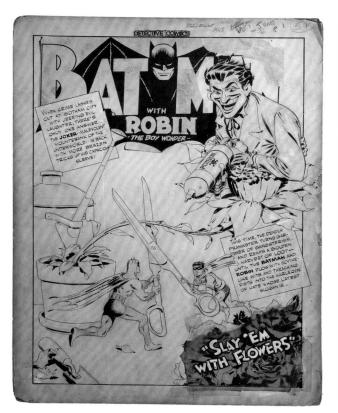

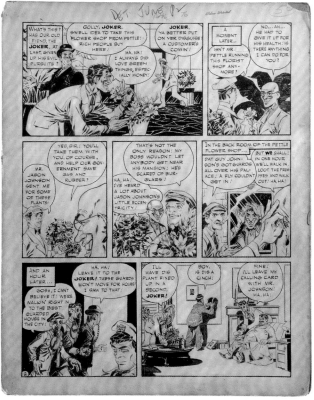

At DC, Robinson worked closely with Whitney Ellsworth, a colleague he respected and enjoyed working with. "I loved to do the Joker covers, he was my character," Robinson recalled. "Whit let me do them, knowing my association with *Batman*."

One of Robinson's best covers features no villains or gangsters, only Batman and Robin. Drawn for *Detective Comics* no. 70 (December 1942), it illustrates a scene from the Bill Finger story "The Man Who Could Read Minds." An archfiend has trapped Robin in a bathysphere at the bottom of the ocean, and Batman is using a blowtorch to burn open the metal hull and rescue the Boy Wonder from mortal danger. The dramatic action is shown in a restrained, almost classical style, contrasting with the emotional sight of Robin apparently about to take his last breath. For readers who identified with the boy hero, the image would have been riveting.

Almost alone among early comic book creators, Jerry Robinson soon came to feel what was he was doing was a valid, if new, art. Most of his fellow artists and writers were probably too busy to think about this or too young to care, or just enjoyed making comics and that was enough. But Robinson had a different feeling about comic book art. He shared this outlook with Will Eisner, who in a 1941 interview predicted that the best novelists and artists would be attracted to comics in the future.

ABOVE: *Splash page and interior page two, "Slay 'Em with Flowers,"* Detective Comics *no. 76*

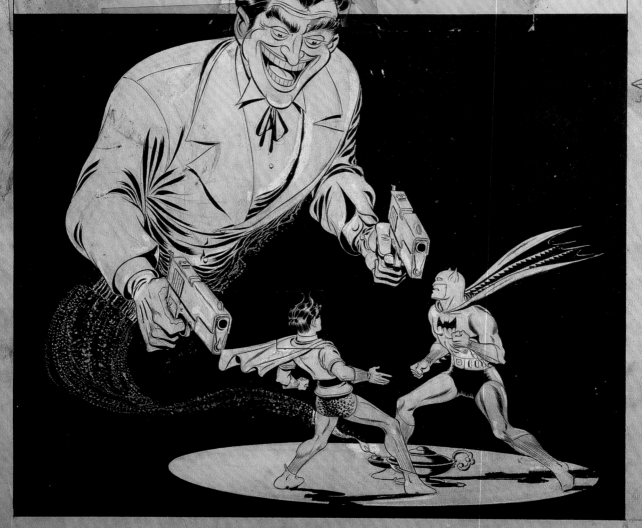

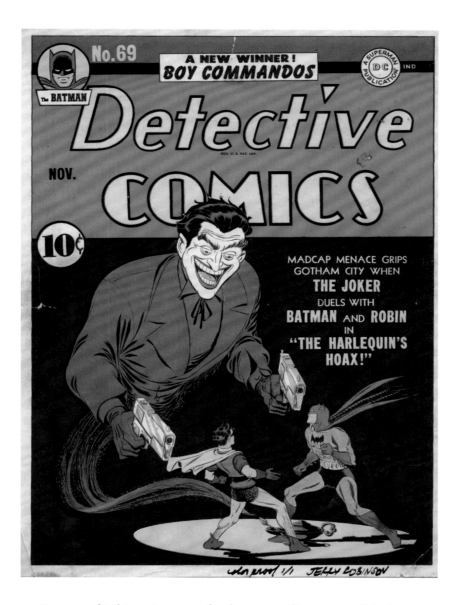

Because of Robinson's respect for the new medium, some of the best early *Batman* cover art has been preserved. Artwork was little respected and rarely returned in the early days of comic books. Once photographed, there was no further need for the original art, and it was regularly discarded. "At the time, nobody ever thought of preserving the original art," Robinson explained. "Most of the art was destroyed. But when I was at DC, I would retrieve it." Robinson was able to save some of his own best covers and interiors, as well as those of friends and admired colleagues, like the great team of Joe Simon and Jack Kirby, the masterful Mort Meskin, and the versatile artist Fred Ray, who did iconic *Superman* work. Robinson's interest helped inspire others to look differently at the art they were making, with a little more respect. Little did he know then that he would become one of comics'

OPPOSITE AND ABOVE: *Cover,* Detective Comics *no. 69 (November 1942) DC Comics Pencils, inks, and colors: Jerry Robinson A rare cover showing the Joker with guns*

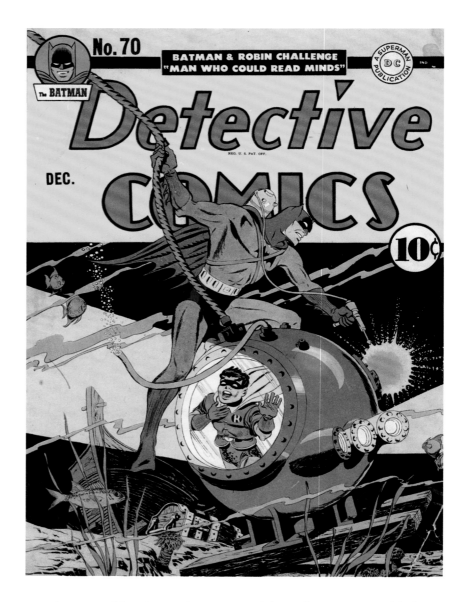

ABOVE AND OPPOSITE: *Cover,* Detective Comics *no. 70 (December 1942) DC Comics Pencils, inks, and colors: Jerry Robinson According to* Batman *aficionados, this bathysphere cover is one of the three iconic Batman covers, along with* Detective Comics *no. 69 and no. 71.*

most important historians and curators, and the art he was responsible for saving would be displayed in galleries and museums around the world.

In 1943, Alfred the butler became one of the final additions to the original cast of *Batman* when Robinson was doing some of his last work on the feature. It appears that Alfred was created for the 1943 *Batman* serial (the first translation of Batman to cinema). Robinson drew the short feature "The Adventures of Alfred," which ran in the back of the *Batman* comic book from 1944 to 1946. These Alfred stories were meant to be lighthearted and humorous, and Robinson created just the right tone for them. Alfred later became a serious figure in the Batman comics and films.

By 1946, Robinson had been working on *Batman* for almost seven years. His creative tendency was always to experiment, and that seemed less

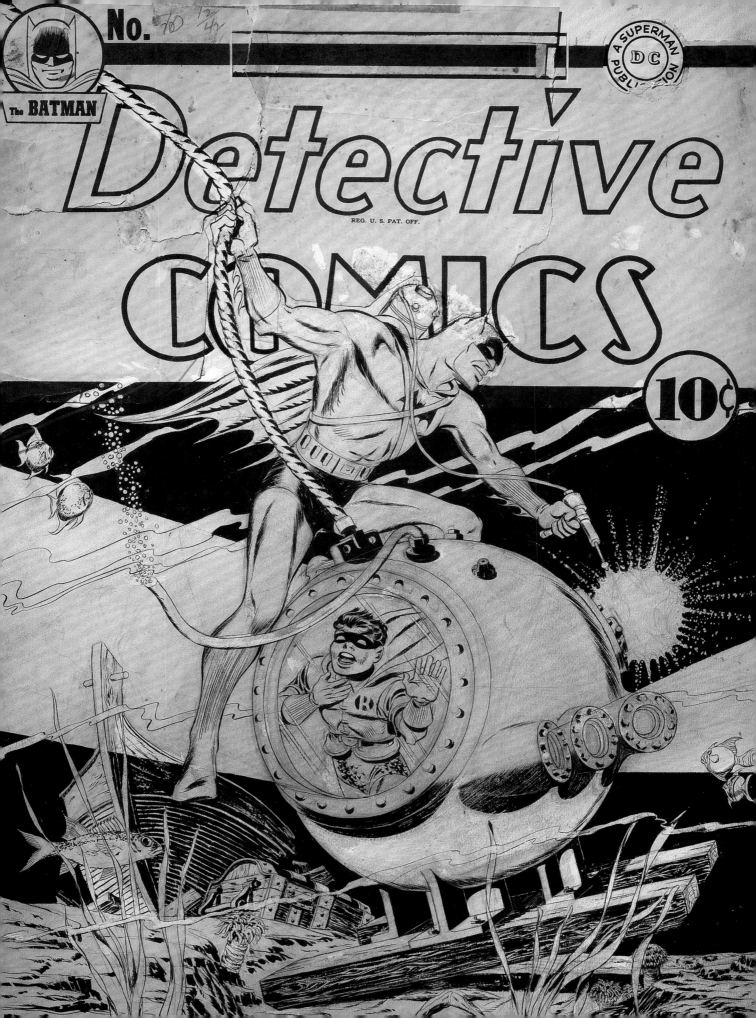

possible: "It was really too restrictive at the end, the format. The basic concept was set; the style was set. The creative part of it was over." Robinson had set out to be a writer, and he might have continued on *Batman* at DC if he'd gotten to write more stories, but he was kept too busy with the art. "It's my theory," Robinson said, "that the most interesting part about comics is the initial concept, the initial creative force. After that, it's a craftsman's

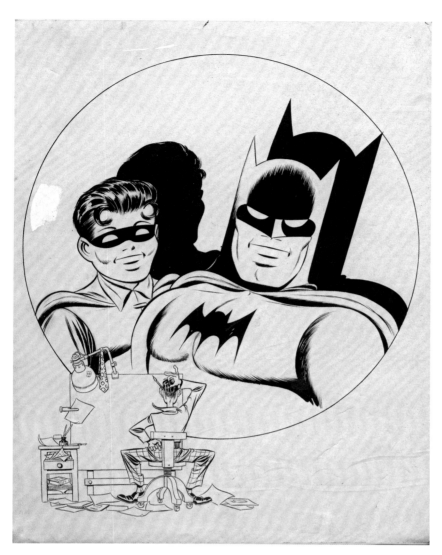

job to keep the strip going at a top level." Innovation is limited: "You can create new characters, new situations, but I really think you're working on the fringes of the central core of the idea." Ultimately he felt it was time to move on to other projects.

Robinson had managed to squeeze in a few freelance projects for other publishers while still working on *Batman,* and this made him want to stretch his creative muscles. As he took on other kinds of comics, he found that he enjoyed working in a variety of styles. He was also looking for opportunities to write stories, as well as draw them, and he wanted the chance to create his own characters. Over the next few years Jerry was to do all these things. And one memorable weekend, he would create a character during an artists and writers' jam session that would inspire one of the most famous episodes in Michael Chabon's Pulitzer Prize–winning novel, *The Amazing Adventures of Kavalier & Clay*. (See page 72.)

OPPOSITE: *The Joker, Jerry Robinson, ink-on-paper (2007)*

ABOVE: *Christmas card, Jerry Robinson (1941)*

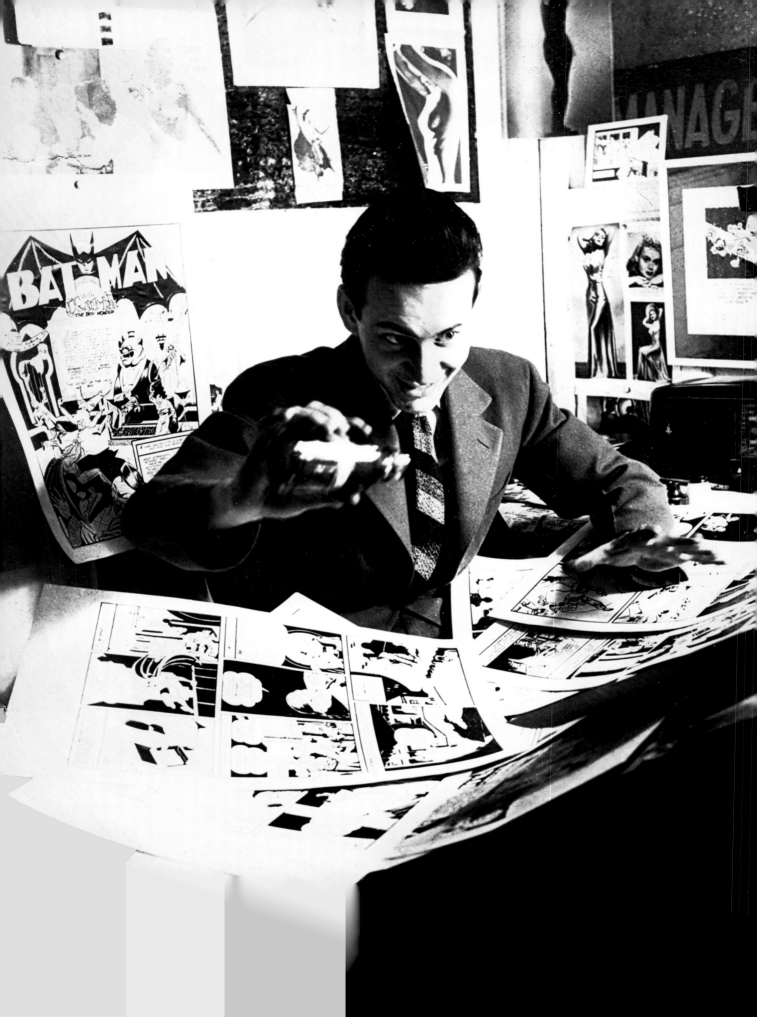

COMIC BOOKS: AN EVER-EXPANDING UNIVERSE

Everybody wanted a "character." That's what super heroes were called at first; once Batman followed Superman as a hugely successful comic book property, other companies that published comics began looking for some of the same magic that DC had. Comic book companies were formed, it seemed, by almost anyone who had been anywhere near a comic book. Although it's apocryphal, it's indicative of the tenor of the times that it was widely believed that Victor Fox resigned as DC's accountant one day and opened an office in the Empire State Building the next day to start his own comic book company. (It *is* true that Fox hired Will Eisner to create Wonder Man, a copycat super hero based completely on Superman; the former accountant soon found himself on the losing end of a copyright infringement lawsuit brought by DC.)

Since the readers, not advertisers, supported the early comic books, that had its effect on both the packaging and the art. Thicker was better (more for your money), and the early comic books soon settled on a big sixty-four page package, the whole thing held together by two staples in the spine. These fat little magazines with lots of pages and multiple stories were all readers could want. "All in color for a dime" was a promotional slogan that appeared on the comics (and later served as the title for one of the first books of comics history, written by Richard A. Lupoff and Don Thompson). Full color set these comic books apart from the black-and-white comic strip reprint books still sold.

The origin of the comics in newspaper strip reprints, and the publishers' need to give readers plenty for their money, sometimes inhibited what the artists could do. Robinson was always trying to innovate, to stretch and extend what he could do in the new medium of comics. He wasn't the only one, and soon found that other artists were just as interested as he was in

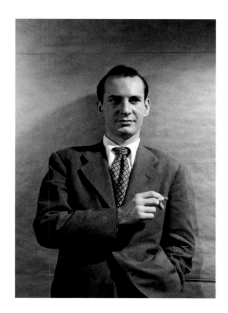

OPPOSITE: *Jerry Robinson clowning around in the studio in the* New York Times *building (1940)*

ABOVE: *A portrait of Robinson by Rudolph de Harak (1950s)*

ABOVE: *Orson Welles's* Citizen Kane, *widely regarded as one of the best films of all time, opened on May 1, 1941, at New York's Palace Theatre. It caused a sensation among comics artists, including those working in the DC bullpen. "Fred Ray probably went to see it thirty or more times. I saw it a couple of dozen times," Robinson recalls.* Citizen Kane *became part of the patter in the artists' workspace: "We would sit at our desks and reenact the scenes, I can just hear Fred hoarsely whispering, 'Rosebud,' evoking Kane's last word in the film.*

*"We were inspired by the innovative storytelling and particularly the ground-breaking visual effects of cinematographer Gregg Toland," said Robinson. "*Citizen Kane *was a reaffirmation of what we were already doing." It incorporated vertiginous shots, both interiors and exteriors, remarkable deep-focus effects where foreground objects or actors would be in focus as sharp as the background, striking cuts that moved through time, and sound editing that linked scenes in remarkable ways. Robinson recalls that the DC artists would tell each other, 'See, there's a shot we did in* Batman.' *We saw the same freedom we had to shoot anywhere we wanted and to utilize the dramatic angles not seen in films before." The boy genius of cinema had given comics artists another reason to feel proud of their work.*

experimenting. Once Robinson stopped working in Bob Kane's studio and began to draw *Batman* directly for DC Comics in 1940, he found there was a whole world of young artists out there who were trying new approaches to comic book art.

The DC bullpen was filled with talented artists and writers, such as Superman's creators, Jerry Siegel and Joe Shuster. Other artists who worked with Robinson over the half-dozen years he was there included Jack Kirby, Fred Ray, Charles Paris, Stan Kaye, and later his close friends Bernie Klein and Mort Meskin. Klein was also from Trenton, and Robinson was the one who brought Bernie and Mort to DC, as well as George Roussos, who had also been assisting Robinson, inking and drawing *Batman* backgrounds when they were both with Kane.

Even while he was still working on *Batman*, Robinson and other artists were trying to break down the multipanel grid that dominated early comic book pages. "Since the first comics were reprints from the Sunday pages," Jerry remembers, "we inherited this format where most of the panels were the same size and shape. That was so restrictive, of course we wanted to change it." But the artists ran into resistance from the editors and publishers. "More for the money" was the catch phrase, and the editors interpreted this as the more panels per page, the more the readers would feel they were getting. Sometimes the artists would find scripts forcing them to draw up to twelve panels per page. Gradually, however, they got more freedom. "At first, we managed to create a large panel that would introduce the story—we called that the splash. Then we moved on to combining other panels in the story. We would take a three-panel register across the page, and make that into one panel," Robinson explained.

Robinson also benefited from the counsel of an older artist who worked in the DC bullpen, and whom he fondly remembers to this day; an experienced illustrator named Raymond Perry. To nineteen-year-old Jerry, a man in his sixties or seventies seemed ancient. But Perry took a special interest in the younger artist, who had never been to art school and was almost entirely self-taught. Perry worked as a comics colorist, and was given the most important stories. At the office, Robinson learned much from his mentor about art and color; when the two artists got together outside of work, Perry introduced Robinson to his own illustration work and gave him books on costume history and visual references from his lifetime accumulation of resources.

After he started working on *Batman* in the bullpen, Robinson began to freelance on other comic books, not published by DC. Of course, those were freewheeling days in the comics industry, and artists often collaborated when one of them got behind, or had multiple jobs at once. "Quite often we'd help each other," Robinson recalls. "If it was a big job, some money would change hands. Most of the time, not. This time I help you, next time you'll help me, and so on."

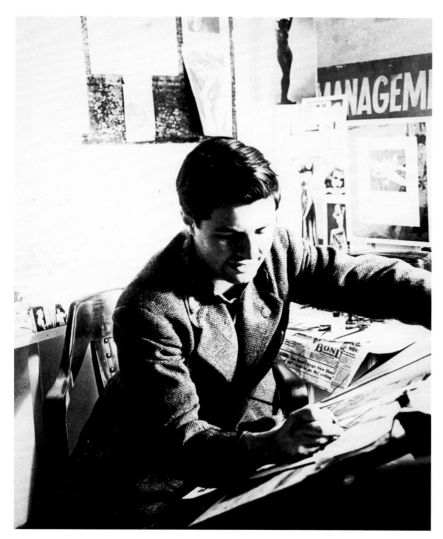

In 1940, after the success of *Batman*, the *Times of Trenton* ran a "home-town boy makes good" article about Robinson. It was pretty heady stuff for a nineteen-year-old; no one knew then that it would be the first of a lifetime of articles about Robinson. On New Year's Eve that same year, Jerry returned to Trenton for a party. He'd been in New York a little more than twelve months. Most of his high school buddies and other friends were still in Trenton. Sometime after the revelers ushered the New Year in, a young man about three or four years Robinson's senior came up and introduced himself. He turned out to be an aspiring artist who actually worked at the *Times of Trenton*—on the loading dock. But he had sold the newspaper a few sports cartoons at five dollars a pop, and now he asked the question that, genera-tions later, young artists are still asking: How do I break into the comics? His name was Bernie Klein, and he'd wangled an invitation to the party through mutual friends. Klein had seen the article about Robinson and had come to

ABOVE LEFT: *Bernie Klein, who became Jerry's closest friend, had been a Golden Gloves boxer in Trenton and started out selling a few sports cartoons to his hometown newspaper, the* Times of Trenton, *for five dollars a pop. (1940)*

ABOVE RIGHT: *George "Inky" Roussos was a lifelong friend of Jerry, and his first assistant on* Batman. *Roussos later worked for Marvel Comics on a number of titles and was a noted colorist. (1941)*

ABOVE: *Mort Meskin, a brilliant artist and
one of Jerry's closest friends. Robinson and
Meskin made an outstanding team,
collaborating on a number of features.
Meskin is shown here working on a page for
Crestwood Publications. (c. 1960)*

the party specifically to meet the *Batman* artist. He and Jerry Robinson
would become best friends.

Bernie Klein had actually brought copies of his cartoons and other
art samples to the party, and it was clear that he was talented. As he has
hundreds, if not thousands, of times since with other aspiring artists,
Robinson encouraged Klein, made suggestions about how to prepare samples
for the comic book publishers, and told him to call when he came to the city.
Less than two months later, Klein called and said he was in New York.
Robinson suggested they meet for dinner, expecting to be asked for more
advice. Instead, Bernie had news for him: He was already living in a rented
room in the city, had followed Robinson's advice about preparing samples
and showing them to comic book companies—which he'd researched
and located himself by buying comic books—and was already working at a
second-tier comics company called MLJ. However, the MLJ artists
and writers were first-rate; many of them became Robinson's friends and
collaborators, and they played major roles in the future of comic books.
MLJ was just later out of the gate than DC, and the competition was fierce.
The gifted MLJ staff included editor, artist, and writer Charles Biro and
artist Bob Wood, whose other brothers, Dick and David, would soon join the
comics game. Through Bernie at MLJ, Robinson met the artist he would
soon grow closest to, the remarkable Mort Meskin.

Robinson ended up working with most of these artists on a variety of
projects. He and Meskin became close collaborators, but he also worked
often with Biro. "I liked Charlie Biro," Robinson remembered. "He was a
very talented writer, artist, and editor—an incredible, larger-than-life
character. Charlie was big and stocky, with a very ruddy face, and a unique,

hearty laugh. I can still hear him." Biro was well connected both inside and outside of comics, and asked Robinson to help him on a variety of different commissions, including the famous weekend when a bunch of comic writers and artists created a whole comic book in just a few days. (See page 72.) Biro didn't only do newsstand comics. "I helped him on a number of dead-lines for advertising and commercial jobs," Robinson recalled, "including an advertising comic for Buster Brown shoes that paid very well."

Mort Meskin was one of the very few—almost the only one—among the early comic book artists who had actually been to art school. Meskin was a graduate of Pratt Institute in Brooklyn, and comics might not have been his first choice as an artist if it hadn't been for the devastation of the Depression. Nonetheless, Meskin took to the medium like few others. His compositions and technical mastery with pen and brush were unsurpassed. Later, when he and Robinson were sharing a studio, they'd play the kind of competitive games that entertain young men: They'd challenge each other to draw a story only with the brush, or only with the pen, or to get an effect that seemed nearly impossible, like doing a whole story lit only from above, or drawing a scene or page without preliminary pencils, just going right to the inks, placing everything on the page in their heads, and then laying down the black lines and shadows with no chance to erase mistakes. Robinson learned a great deal from Meskin, but Mort made him work for it. "I'd ask him how to solve some anatomical problem and he'd just tell me to work it out myself," Jerry recalls. It was a great way to learn because the lessons weren't easily forgotten.

Jerry Robinson and Bernie Klein shared an apartment on West Seventy-fifth Street in Manhattan, with another comic book artist, Lee Harris, who

ABOVE: *Irwin Hasen, in the early 1940s. After Klein, Hasen is Robinson's oldest friend; the two met in 1940. Hasen's credits include* Green Lantern *and* The Flash, *and the newspaper feature* Dondi, *which ran for more than thirty years. Hasen's dedication on this photo reads: "To Jerry— A guy with a future (and what a past)."*

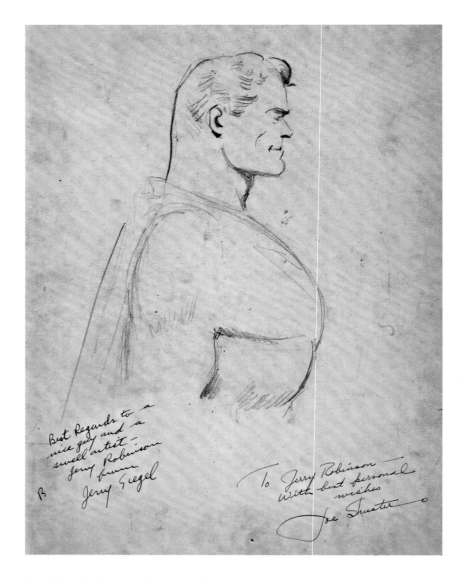

ABOVE: *Jerry Robinson and Bernie Klein's apartment on East Thirty-third Street was an epicenter of comics activity—and hijinks. The apartment had its own guestbook, which was inscribed by many of the artists, writers, editors, friends, and girlfriends who dropped by. This page from the guestbook is by Jerry Siegel and Joe Shuster. (1940s)*

lived there before Meskin moved in. This apartment was where Jerry and Bernie's friendship really took root, a deep friendship that meant a great deal to Robinson. Jerry introduced Klein (and later Meskin) to Whit Ellsworth at DC, and Bernie was soon freelancing on various DC comic books.

The apartment the three artists shared was a second-floor walk-up in a brownstone. "We used to work round the clock, all different hours," recalls Robinson of the early days when he and his roommates were among that first generation of artists inventing the visual language of comics. They lived like teenagers: "Whenever we got hungry, we'd run out to the deli on the corner." The apartment was a high-spirited place.

While he lived on Seventy-fifth Street, Robinson spent a good part of the day at the DC offices in Midtown Manhattan. Meanwhile, Bernie Klein was freelancing for DC and other companies, but he found it difficult to work

alone. When Robinson got back from DC each day, they'd have a bite to eat and get down to work. "Bernie's happiest days were when we were working together or at DC in the bullpen along with everybody else."

Klein was not just social; he really was a happy-go-lucky person. "He didn't care if he made money, if he didn't make money. He loved to draw and he liked the camaraderie," Robinson remembered. Jerry and Bernie moved downtown, to an apartment on Thirty-third Street, within walking distance of the DC office on Forty-sixth Street and Lexington Avenue. "We rented that apartment furnished and with maid service. Of course the maid could never get in," Robinson recalled. "The dishes piled up in the sink so you couldn't get any more under the faucet. One time my mother came to visit: She was appalled."

The Robinson-Klein apartment quickly became a hangout. Everybody from DC as well as a host of other artists and writers came by, Robinson remembers: "Jerry Siegel and Joe Shuster, Fred Ray, Mort Meskin, Irwin Hasen, personal friends, girlfriends. Whit Ellsworth used to come down, and the Wood brothers, Bob and Dick, a whole crowd." Something was always happening.

For freelancers then and now, it's hard to draw a line between work and life, and when artists dropped by the Thirty-third Street apartment, they often started drawing. If someone was behind on a deadline, everybody would pitch in and they'd soon be sprawled all over the apartment, penciling and inking, to help get the job done. Like many artists, they needed music when they worked. "We had a little radio. It was an Atwater Kent, a classic. It was completely covered with clips from comic books," Robinson recalled. Jerry, Bernie, and their guests also hung comic art and salvaged cartoons on

ABOVE: *Mort Meskin's contribution to the Robinson/Klein apartment guestbook*

ABOVE: *Two pages from the Robinson/Klein guestbook. The top drawing is by DC editor Whitney Ellsworth; the bottom drawing is by Fred Ray, who served in World War II.*

the walls: "That was all we saved them for, was to display them, and not have them destroyed."

The artist-roommates also liked electronic toys, and they made frequent use of one rather unusual item. "Mort bought a recording machine, which was quite modern technology for then," Robinson said. "We had plastic disks that we recorded on. Mort fancied himself a singer, and he had half a good voice." Robinson makes no claims to be a singer, but the machine was irresistible: "We recorded songs and ditties and even recorded our thoughts on this or that topic."

The Thirty-third Street apartment wasn't very big. Whenever the roommates had parties, every available spot was taken. "We had beds in one room and a table and a couple of chairs in the other room, that's it," Robinson remembered. "When we had crowds, almost everybody sat on the floor. I still remember Whit Ellsworth sitting cross-legged on the floor, holding forth."

By this time, Robinson was working directly for DC. It wasn't a nine-to-five job. Jerry would sometimes put in long days at the DC bullpen and evening hours saw him and other artists working on their freelance jobs. Often the work stretched deep into the night and through the weekends.

In the 1940s, comic books were streaming off the presses and, with World War II looming, super heroes became more popular and more numerous than ever. The U.S. economy was going on a war footing, despite isolationist restrictions from Congress. Shipyards were ramping up to produce vessels for President Franklin Delano Roosevelt's Lend-Lease program to support England in its battle with the Nazis, but also with an eye toward getting ready for what was coming. Economic controls were beginning to be imposed on strategic materials, such as paper. And as a result, Robinson, Klein, and some other artists were about to have a weekend they'd never forget.

One day, Robinson's friend Charlie Biro called up. He needed help. Biro's publisher, Lev Gleason, had some tonnage of paper left over that he hadn't used for the books he was publishing. Under the government paper restrictions at the time, you had to use up your paper allotment, or you lost it. Surplus couldn't be carried over to the next month. Gleason's company already published the somewhat successful super hero Daredevil. Gleason decided to use up the extra paper by rushing out a comic book with Daredevil by Biro as the lead feature and with backup features that would star newly created characters. Robinson got the call just a day or two before the work had to start. Being asked to freelance on a short deadline wasn't anything new, it happened to artists all the time. Robinson liked the idea of creating his own, new character. But there was one thing, a *big* thing, which had to be dealt with. Biro told him, "We've got to do this book by Monday morning or we lose the paper."

Charlie Biro would draw the Daredevil story himself, but he needed to put together a team of artists who could create a full sixty-four-page comic book in a single weekend. Biro would bring Bob Wood, of course,

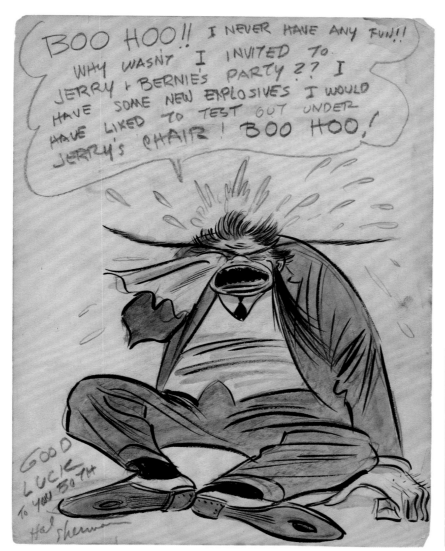

who worked with him at Gleason. By this time, Bob's younger brother, Dick Wood, also a writer, was in the city, and he was going to join the party, too. Robinson recruited his friend and roommate, Bernie Klein, and he also brought in George Roussos, another *Batman* veteran. Now all they needed was a place to work.

Cartoonists sometimes rented the top floor of a walk-up building not too far from Rockefeller Center. As Robinson described the place, "It was a bare room, a bathroom, and an empty kitchen with no equipment."

According to Jerry, the gang of artists started work first thing on Friday, March 7, 1941, and were prepared to keep going around the clock. "We got together, and the idea was that each one of us would create a character, write, pencil, ink, and letter the story, and by Monday morning it would all go to the engraver. Out of the blue, each of us had to create our own character and story."

ABOVE LEFT: *Hal Sherman, who drew the feature* The Star-Spangled Kid, *contributed this cartoon for the Robinson/Klein guestbook.*

ABOVE RIGHT: *Robinson's holiday card (1944) featured gangsters caroling around a pile of tommy guns.*

Two artists set up in the main room, Robinson recalled: "Drawing boards right in front of each other, near the two windows in the large room. The others had to draw while sitting on the floor." Writing was done on a typewriter, also on the floor.

"Bernie Klein did a boxing strip because he was an amateur boxer," Robinson recalled of his best friend's story. The other artist Robinson had recruited also followed his own personal taste for his contribution: "George Roussos did a mystery strip; he liked dark stories." Dick Wood turned out scripts for both Bernie and George: "Dick was on the floor typing. As fast as he whipped out a page, he'd give it to Bernie or George and they would start drawing." Robinson created his own new hero, London, which would continue to run in *Daredevil Comics* for the next year. "I would write out a page of script and start drawing it," Robinson said of his own working method, "and then think about what the next page was going to be while I drew the last one."

Of course, the six men had to eat—that's what delis are for. The young artists had a sort of relay system. "For food during the day somebody would just dash down to Sixth Avenue to a deli, pick up some sandwiches and coffee. First one guy would do it, then another," Robinson recalled. "We had nothing there to cook with, no refrigerator, nothing. So that's how we survived that weekend."

But then the unexpected happened: New York was hit by one of the largest snowstorms in a decade. It was the second big nor'easter of that month, a blizzard of a storm that stretched from Washington, D.C., to Connecticut. New York City was slammed hard and fast, starting at about 7:30 P.M. on Friday. The snow was wet and heavy—and seven and a half inches of it fell in the first six hours of the storm. Everything stopped except the subways. The storm lasted twelve hours without a break, and by the time the blizzard ended Saturday morning, New York City was immobilized under 11.6 inches of snow, with drifts up to eight feet. The newspapers were full of pictures of buried cars and stranded buses. One snowplow operator was killed when his machine plunged into the East River while dumping snow off a ramp.

The artists were stranded, too. "The snow was halfway up our doorway," said Robinson. "There was no traffic, there was absolutely not a car moving." Even though the artists were in an apartment in the heart of Midtown, a block from Radio City Music Hall, the area was deserted: "No stores were open. Cars couldn't move, the snow was so thick, and the streets weren't plowed." After the snow ended, freezing rain followed for a couple of hours.

"We were starving by morning, after being up all the night working, and running out of coffee, and having nothing to eat," Robinson remembered, still with a twinge. There was only one thing to do: "One of us had to go out and forage for food. We drew straws." Robinson recalls it was Bernie Klein who was sent off into the snow. Around 7 A.M. Saturday morning, the artists cleared the snow away from the building's entrance, and dug out a path to the street where there were some car tracks Bernie could walk in. After he

OPPOSITE: *Original hand-colored splash page, "London Can Take It,"* Daredevil Comics *no. 2 (August 1941) Lev Gleason*
Script, pencils, inks, and colors: Jerry Robinson
The first appearance of the suave wartime hero who epitomized the courageous British during the Nazi Blitz

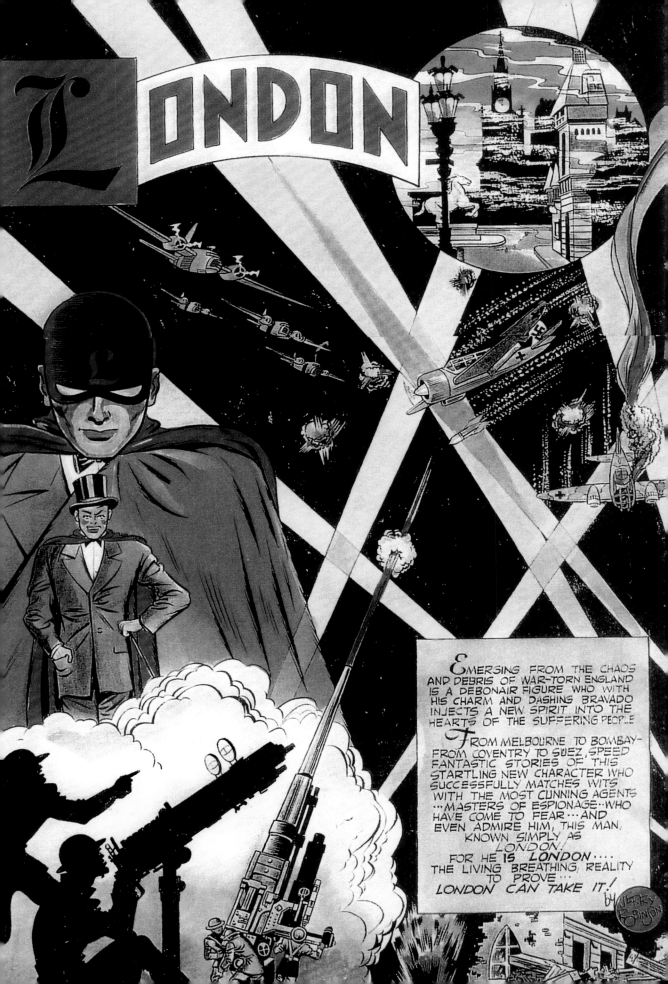

left, they went back to drawing. And waiting. And waiting some more. Eight hours later, at 3 P.M., Bernie finally returned! "By then, I think we were down to eating old scripts," Robinson joked.

Klein hadn't found any stores open. He'd finally made it to a bar somewhere near Fourteenth Street, where the barkeepers took pity on him and gave him a dozen fresh eggs. (Bartenders used raw eggs in drinks in those days.) They'd also given him a can of beans. The cartoonists looked at Bernie's offerings and said, "What the hell are we going to do with these?"

They managed to pound the can of beans open. "We probably used a T square," Robinson speculated. But with no stove, what could they do with raw eggs? "You couldn't build a fire on the wooden floor," said Robinson. "But we were comic book artists and writers. We were supposed to be creative. We found a solution. We pried the ceramic tiles off the bathroom wall and put them together, making a big square in the middle of the floor," Robinson explained. The artists then started burning newspapers on their makeshift hot plate. As Robinson described it, "We heated the tiles, cooked the eggs on them, heated the baked beans somewhat, and that was our meal."

Robinson's experience getting snowed in with a gang of artists while crashing a deadline has become comic book legend. The story first appeared in print in Jules Feiffer's influential volume *The Great Comic Book Heroes* (1965). Feiffer heard the story when he interviewed Robinson about the early days of comics for his book and included it as one of the legendary events of that period. The same story, transformed into fiction, reached a huge audience in Michael Chabon's marvelous and affectionate tribute to the comic book pioneers, *The Amazing Adventures of Kavalier & Clay (2000)*.

That infamous weekend was Robinson's first chance to create his own character, his first masked super hero. He had already created or contributed to some of the most successful and original villains in comics, so it's not surprising that Robinson tried something completely new when he created his first hero, London.

London was a character whose exploits were ripped straight from the news headlines. He wore a cowl with an Old English *L* on it and a swirling cape over a dapper tux and tie. His secret identity was Marc Holmes, an inspiring radio broadcaster whose nightly broadcasts helped the British stand up to the continual bombing of their capital city by Nazi aircraft during the Battle of Britain (1940). Robinson said of his creation, "I was even then a very political animal. I followed politics religiously in the news."

"I believed deeply in the cause of Great Britain, in her fight to survive," Robinson recalled. "I supported President Roosevelt and everything he was doing, like the Lend-Lease program, which was a way to get around the embargo and lend destroyers to Britain. So I decided to make my hero London." The character of Marc Holmes was also inspired by the journalist Edward R. Murrow (later depicted by David Strathairn in the 2005 biographical film *Good Night and Good Luck*). Murrow was the CBS Radio reporter

OPPOSITE: *Splash page, "The Submarine Signaller,"* Daredevil Comics *no. 4 (October 1941) Lev Gleason*
Script, pencils, inks, and colors: Jerry Robinson
London faces the U-Boat threat.

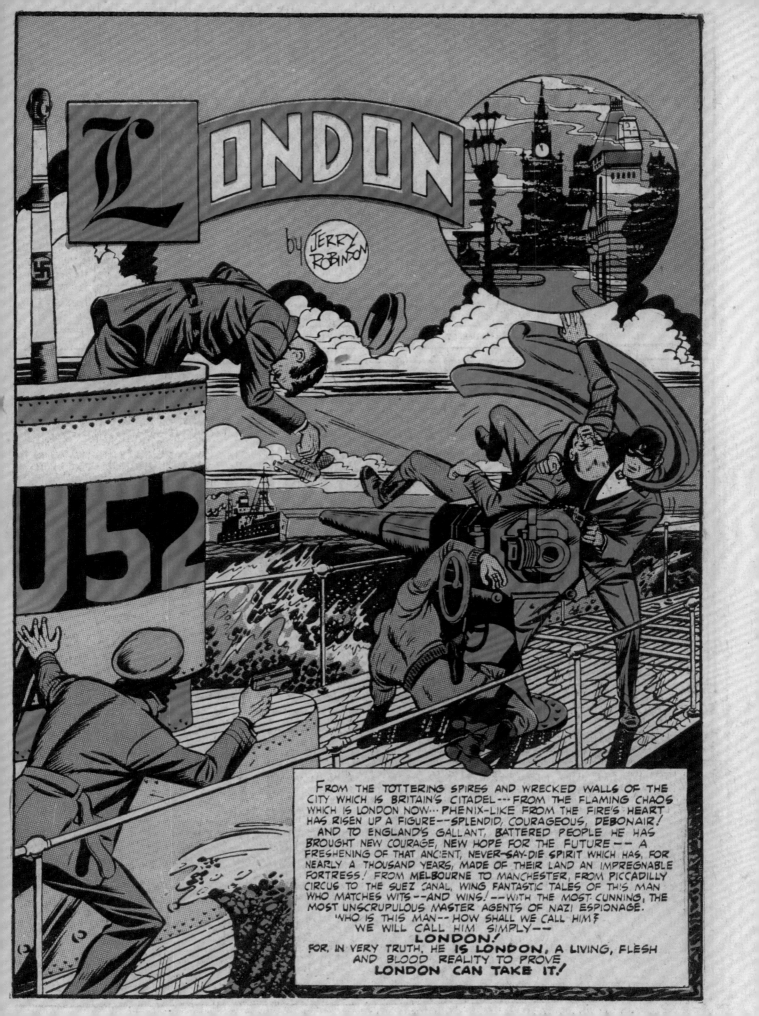

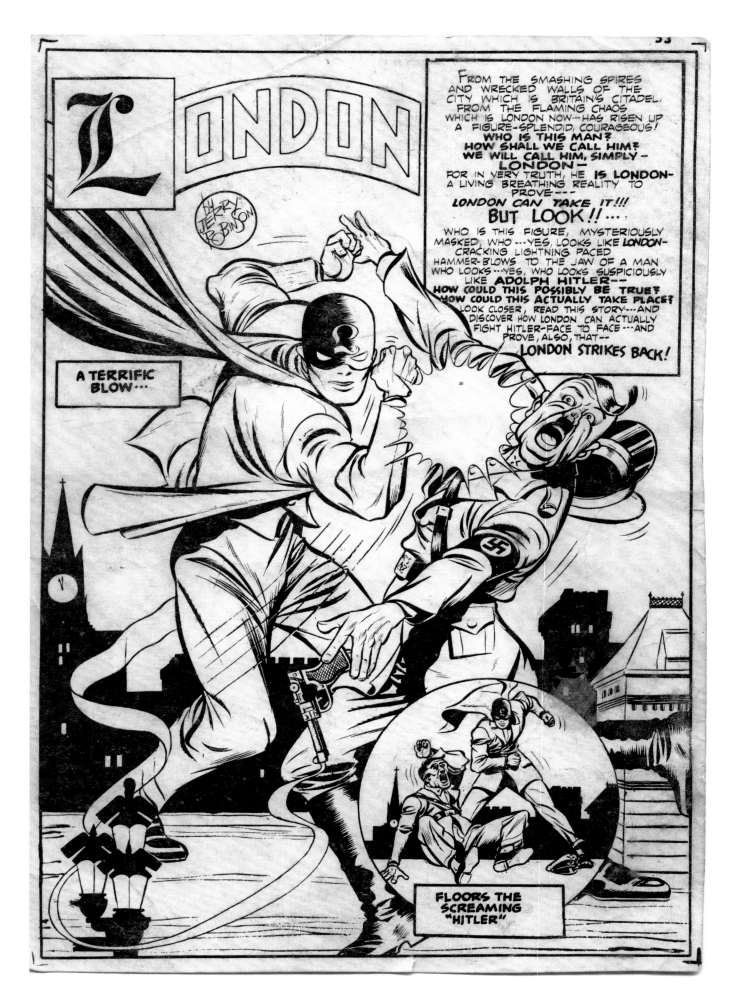

who covered the rise of Hitler, the fall of Austria, and the Battle of Britain. His harrowing reports of tragedy and courage inspired American support for Britain. Murrow's unforgettable opening for his broadcasts: "This is London," probably suggested the name for Robinson's character, as did the catch-phrase in Jerry's story: "London can take it!"

Robinson drew the *London* stories in a clean, open style. He filled them with realistic details and action-packed panels where London pounded Nazi agents. Robinson even included Winston Churchill in a cameo role in a *London* story. "Churchill's speech about the RAF saving the West stirred all of us," Robinson recalled, quoting Churchill's memorable line: "Never in the field of human conflict was so much owed by so many to so few."

London/Holmes was subtler than some of the super heroes who fought World War II in the comics. He was almost as much secret agent as costumed avenger and used his detective skills to foil spies and save a passenger liner from a Nazi U-Boat, one of the German submarines that menaced Allied shipping throughout the war.

During the war, the British film industry and great filmmakers such as Alexander Korda produced superb and inspiring patriotic films. These films inspired "London Strikes Back," probably the most famous of Jerry Robinson's *London* stories. In the storyline, London and Hitler are characters in a film, but the "real" London discovers that the actor portraying Hitler is indeed a Nazi agent. Robinson was pleased to be able to include the original art of London punching Hitler in an exhibition that he curated at the Jewish Museum in New York in 2005.

In a subsequent *London* story, Robinson created a Nazi supervillain, the Boar, who terrorizes England. Many years later, Robinson received a call from the Brazilian scholar Francisco de Araujo, who was in New York and wanted to meet him. Expecting to be asked about Batman, he was surprised when Araujo said how pleased he was to meet the creator of London, a character Robinson hadn't thought about in decades. Araujo explained that his research had determined that *London* was a milestone in the history of comics. As Robinson recalls, Araujo explained that, "It was the first feature that was conceived, written, drawn, published, and sold to the public at the same time as the events that it depicted."

Many cartoonists were drafted during World War II. Jerry Robinson was called up for physicals twice. He was just too thin to be drafted. The second time Jerry was called in, the examining physician informed him that he wouldn't be called in again. But he did it in a joking way that Robinson has never forgotten: "Look, son, we'll call you when the Nazis get to Fourteenth Street."

But Robinson's best friend, Bernie Klein, was drafted. Klein continued to draw comics for DC, Lev Gleason, and others up until he went into the Army in 1942. After basic training, Klein was assigned to a combat photography unit and dispatched to North Africa. Combat photographers were often

OPPOSITE: *Original splash page, "London Strikes Back,"* Daredevil Comics *no. 5 (November 1941) Lev Gleason Script, pencils, inks, and colors: Jerry Robinson This* London *story takes place before the U.S. entered World War II.*

at real risk, because they had to be near or on the front lines if they were going to do their job in a way that was useful to the Army. Klein went through the whole North Africa campaign and, like many of the troops who fought there, continued on through the invasion of Sicily and then into Italy. He was killed on the beaches at Anzio in January 1944 in one of the most famous and tragic battles of the European campaign. The landing by U.S. forces was bungled, and many Americans died needlessly. Years after the war, Robinson met a veteran at a reception in Washington, D.C., who had been with Bernie. The vet told Robinson that Bernie died heroically when his jeep was struck as he was trying to make contact with the main body of troops to let them know about an isolated unit.

Robinson was devastated when he heard his best friend had died. "I dreamed about Bernie every night for something like twenty-five years after he died in the war," Robinson said. "I would be looking for him everywhere, sometimes in New York, sometimes back home in Trenton. Always searching for him and never finding him. It was a very frustrating dream. All those years. Obviously I had never really accepted his death. He was still with me."

Eventually the dreams ended, in a way that was almost poetic. Robinson remembered, "One day I had a dream, decades later, that I finally found Bernie at our apartment on Thirty-third Street, from where he'd gone off to war. It was incredible. We fell into each other's arms. Bernie was alive! It was a wonderful reunion. And then I never dreamt of him again after that. It had finally sunk in. I had accepted the fact that he was gone."

ABOVE LEFT: *Max Baer, 1934 Heavyweight Champion of the World, checking out a copy of* Atoman *with Jerry Robinson (1940s)*

ABOVE RIGHT: *Robinson working on* Atoman *in Miami Beach, Florida, before Crossen's Spark Comics failed (1946)*

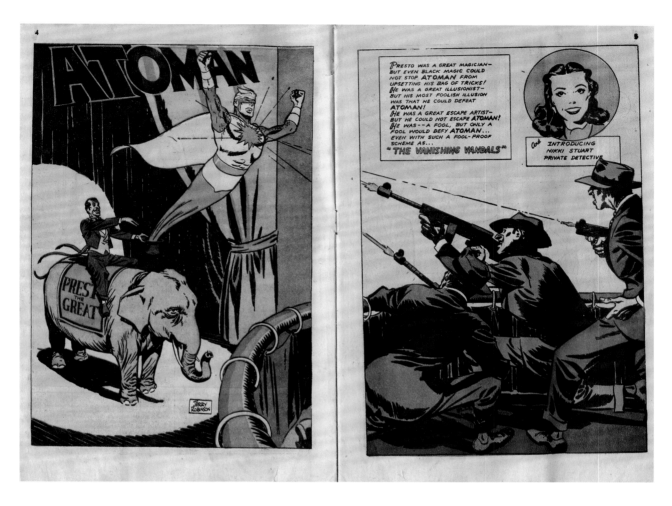

After the war, as Robinson phased out his last work for DC Comics, Ken Crossen at Spark Comics offered him the opportunity to write and draw his own stories. Robinson created another groundbreaking, original character: Atoman, one of the very first super heroes who owed his powers to atomic energy.

Spark Comics, also known as Crestwood Publications, produced a polished and attractive line of comics in the mid-1940s. Spark publisher Crossen was ahead of his time: He paid his artists well—twice the going rate at other publishers—encouraged them to create original characters, and gave them a lot of freedom in doing so.

"One day, Ken said he was looking for a new character, a super character, for a new publication," Robinson recalled. Crossen wanted Robinson to write and draw this new feature, which would headline the comic book. Working on original material really appealed to Jerry, and Crossen raised the ante when he added, "I'll pay you a hundred dollars a page." Robinson was astonished: "That was unheard of in those days. I think I got thirty-five dollars from DC, and that was a very good price."

ABOVE: *A splash spread from* Atoman *no. 2 (April 1946) Spark Comics*
Script, pencils, inks, and colors: Jerry Robinson

ATOMAN

Feb. 1946
No. 1
pdc

TEN CENTS

Plus
KID CRUSADERS
WILD BILL HICKOK
MARVIN THE GREAT
AND OTHER FEATURES

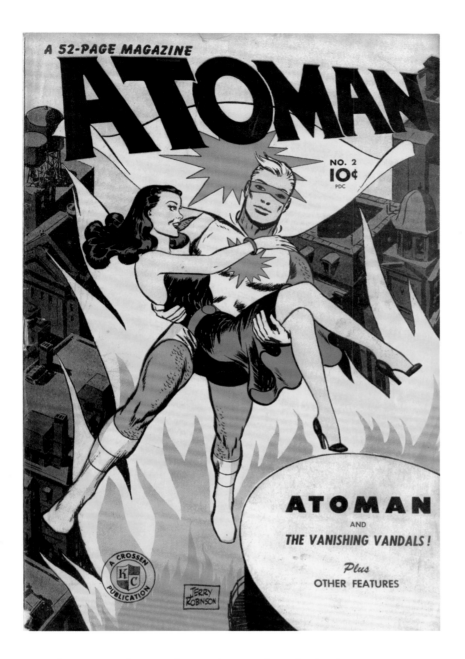

Robinson went home and created a super hero for the times: Atoman. The back story involved an evil industrialist, Mr. Twist, who tries to get atomic scientist Barry Dale to give him the secret of atomic power so Twist could exploit it for his own ends. Dale discovers that working with atomic materials had made him invulnerable *and* given him superspeed and superstrength. Robinson outfitted his new hero in a beautifully designed red and gold caped costume; his *Atoman* stories combined elegance in figure design and line work with the deep and angular viewpoints of his *Batman* comics. He depicted Atoman's superspeed with fluid, multiple figures rather than speed lines, a technique characteristic of Mort Meskin's Johnny Quick stories, on which Robinson later collaborated. (Meskin also did a new super hero for Ken Crossen, a character called Golden Lad, who also headlined his own book.)

OPPOSITE: Atoman *no. 1 (February 1946)*
Spark Comics
Script, pencils, inks, and colors: Jerry Robinson
Robinson's idealism shines in the Atoman origin story when Dale tells the evil Mr. Twist, "Atomic power is too dangerous to be controlled by one man or one corporation! All the people should benefit from it!" Robinson modeled the villain's look on the famous Shakespearean actor John Barrymore.

ABOVE: Atoman *no. 2*

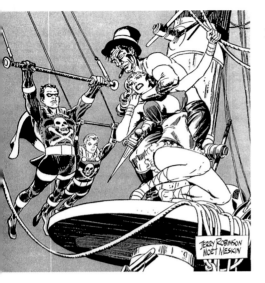

The *Atoman* deal seemed to good to be true…and so it turned out to be. Robinson took the assignment down to Florida for the winter and prepared to settle in. He turned out the first *Atoman* story, and the second. He was enjoying life in Florida: "I remember thinking, 'This is great: playing tennis, going to the beach, the sun, and drawing and getting paid for it.'" Robinson had written and was starting to pencil the third story when he got a phone call, probably from Mort Meskin: Crossen's comic book company was out of business for lack of distribution.

For their next act, Robinson and Meskin worked together on some existing comics heroes, the Black Terror and the Fighting Yank, for Nedor Publishing (also called Standard or Better Publications). The Black Terror's costumes, as well as those of his young sidekick, were quite striking: skin-tight, all-black suits with gold trim and belts, and a uniquely macabre image for a super-hero costume: a bone-white skull and crossbones splashed across the chest. The Fighting Yank, a.k.a. Bruce Carter III, was the descendant of a hero of the American Revolution. The Fighting Yank gets his powers when he puts on his ancestor's cloak and a tricornered hat.

Robinson and Meskin took this unpromising material and created some remarkable and innovative stories with it in the studio they shared on Forty-second Street, off Sixth Avenue; they worked closely together for several years there. The stories Robinson and Meskin did for Nedor are universally regarded as excellent, inventive comics. Although these comics lacked the Expressionist, experimental quality of Robinson's *Batman* work, and were consciously distinct from the heroic elegance of his *Atoman* (or even Meskin's spare and soaring *Golden Lad*), each story offered a new opportunity to experiment with characters, viewpoints and action, as well as lighting and inking effects. Panels were relatively consistent in size but were frequently small masterpieces of chiaroscuro; or experiments in showing deep recession in the smallest space; or sequences showing a key character from multiple viewpoints in a variety of scales in three or four or five sequent images. The *Fighting Yank* didn't offer quite as many opportunities for bravura effects, but sometimes colorful settings, in ports or at sea, offered scope for some atmospheric effects, as did one of the odder features of the strip: At moments of crisis, the ghost of Bruce Carter's ancestor would appear, pale and towering over the modern scene.

Probably the best-known *Black Terror* story is "Danger in the Air" from issue no. 23 (1948). This circus story, with its strongman, clowns, and other sideshow denizens, offered Robinson and Meskin the opportunity to draw idiosyncratic characters. The story centers on the murder of the lovely aerialist Nellie, and the swings and high wires under the big top provide the scene of action for the acrobats, Black Terror and Tim. The scantily clad Nellie appears as both aerialist and damsel in distress. Reportedly her beautifully rendered charms led to the removal of the comic book from newsstands in Boston.

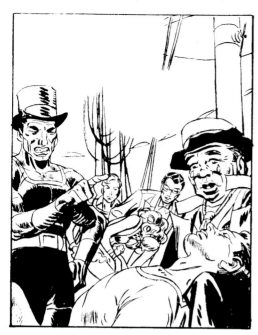

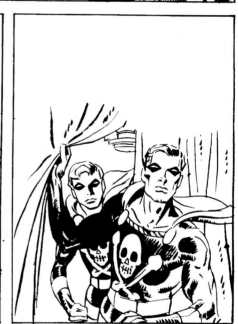

By the late 1940s, Jerry Robinson and Mort Meskin were also collaborating regularly on the adventures of two super heroes, Johnny Quick and Vigilante, for DC Comics. Meskin co-created Vigilante, who debuted in *Action Comics* no. 42 (1941). The Vigilante combined Westerns and super heroes (his secret identity, Greg Sanders, was a radio cowboy crooner called the Prairie Troubadour), and spawned a Columbia Pictures serial in 1946. Meskin also started drawing *Johnny Quick* in 1942 and, later joined by Robinson, continued to draw these adventures through 1946. Johnny Quick was really Johnny Chambers, whose guardian, Professor Gill, had bequeathed him a formula for superfast movement.

Although perhaps not quite as innovative as the comics they did for Nedor, where they were free from editorial supervision, the Robinson-Meskin team again did excellent collaborative work on these two DC properties. Meskin alternated doing the initial breakdowns of the story for both comics, and then he and Robinson collaborated on the penciling and inking. Meskin had

OPPOSITE: *A dramatic Robinson-Meskin splash page from "The Quiz Crime," America's Best Comics no. 27 (August 1948) Standard Publications*

ABOVE LEFT: *A Robinson-Meskin splash page from "Lady Serpent Returns," The Black Terror no. 24 (September 1948) Nedor Comics*

ABOVE RIGHT: *Cover,* Green Hornet *no. 25 (July 1945) Harvey Family Comics, Inc. Pencils, inks, and colors: Jerry Robinson Another super-hero series Robinson worked on in the 1940s*

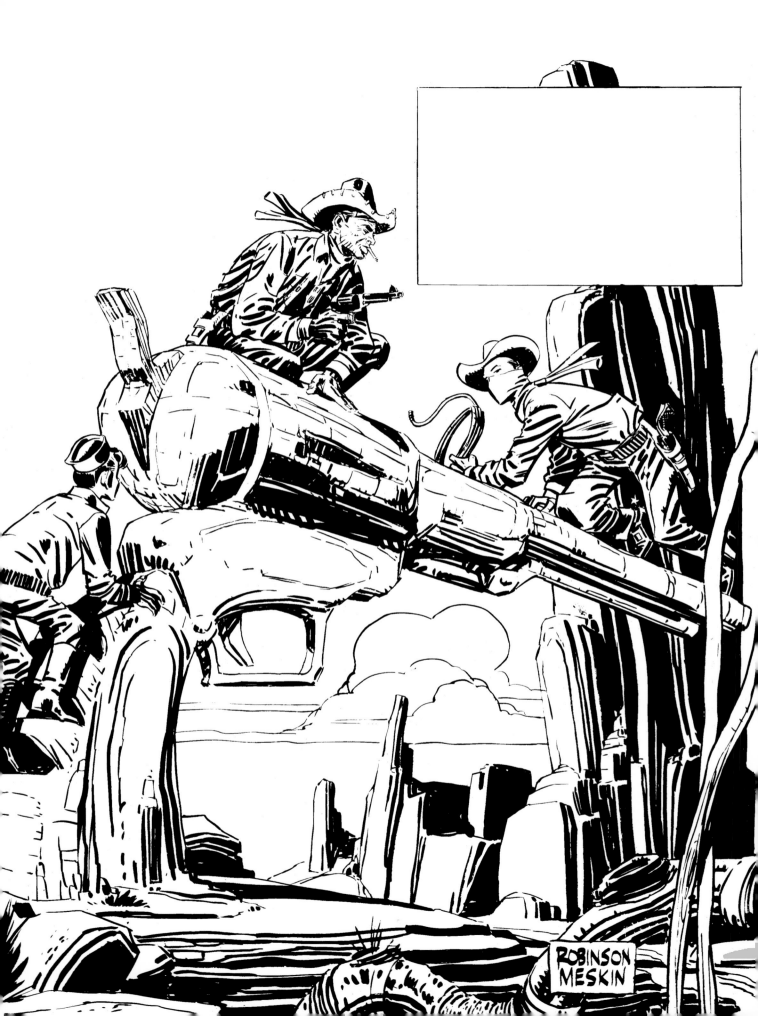

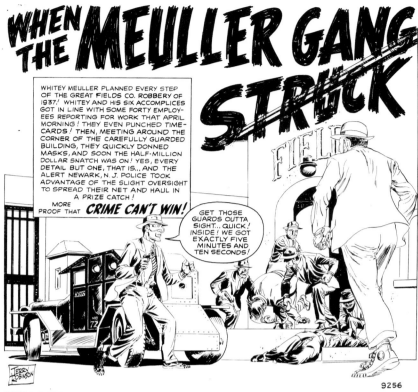

PREVIOUS SPREAD LEFT: *Splash page from a Vigilante story, "The Four Notches of Hate,"* Western Comics *no. 4 (July–August 1948) DC Comics Pencils and inks: Jerry Robinson and Mort Meskin*

PREVIOUS SPREAD RIGHT: *Splash page, "The Big Break,"* Justice *no. 22 (July 1951) Marvel/Atlas Pencils and inks: Jerry Robinson*

ABOVE: *Splash page, "When the Mueller Gang Struck,"* Crime Can't Win *no. 9 (February 1952) Marvel/Atlas Pencils and inks: Jerry Robinson Robinson noted: "To give the illusion of depth, the foreground figure is in outline pen-and-ink, and the background in black-and-white brush."*

OPPOSITE: *Splash page, "The Death of Danny Lewis,"* Justice *no. 25 (January 1947) Marvel/Atlas Script: Carl Wessler; pencils and inks: Jerry Robinson Robinson's clever shot shows the crime in action reflected in the lens and flashbulb attachment of the photographer's camera.*

already done some inventive things in these comics, such as the wonderful conceit of showing Johnny Quick's superspeed by drawing the character in diverse, overlapping positions in a single panel instead of using blurring and speed lines as was done with the Flash. Robinson has compared this to Marcel Duchamp's vision of movement in his famous painting *Nude Descending a Staircase*. But overall, these two DC features seemed to offer fewer opportunities for really pushing the boundaries of the comics medium.

By the late 1940s, super-hero comics had begun to lose their appeal. With the end of World War II, there didn't seem to be as much need for heroes. The division of the world into good guys and bad guys wasn't quite

THE DEATH OF DANNY LEWIS

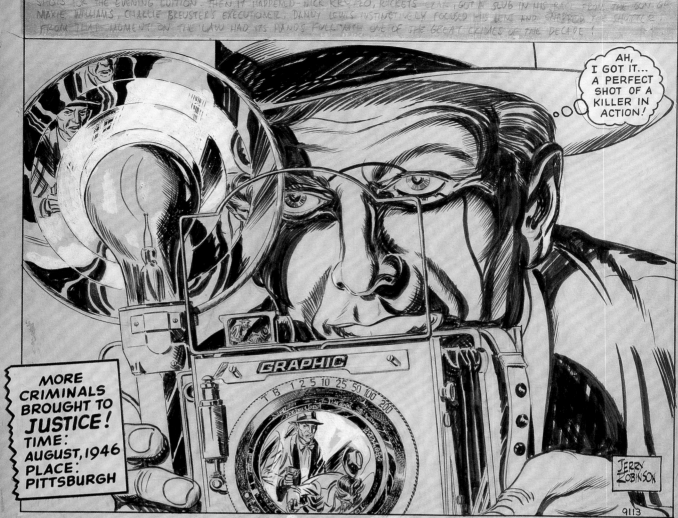

MORE CRIMINALS BROUGHT TO JUSTICE! TIME: AUGUST, 1946 PLACE: PITTSBURGH

AH, I GOT IT... A PERFECT SHOT OF A KILLER IN ACTION!

JERRY ROBINSON

9113

YOU LOON! WHY DIDN'T YOU PLUG THAT BIRD WITH THE CAMERA?

I...I GOT ALL MIXED UP, CHARLIE! WE GOT TO STOP THAT GUY!

RUN, MISTER... THE POLICE! I'VE GOT TO CALL THE POLICE!

ALL NAMES AND PLACES IN THESE TRUE-TO-LIFE STORIES ARE FICTITIOUS. ANY SIMILARITY BETWEEN ACTUAL PERSONS OR PLACES AND THOSE USED IN THESE STORIES IS PURELY COINCIDENTAL

O.K.

...PHASE FOUR OF "OPERATION KILLER"!

RED BUILD-UP AREA

SEOUL

JANUARY.. FEBRUARY.. MARCH, 1951! YOU, PFC. PAUL HAMOND, U.S. ARMY, WERE ONE OF THE THOUSANDS OF UNITED NATIONS SOLDIERS WHO POURED INTO SEOUL WITH THE CHINESE COMMUNISTS HOT ON YOUR HEELS! YOU KNEW THAT A FEW SHORT MILES AWAY, NORTH OF THE 38TH PARALLEL, THE ENEMY HAD STOPPED TO REGROUP IN A BUILD-UP AREA TO PREPARE FOR THE BIG AND FINAL ATTACK AGAINST THE BESIEGED CITY! WHAT WAS ON YOUR MIND THEN, PAUL HAMMOND? WHAT WERE YOU THINKING?

JERRY ROBINSON

A364

YOUR OUTFIT, GENERAL WALTON WALKER'S EIGHTH ARMY, HAD ROLLED OUT! WHEELS HAD SAVED THEM AS THEY FLED SOUTH IN JEEPS, TRUCKS AND TANKS!

GENERAL EDWARD ALMOND'S 10th CORPS HAD ESCAPED BY AIR! BIG C-47'S CAME IN RIGHT UNDER THE CHINESE GUNS TO PICK UP THE TRAPPED SOLDIERS AND LUMBERED OFF TO SAFETY...!

1

"FIVE MILES FROM THE YALU! HOME FOR CHRISTMAS! ALL OF THAT SEEMED SO EASY WHEN WE'D BEEN CHARGING FORWARD AS FAST AS WE COULD TRAVEL! WE HAD EVERYTHING, CONFIDENCE, COURAGE, THE WILL TO WIN...AND ALL OF A SUDDEN THE ROOF FELL IN...."

"THERE WAS MORE NOISE THAN I EVER THOUGHT POSSIBLE! CRATERS OPENED RIGHT NEXT TO US! I SAW GUYS HIT AND DIE ALL AROUND ME AND THEN...."

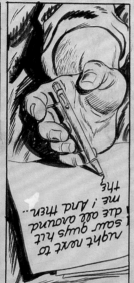

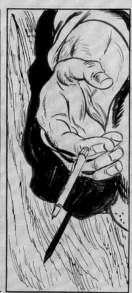

SO LONG, SOLDIER!

OUTSIDE THE DUGOUT THE BATTLE RAGED IN ALL ITS FURY! THE EIGHTH ARMY HAD BEEN LURED INTO A TRAP, ENDING PHASE TWO...FOLLOWED BY PHASE THREE....

THE BLACK ROBE!

A RUGGED, HE-MAN STORY OF REVENGE!

JERRY ROBINSON

I'M JOHNNY "KID" WILLIAMS, FORMER CHALLENGER FOR THE WELTERWEIGHT CROWN! I RUN AROUND WITH SCAR MOLINA'S MOB... BUT I AIN'T NO GANGSTER! Y'SEE, THREE YEARS AGO, MY KID BROTHER, CHARLIE, WITNESSED A HOLDUP AN' MURDER, AN' HE WAS KILLED BEFORE HE COULD GIVE EVIDENCE! I WAS NUTS ABOUT THE KID, THAT'S WHY I'M WITH MOLINA'S BUNCH...TO TRY AN' FIND THE RAT WHO KILLED MY BROTHER!

8567

"THE NEW YEAR WAS CLOSE AGAIN...THREE YEARS SINCE CHARLIE WAS KILLED AN' I WAS NO CLOSER TO HIS MURDERER THAN I'D EVER BEEN!"

HI, KID! LOOKIN' FOR SCAR?

YEAH!

MY BROTHER AIN'T HERE, PUNCH-DRUNK! WHY DON'T YUH GO IN THE ALLEY AN' KNOCK YOURSELF OUT! HA! HA! HA!

PAUL, LAY OFF KID WILLIAMS, HE'S A NICE GUY!

DON'T GIVE ME ANY LIP, SCANLON, OR I'LL HAVE SCAR TAKE CARE OF YUH! WILLIAMS IS A JERK! HEY, DID I TELL YOU GUYS ABOUT THIS NEW DAME? A KNOCK-OUT...AN' BOY DOES SHE GO FOR ME! LISTEN...

1

so clear. Film noir cinema, dark and haunting films about crime and betrayal, replaced the war movies that had dominated the theaters during and just after the war. The Korean War, a confused and messy conflict that wasn't even officially a war (it was a "police action") seemed to add to the disenchantment. DC kept its flagship characters—Superman, Batman, Wonder Woman—going. Other publishers found success with different genres of comics. Lev Gleason and Charles Biro sold large numbers of comics such as *Crime Does Not Pay,* a dark and violent comic book that seemed to match the postwar mood of lingering disillusionment that found expression in movies such as *The Lost Weekend* (1945) and novels such as *The Man in the Gray Flannel Suit* (1955).

At this point in his career, Jerry Robinson was a consummate super-hero comic book artist. He really hadn't worked in other genres, but he was always

PREVIOUS SPREAD: *Inked pages from "O.K. ... Phase Four of 'Operation Killer,'"* Battlefront *no. 1 (June 1952) Marvel/Atlas Script: Don Rico; pencils and inks: Jerry Robinson*

OPPOSITE: *Splash page, "The Black Robe,"* Man Comics *no. 10 (October 1951) Marvel/Atlas Robinson's unique perspective on a gangland murder*

ABOVE: *A science-fiction splash page montage from "The City That Vanished,"* Mystic *no. 5 (November 1951) Marvel/Atlas Pencils and inks: Jerry Robinson*

willing to take on something new, even if it was entirely unlike anything he'd ever done before. (Later in his career, he would leave comic books entirely and find success in book and magazine illustration, comic strips, and editorial cartooning.) Thus, it's not surprising that when the comic book field changed, Jerry was ready to change along with it.

During the first half of the 1950s, Robinson drew every genre of comic book, except the one in which he had established his reputation—super-hero. He was invited to draw all these different kinds of comics by a young editor, one he hadn't worked with before. This editor, who oversaw all kinds of comic books, *except* super-hero, would one day become perhaps the most famous super-hero writer and editor of all time: Stan Lee.

Lee started in comics as a teenager, hired by his cousin Martin Goodman, who owned what was originally called Timely Comics and what eventually became Marvel Comics. Goodman used many different names for his publishing company; in the 1950s, it was often referred to as Atlas Comics. Goodman's publishing company had given the world Joe Simon and Jack Kirby's *Captain America*, but now the publisher and his editor, Stan Lee, were turning out a wide variety of genres: Westerns, romance, crime, the occasional science-fiction, fantasy, and war. War stories included *Battlefield, War Adventures, War Combat,* and the completely generic *War Comics.* Westerns and war stories appeared in the anthology titled *Man Comics,* as well as in comics like *Western Thrillers.* Science fiction and fantasy comics included *Astonishing Adventures* and *Weird Worlds, Mystic,* and of course *Marvel.* Crime titles such as *Crime Must Lose* and the equally inventive *Crime Can't Win* echoed Charlie Biro's successful book *Crime Does Not Pay.* Stan Lee wrote a lot of the stories himself and hired fully professional and talented scriptwriters such as Don Rico, who did many of the stories that Robinson would illustrate.

Robinson wasn't really looking for comic book work, and it was a kind of coincidence that he started working for Lee and Timely Comics. "I was teaching at the School of Visual Arts, five days a week," Robinson remembered. "I would invite guest speakers to come talk to my classes, people who worked in comics, not just artists. I invited Stan Lee to come talk." Lee asked Robinson if he'd like to join Timely, and Robinson said yes. Over the next ten years, he collaborated with Lee in virtually all the genres the company was publishing.

"Stan was very easy and fun to work with," Robinson said. "He was very creative and rarely asked me for changes. I had a lot of freedom." Jerry found the war stories about Korea a particularly good place to experiment with storytelling and character. (Later, Robinson would draw upon his experiences on a trip to Korea with a group of comic book and comic strip creators assembled by the National Cartoonists Society and sent over to entertain the troops. There he absorbed the terrible reality and firsthand tragedy of the Korean conflict.)

ABOVE: *Splash page, "The Death-Trap of General Chung!"* Battlefront *no. 4 (September 1952) Marvel/Atlas Robinson illustrates an impending disaster in the Korean War.*

Robinson did extensive research on military uniforms and equipment and on what the battlegrounds looked like. "I really tried to get the drudgery, the brutality, the horror, even the smell," he recalled. "The Korean War was like World War I," he added. "And I wanted to convey the same emotional response I had watching the World War I antiwar film *All Quiet on the Western Front*."

For his work on the detective, crime, and science-fiction comics, Jerry found a number of ways to be innovative. "In doing these Timely stories, I decided to start opening the stories with montages," he explained. "I did these montages on the splash page, combining various elements that appeared in the story." The idea was to pull the reader into the story immediately. "I didn't want to start these stories with something like a shot

of a couple of people sitting in a car. That would be very dull. I wanted to begin with the more exciting elements of the story, and then the actual narrative started after the splash," explained Robinson.

He drew one of his favorite splashes for *Amazing Detective Cases.* It was a surrealist urban landscape where the buildings and street signs come to life around the criminal. As Robinson described it, "I filled this montage with symbols, all pointing at him as guilty. It's surrealist. I was interested in the symbolism in surrealist paintings by artists like Salvador Dalí and Marcel Duchamp." Robinson felt that the psychological aspects of surrealism, its ability to convey the unconscious and archetypes, worked well in this particular crime story. "It's a very personal story, introspective and symbolic. I think the reader got to know this guy," said Robinson.

ABOVE: *Splash page, "Danger in the City,"* Amazing Detective Cases *no. 6 (May 1951) Marvel/Atlas*
Robinson's surreal montage for a psychological thriller. Note the unusual perspective of the alarm clock as seen by the character.

ABOVE AND OPPOSITE TOP LEFT:
*Three of Robinson's penciled pages
from "Gold Fever,"* Bat Masterson *no. 6
(April 1961) Dell
Robinson drew upon his storytelling tech-
niques and superb draftsmanship to create
panoramic compositions and close-up
sequences. These images show the careful
construction of each set, and the gestured
character development.*

OPPOSITE TOP RIGHT: *An interior
page from "Showdown in Dodge City,"*
Bat Masterson *no. 6 (April 1961) Dell
Pencils and inks: Jerry Robinson*

OPPOSITE BOTTOM: *Robinson sketches
Lassie, the star of a popular television
show and comics series in the 1950s,
during a lecture.*

Robinson's least favorite stories were done for the romance comics.
The scripts he had to work with were not outstanding, but he enlivened them
with striking angles, disturbing reflections, and sensuous heroines. At the
School of Visual Arts, Robinson was recognized as a master at drawing strong
and beautiful women.

There was a certain quality of gritty realism that was appropriate,
not just for the war comics, but also for his crime stories. Robinson found
some resonance between the stories he was working on for Stan Lee and
postwar cinema. "Going to the movies with Bill had gotten me into foreign
films," he recalled, "and I continued to seek them out; in the 1950s, I got into
Italian films." Robinson discovered the masterpieces of Italian neorealist
cinema, which looked at the social dislocation, poverty, and corruption of
postwar Italian society with disillusioned but poetic eyes. "I liked Roberto
Rossellini, Vittorio De Sica. I went to see their films when I was working on
the Timely comics," Robinson said. These atmospheric films, usually shot
in black and white, reinforced the kind of mood Robinson sought in his work
at the time.

In the mid-1950s, Jerry's schedule was increasingly busy as he began to
devote more time to book and magazine illustration and, later, to drawing

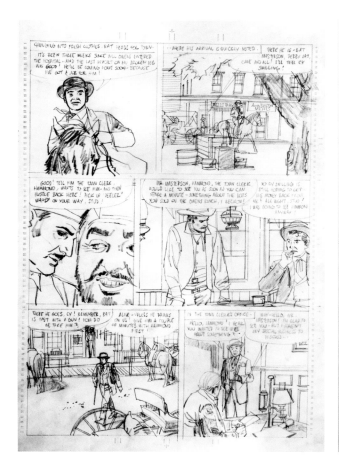

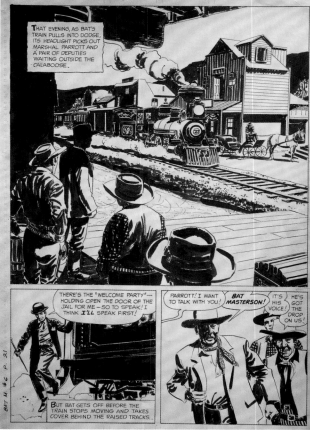

comics for newspapers. But toward the end of the 1950s, he did find time to take on a few more comic books. The Dell Comic Book Company specialized in children's comic books; their most successful titles were licensed from Hollywood. Dell hired Robinson to draw *Lassie* comics for two years. It was not the most rewarding job. "I got to really dislike drawing that dog," said Robinson, laughing. "I'd try to design the panels so you'd only see her nose or her tail." A much more enjoyable Dell title was *Bat Masterson*, based on the entertaining Western TV series starring Gene Barry. Here the clean and open style that Robinson had deployed in comic books such as *Atoman* formed the ideal artistic vocabulary for a comic aimed at younger readers, but it also allowed him to give the book a sense of classic, beautifully shot and composed Westerns like those of John Ford. Robinson researched the Old West before drawing the wide-open landscapes, steam railroad trains, and other characteristically western images called for by the stories.

Although Jerry Robinson stopped drawing comic books in the late 1950s, three decades later they came back to him, from a most unexpected source: Japan. In the late 1980s, Robinson met the multitalented composer and lyricist Sidra Cohn, who also summered on Cape Cod. When Cohn learned that Robinson had created the Joker, she asked him to collaborate on a musical.

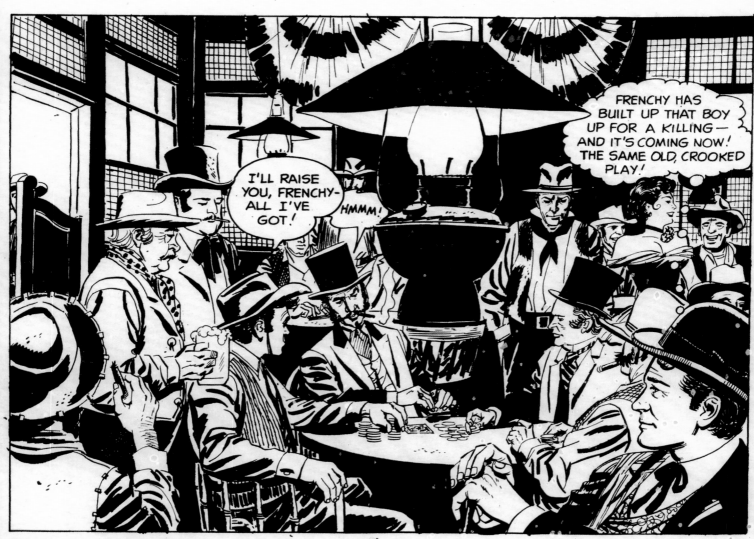

Partly because it was a challenge and partly because he thought working with Sidra might be an enjoyable project for the summer, he said yes.

The musical they came up with, *Astra: A Comic Book Opera*, was a kind of science-fiction political-satire space romp, starring a sexy intergalactic heroine named Astra. They collaborated on the book and lyrics for thirty songs, and Cohn composed the music. (The Warehouse Theater of Washington, D.C., staged a lively and spirited adaptation of *Astra* in 2007, which garnered favorable reviews.)

To help visualize the character and sell the property, Robinson and Cohn asked Frank Thorne, an artist famous for drawing sexy, strong women such as Red Sonja, to do a series of concept sketches. When Robinson went to Japan for a retrospective of his work in the late 1990s, he included Thorne's drawings of Astra in the exhibition as an example of Jerry's latest project. When he returned home, a publisher of Japanese comics came to New York to license the rights for a manga adaptation of *Astra*. Robinson agreed and was flown to Japan to spend a few weeks working with the manga writer Ken-Ichi Oishi and the artist Shojin Tanaka. It was one of the first American-Japanese collaborations on a manga book. The Japanese edition of *Astra* was published as a series of comic books, translated into English, followed by an *Astra* graphic novel in 2001.

By the end of the 1950s, Jerry Robinson had drawn just about every kind of comic book there was. None of this was planned—neither his first accidental invitation to work on *Batman,* nor being asked by Stan Lee to draw for Timely Comics, nor drawing comics for kids based on popular TV shows. But these experiences helped Jerry develop a mastery of many different styles of drawing, from cartoony to photorealist. As he expanded his creative universe from comic books to other fields—book illustration, comic strips, and editorial cartoons—Robinson was able to draw on everything he had learned in comics . . . *literally*!

OPPOSITE: *An inked page from "Duel by Deceit," Bat Masterson no. 3 (May–July 1960) Dell*

ABOVE: *Cover, Astra, Media Factory, Tokyo (1999). Created by Jerry Robinson and Sidra Cohn; art by Shojin Tanaka; script adaptation by Ken-Ichi Oishi; based on the Robinson-Cohn musical Astra.*

ATOMIC ENERGY

by Jerry Robinson

Maxton Books for Young People

BOOKS, BROADWAY, AND BECOMING PROFESSOR ROBINSON

"**D**rawing comics was a kind of education most artists don't get," Robinson has said. He feels that drawing comics actually prepared him more for his years as an illustrator than a conventional artistic education might have. "Because I started in comic books, I had to learn to draw *everything*," Robinson recalled. "You had to know how to do anything, from the weirdest perspectives to such mundane things as drapery." His work in comics required going far beyond studio anatomy and still-life drawing; Robinson had to embrace narrative. "You really learned to tell a story and to manipulate time," he explained. "All the storytelling techniques that you might see in a film, we had to employ.

"Of course, you had to master anatomy to draw comics, but even for the super-hero comics, you had to learn to draw identifiable characters, many different kinds of people," Robinson continued. "We drew the figures without models. We didn't have time to use them. We really had to learn how to visualize figures and forms from every perspective.

The heroic comics that Robinson drew, including *Batman, Black Terror, Green Hornet,* his own *Atoman,* and a number of others, included elements of both crime and adventure stories. Scenes took place in dozens upon dozens of different settings, and the comics were populated with just about every kind of human (and nonhuman) character imaginable. As Robinson worked on more and more comics, he developed a kind of repertoire of character types for his stories. "Every artist does that," he explained.

As a comic book artist working in a variety of genres, Robinson had also drawn every kind of scene imaginable, in every kind of lighting, and hundreds if not thousands of images of people in motion—on planes, trains, and automobiles of every type. Fantasy and surreal scenes for mystery and

OPPOSITE: *Robinson did the cover (ink and casein), design, and interior illustrations for* A Maxton Book About Atomic Energy *by Dr. Vera K. Fischer (Maxton Publishers, 1959). Robinson sketched the nuclear reactor at the Brookhaven National Laboratory.*

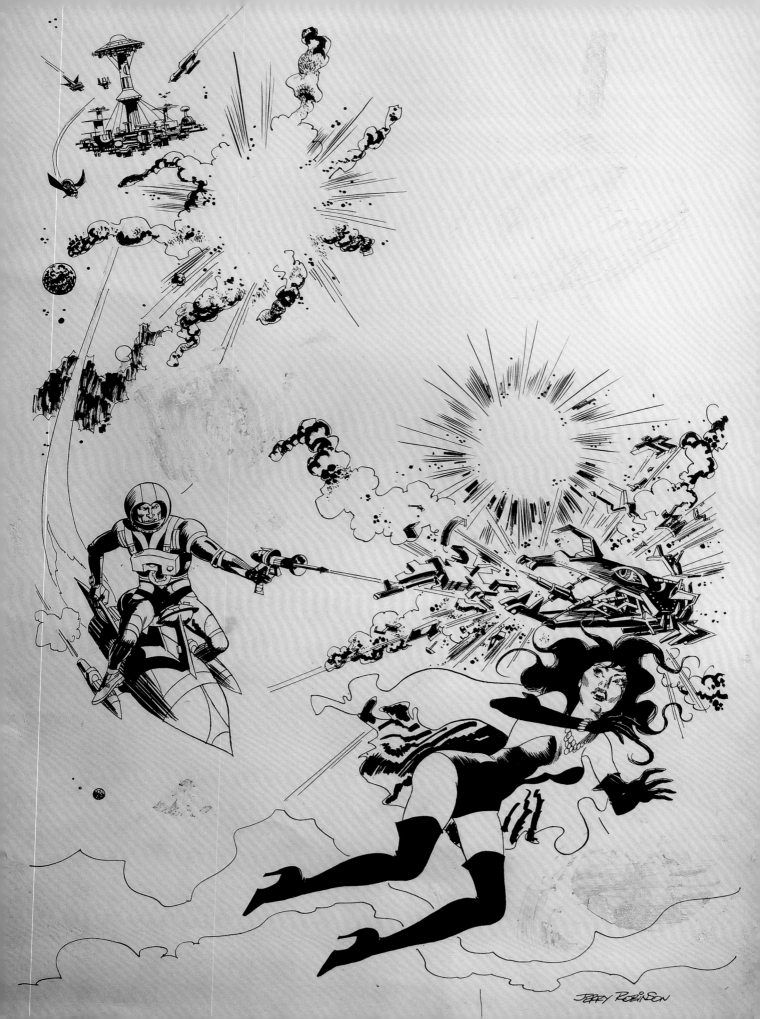

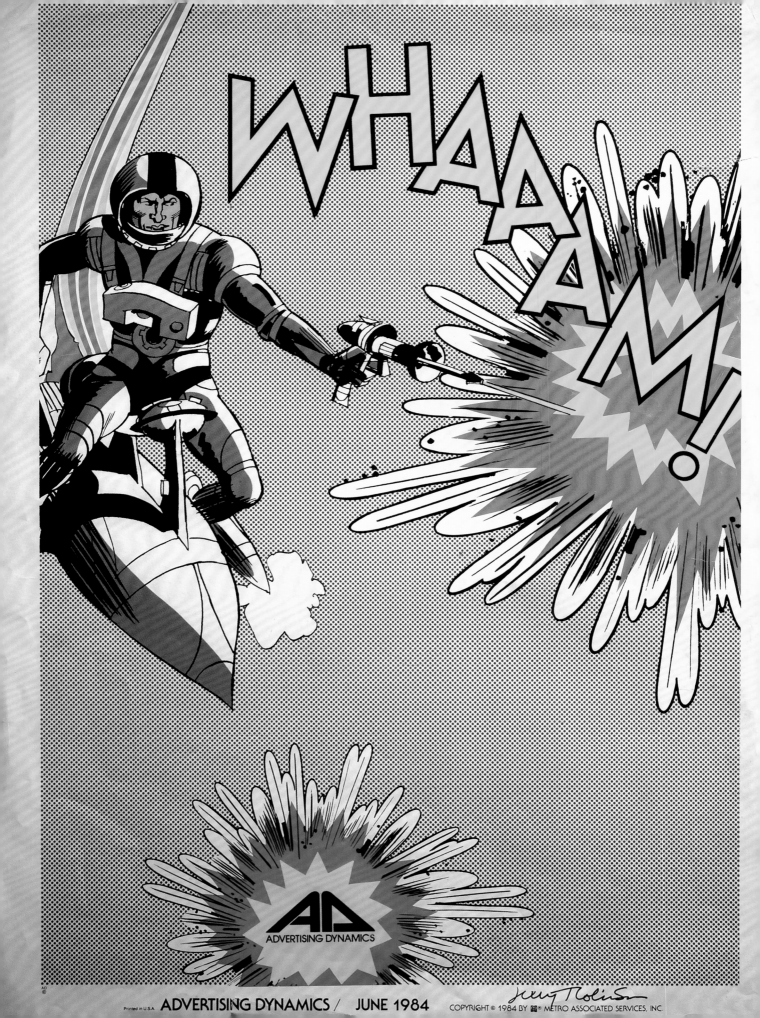

science-fiction comics had flowed from his pen and brush. There was nothing he couldn't draw.

At the same time that the number of comic books being published decreased in the 1950s, Jerry found that opportunities in book and magazine illustration grew. He plunged into this field with his usual enthusiasm. During his years as an illustrator, Robinson embraced the same kind of diversity he had pursued in comic books. He did book covers for genres from science fiction to literary classics, and interior illustrations for history, humor, and educational titles, as well as books on anatomy and paleontology. Comics had prepared him to handle any assignment.

Robinson worked extensively in the illustration field from the 1950s through the 1980s. He produced hundreds of illustrations for trade books, popular magazines, advertisements, and technical and educational books. His illustration work is extremely diverse, ranging from detailed technical images for textbooks and other scientific and educational publications, to cartoon-style illustrations for children's books and magazines to realistic and sometimes emotionally charged drawings and paintings for historical works. Hallmarks of Robinson's illustration include detailed research and thoughtfully rendered characters who expressed ideas and emotions in inventive and unmistakable ways.

Robinson got his first illustration assignment through a colleague, the superb comic strip artist and illustrator Frank Robbins. Robbins had taken over the *Scorchy Smith* daily strip from the legendary Noel Sickles, and then created his own successful aviation adventure strip, *Johnny Hazard*, in 1944. Robinson recalled that Frank Robbins "was a good friend. One day he called and asked me to drop over to his studio, he might have something interesting for me." Robbins was doing both *Scorchy Smith* and magazine illustration when he got commissioned by *Look* magazine. It was an assignment he was just too busy to accept, but he thought Jerry might be interested.

Look was probably the most popular large-format magazine at the time, after *Life;* like the *Saturday Evening Post, Look* was also a prestigious place for illustration. Frank called the editor of *Look* and recommended Jerry for the job. Robinson was a little nervous about jumping into such a big pond, but he had confidence as well: "I was really very apprehensive about taking it on, but no matter what the assignment, I always got it done somehow. If they had wanted an oil painting, I would have said yes, and then figured out how I could do it."

Robinson really didn't have any illustration experience at the time, and he was only twenty-two—a pretty young age to break into the profession. But he went to meet the editor of *Look*, taking along his portfolio, which was all comics drawings, since that's all he had done up to that point. "I showed them some samples, which they probably didn't know came from comic books," Robinson explained. And he got the job: "They probably just took me on faith, because Frank had recommended me, but perhaps they might have seen something they liked."

PREVIOUS SPREAD
Comics and pop art influences can be see in these illustrations Robinson did in 1984 for the firm Advertising Dynamics.

The assignment for *Look* magazine was complex and intense: It was for a large number of drawings for an article by a retired U.S. Army major about the predicted American invasion of Japan. "We were then in Okinawa," Robinson recalls, "preparing for the invasion of the Japanese mainland. Everyone knew that was going to happen, and that it might cause the loss of a half million American lives or more."

"This was my first big break into illustration," Robinson continued, and he took it very seriously. "It required a lot of research and I worked around the clock to make the deadline." Robinson's hard work showed: "They liked it, and subsequently I got several other illustration assignments from *Look*." The assignment paid off in other ways as well. "Although I didn't go into illustration fully until later on, I think that first commission emboldened me later. It was wonderful exposure," said Robinson. It also meant he had something in his portfolio besides comic book excerpts. "I could use those *Look* illustrations to get the next job. One thing led to another," Robinson recalled. That was true of a lot of things in his career.

Robinson wasn't the only comic book artist to move into illustration, but he was one of the few who didn't turn his back on comics when he found success as an illustrator. Jerry carved out a distinctive and rewarding illustration career while still drawing for comic books. He only gave up illustration when his own cartooning, including his editorial cartoons and his humorous *Flubs & Fluffs* comic strip, took up so much of his time and energy that he just couldn't continue with anything else.

ABOVE: *Robinson's ink-and-wash illustrations for the* Look *commission (1945) included this image of the projected U.S. invasion of Japan before the atomic bombing of Hiroshima.*

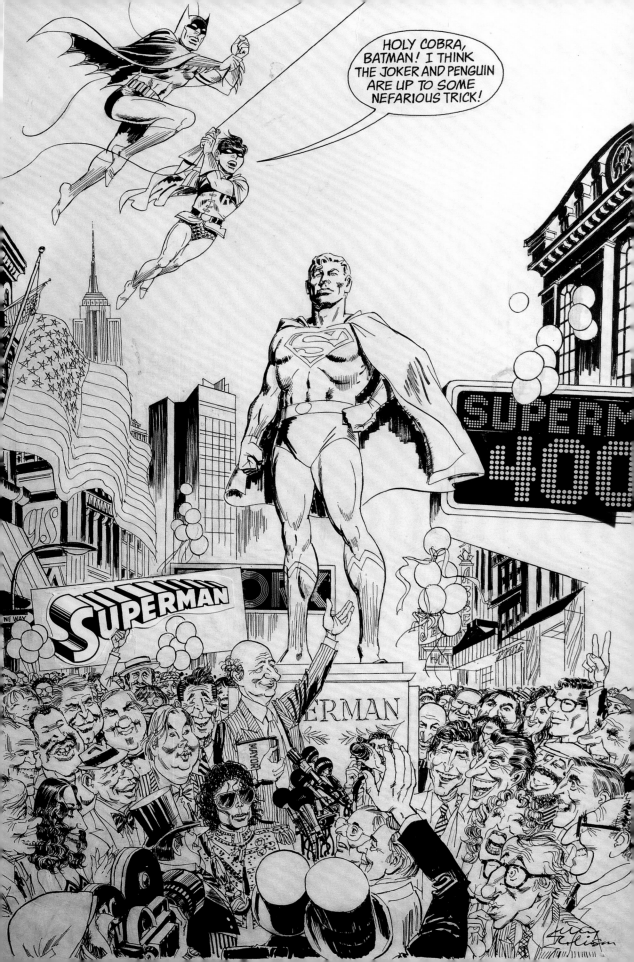

Robinson not only continued to draw comics as he branched out into illustration, he also found the time and energy to teach the art of comics to aspiring young cartoonists at what is now the School of Visual Arts in Manhattan. Originally called the Cartoonists and Illustrators School, SVA was founded in 1947 primarily for veterans eligible for the GI Bill, which paid for college for those who had served in World War II. The school was started by Silas H. Rhodes, an entrepreneur with a PhD in English from Columbia University, and Burne Hogarth, a prominent comic strip artist. The school they created was the ideal artistic and intellectual environment for Robinson. He began teaching at the Cartoonists and Illustrators School in the early 1950s, and soon became an integral part of the faculty. He would later teach comics at New York's finest art schools: Pratt Institute in Brooklyn, and Parsons the New School for Design and the New School in Manhattan. But Robinson was most devoted to the School of Visual Arts, where he taught for ten years.

Robinson, who would later start a speaker's bureau with Will Eisner to give talks on the comics to educational and cultural audiences, teamed up with Hogarth for regular lectures on different artistic problems or themes at the Cartoonists and Illustrators School. "The whole school used to come; we booked them into the largest auditorium," Robinson remembered. "Burne and I would spend several hours going back and forth, exploring the subject from every angle and answering students' questions. It was intense fun; Burne was a dynamic speaker, and he had an extensive knowledge of art history." Robinson and Hogarth also made their points by doing large

OPPOSITE: *Original pen-and-ink for the anniversary issue of* Superman *no. 400 (October 1984) DC Comics. Robinson's homage shows Batman and Robin dropping in on the unveiling of a Superman statue by New York City mayor Ed Koch. Among the celebrity crowd pictured are Michael Jackson, Woody Allen, Henry Kissinger, Walter Mondale, Ronald Reagan, Jimmy Carter, Gerald Ford, and Richard Nixon. Robinson also included Superman creators Jerry Siegel and Joe Shuster (center), and* Batman *characters the Joker and the Penguin.*

ABOVE, LEFT TO RIGHT: *Legends of the comics industry Will Eisner, Burne Hogarth, and Jerry Robinson, who all taught at the School of Visual Arts (SVA), met with Jack Kirby (right) at the 1989 Comic-Con International in San Diego.*

drawings in front of the audience. "We used to draw on these large pads, and those sheets were highly sought after by the students," he said. "Burne's [drawings] were beautiful, drawn in chalk with his trademark modeling."

Robinson always enjoyed teaching, although it was truly a case of burning the candle at both ends all during his years at SVA. He freelanced all day, whether on comics or illustration or later on his own cartoons and features. Then he taught four hours a night, five days a week.

Among Robinson's students were a variety of artists who gained a great deal of renown in comics, illustration, and commercial art. He found the young Steve Ditko, who would later co-create Spider-Man, to be very talented, and secured a scholarship for him to continue his studies at the school. Ditko later said, "Jerry Robinson was a great teacher for teaching fundamentals in how to tell/show comic book story/art. What one learns, knows from seeing, studying others' artwork, is mostly visual. But what one learns from a teacher like Jerry is how to use one's mind with solid comic book panel/sequence principles."

A number of Robinson's students later worked with him in his studio or at the Cartoonists & Writers Syndicate, which he established in 1977. (See the chapter "Cartoons for International Understanding," page 171.) Among those students were Steve Flanagan, who later became a fine painter and art director for a major publisher, and Bob Forgione, who became a creative director at a big ad agency. Other students under Robinson's tutelage were successful in various comics genres: Stan Lynde created the popular syndicated Western strip *Rick O'Shay*, which he wrote and drew from 1958 to 1977; Don Heck co-created the comic book hero Iron Man, with Stan Lee; Dick Hodgins Jr. was a versatile talent, working as both a political cartoonist and illustrator of Hank Ketcham's Navy comic, *Half Hitch*; Jack Abel became a comic book artist and one of the most versatile inkers in the business, credited with hundreds of stories, including many issues of *Superman* and *Iron Man*; Stan Goldberg, already a prolific colorist, went on to draw many teen and romance comics, including decades of work on *Archie*; Marie Severin worked on major features such as *The Incredible Hulk*, *Sub-Mariner*, and *X-Men*; Mort Gerberg became a noted *New Yorker* cartoonist; Daryl Cagle became a widely syndicated political cartoonist; and Eric Stanton, who shared a studio with Steve Ditko for several years, pursued one of the more unusual careers in comics. Stanton is probably the most famous and widely published bondage and domination cartoonist in the world. Robinson remembered him as a talented student who needn't have drawn erotic comics—he could have mastered any part of the field—but "he found success there, and so he pursued it."

Robinson's students weren't the only young people around him at this time. He and his wife, Gro Bagn, whom he had married in 1955 (artist Wally Wood was their best man), had started a family. Their children, Kristin and Jens, influenced Jerry's decision to start doing artwork for kids' books and

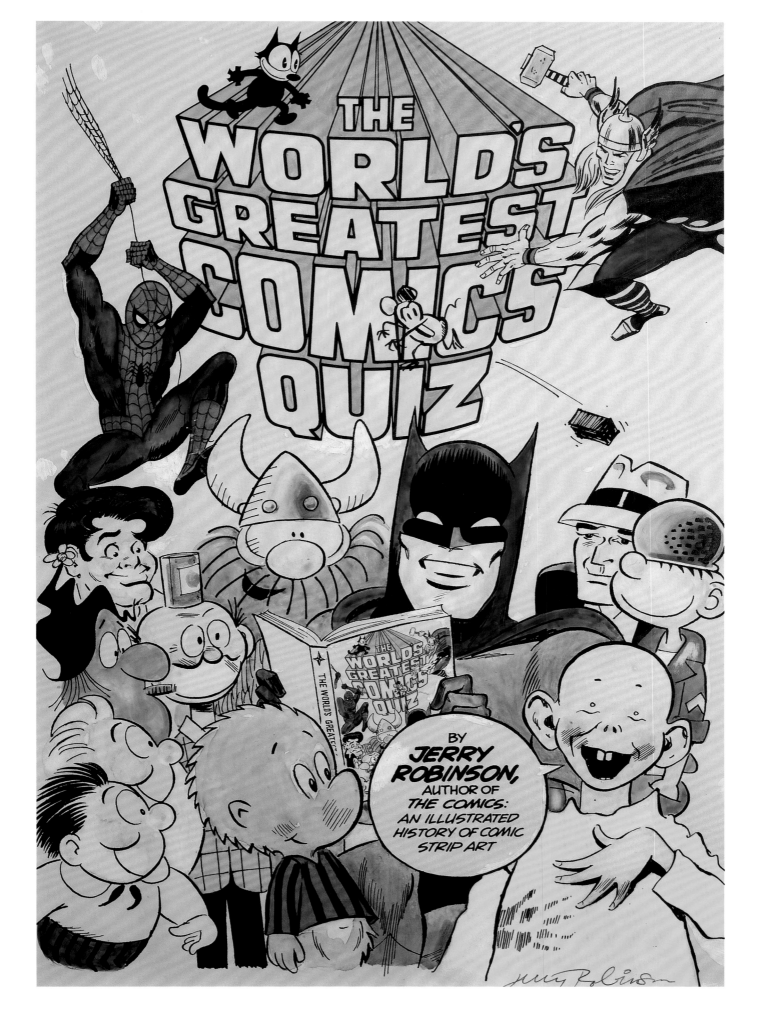

magazines, another growing field for artists at this time; Jerry's son and daughter became his favorite models.

The 1950s and 1960s were a golden age for the publication of children's books. Americans were better educated than ever, the parents of the baby boomers bought tons of books and magazine subscriptions for their kids, and juvenile publishing was booming. Many of Robinson's most satisfying illustration assignments were in the field of nonfiction books for younger readers and children's magazines. Robinson remembers, "I did some work for children's magazines published by Scholastic, and *Parents* magazine." He received many commissions for interior illustrations, "mostly black-and-white drawings and wash." Robinson also wrote and chose illustrations for a history of comics published in *Children's Digest* in 1967 when he was president of the National Cartoonists Society (1967–69); and he wrote a history of comics for a stamp magazine. These were a portent of things to come, because Robinson would later become one of comics' foremost historians.

Although he enjoyed drawing for magazines, these jobs always had tight deadlines and usually involved only one or two illustrations per story. Book commissions often called for a dozen or more illustrations, done over a period of weeks or months. Robinson found this kind of work more artistically satisfying because it gave him the scope to create a particular look or style appropriate to the book's subject matter, and to develop a narrative and characters in the series of illustrations.

Robinson took a great deal of time and care with his book illustration. He remembered how important illustrated books had been to him as a child, and he put as much effort and attention into his work as possible. In addition to careful historical and visual research, he tried to make the pictures visually rewarding. He was particularly adept at creating extraordinary depth in his images, probably because of his training in comics. Robinson wanted to create illustrations that would carry the reader away to the time and place being depicted and, knowing that kids often read and reread illustrated books, as he had done himself, he wanted to create images that would remain visually exciting through repeated viewings.

As a children's book illustrator, Robinson specialized in history, biography, and science books. Two of Robinson's best works in the illustration field were on Abraham Lincoln and on the Civil War. *Abe Lincoln, Frontier Boy* (Bobbs-Merrill Company, 1959) was a children's biography of Lincoln, concentrating on Lincoln's boyhood. "Of course, I'd read Sandburg's biography of Lincoln," Robinson recalled. Reading Carl Sandburg's masterwork gave Robinson a feeling for Lincoln and his life. "I always researched everything carefully, but I particularly enjoyed doing this one," he said. "It was a pioneer story. And I had a young son of my own, so that gave it added interest." One of the most moving illustrations in Robinson's *Abe Lincoln* shows young Abe asleep, curled up on a hard wooden bench.

PREVIOUS SPREAD LEFT, TOP TO BOTTOM: *Gro Bagn, Jerry Robinson's wife, is a graduate of Columbia University, and has worked as a journalist in Norway, and a museum curator and psychotherapist in New York. (1970s)*
Tatyana Wood, comics artist Wally Wood (who served in Jerry's wedding as best man), Gro Bagn, and Jerry Robinson in the 1950s. Jerry Robinson shot these two photographs of his young children: Jens collects seashells at the family home in Cape Cod; a pensive Kristin poses in a summer hat. (1950s)

PREVIOUS SPREAD RIGHT: *Robinson's original pen-and-ink and watercolor for the cover of* The World's Greatest Comics Quiz *(Tempo 1978), a book he also wrote.*

ABOVE: *A cartoon from* Science Teasers, *illustrated by Jerry Robinson and written by Rose Wyler; published by Harper & Row (1966).*

Some years later, Robinson had the opportunity to meet Lincoln's biographer in person. He was invited to an intimate evening at the Bronx home of a fellow cartoonist, Gregory D'Alessio, and his wife, Hilda Terry; Carl Sandburg was the guest of honor.

Two Flags Flying (Platt & Munk, 1960) contains a gallery of Civil War portraits. All of the major political and military leaders appear in pen-and-ink illustrations by Robinson, again the product of a large amount of research. "This was in the days before the Internet, of course," recalled Robinson. "It took many months to track down images of all these Northern and Southern generals and politicians." Perhaps the best are the portraits of Lincoln, late in his presidency and weary from the war, and General William Tecumseh Sherman, a stark drawing that captures his iron determination.

Robinson's illustrated biographies included contemporary as well as historical figures. In addition to the book on young Abe Lincoln, he illustrated a boyhood biography of a famous baseball player, *Lou Gehrig, Boy of the Sandlots* (Bobbs-Merrill Company, 1959). When Jerry drew illustrations for a biography of the young Mozart, he adopted a fluid brush style that captured some of the elegance of the Romantic period.

He returned to presidential topics in *Let's Go to the White House* (G. P. Putnam's Sons, 1959), part of a series about kids visiting famous or interesting places. "When they asked me to do a book in the series, they gave me a list of places; as soon as I spotted the White House, I said 'I'll illustrate that one,'" Robinson remembered. The book shows a little boy and a little girl touring the rooms, with historical drawings mixed in. "My daughter, Kristin,

ABOVE LEFT: *Robinson's sketch of Carl Sandburg, the Pulitzer Prize–winning poet and Lincoln biographer (c. 1955)*

ABOVE RIGHT: *Robinson met Carl Sandburg at a private party and took this photograph of the famous poet with Jerry's young daughter, Kristin. (c. 1955)*

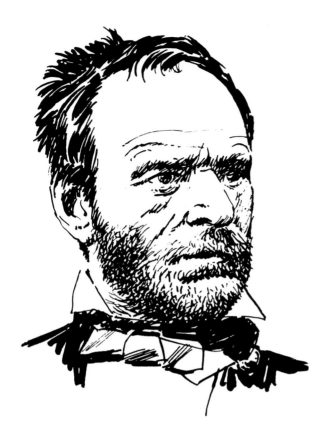

ABOVE: *Two of Robinson's pen-and-ink portraits from the book* Two Flags Flying *(Platt & Munk, 1960): General William Tecumseh Sherman (left) and President Abraham Lincoln (right)*

was about eight or ten at that time. She posed for the little girl, and the son of our apartment building's super posed for the boy." Robinson did his usual meticulous research in order to faithfully render the rooms in the presidential home. But it wasn't just the historical interest that drew him to the book. "I chose the White House book because I thought it would be the most interesting," Robinson said, "and because it also looked like it would have longer legs. The book sold well for a number of years, until Jacqueline Kennedy redid the White House. I think she ruined me!" joked Robinson.

Two of Robinson's books for children are part of the technological confidence and optimism of the 1950s, and parallel his work on the near-future science-fiction comic strip *Jet Scott. A Maxton Book about Atomic Energy* (Maxton Publishers, 1959) has one of Robinson's most striking color paintings as its cover. His research this time included sketching at the Brookhaven National Laboratory on Long Island, a key site in the Manhattan Project and a major player in the development of atomic energy.

One of Robinson's most complex series of illustrations was executed for *Moon Trip: True Adventures in Space,* by William Nephew and Michael Chester (G. P. Putnam's Sons, 1958), a book that projected the technology needed to explore the moon. Robinson created convincing lunar landscape paintings by using striking black-and-white contrasts and loading the paint with sand, building up the impasto to get the effect he wanted. Robinson

LEFT: *Robinson's drawing of Mozart as a young boy for a children's biography of the composer*

TOP: *A drawing from* Let's Go to the White House *(G. P. Putnam's Sons, 1959), illustrated by Jerry Robinson*

BOTTOM: *Robinson's pencil illustration of frontier life for a children's magazine published by Scholastic Inc. (1960s)*

recalled a humorous moment when his editor looked at his paintings and said, "That's not what the surface of the moon looks like!" He and Robinson then both realized at the same moment that *no one* knew exactly what the lunar surface looked like in the kind of detail that was presented in his paintings. (At the time, the moon had only been seen from telescopes; it would be years before probes would shoot close-up photographs of the moon's surface.)

Generally, in book illustration, an editor often pairs writer and artist, and the work goes through that editor. But in one case, Robinson worked in a real collaboration on an educational project, creating a new and memorable character.

Rose Wyler had developed a reputation as one of the best educational science writers by the time she met and began to work with Jerry Robinson in the mid-1960s. Many of Wyler's books were written with her husband, Gerald Ames, including the very popular Golden Books titles *The Giant Golden Book of Astronomy* (Simon & Schuster, 1956) and *First Days of the World* (Harper & Brothers, 1958), on paleontology. Wyler and Robinson were both based in New York, and both spent summers on Cape Cod. Together they created a book character named Professor Egghead for a book of science riddles. Professor Egghead looked a bit like Humpty Dumpty with a mortarboard perched atop his dome; "he was meant to make science fun and engaging for kids," Robinson said. "Rose had an amazing talent for making complex scientific ideas understandable to children, and when we worked together, I wanted to make sure the illustrations had the same quality."

ABOVE: *Robinson's illustration of Albert Einstein and his famous equation for* A Maxton Book About Atomic Energy *(1959)*

OPPOSITE: *This example of Robinson's color art in mixed media for* Atomic Energy *captured the futuristic outlook and excitement of the time.*

Both have oil inside.

PREVIOUS SPREAD: *In* Moon Trip: True Adventures in Space *(G. P. Putnam's Sons, 1958), Robinson visually imagined what astronauts would find on the lunar landscape—information unknown at the time. Mixed media.*

ABOVE AND OPPOSITE: *These three illustrations by Robinson capture the wit and humor of* Professor Egghead's Best Riddles *(Simon & Schuster, 1973). Also shown: Robinson's cover design and illustration.*

Professor Egghead's Best Riddles was published by Simon & Schuster in 1973. "We had a lot of fun with the illustrations," Robinson recalled. "One of the topics was inventions, so I had Professor Egghead build an invention machine. It duplicated itself, and the illustration was filled with tiny invention machines." When Robinson and Wyler started collaborating, they visited schools to do presentations. They tried out the concept for their new science book. "I had conceived the Egghead character as a way to give the book continuity, the key to bringing the whole book together. I drew a picture of him with several names written below it, and we asked the kids to vote on the best name," Robinson recalled. "Before we could even take a vote, the kids were shouting, 'Professor Egghead!'"

Robinson also illustrated book covers, and these commissions called on his skills both as artist and designer. For a paperback edition of Jane Austen's *Pride and Prejudice* (Scholastic, 1962), he produced a striking image. His most important book cover commission was for a science fiction novel that became a classic. Author Robert Heinlein had written a hugely successful series of juvenile science-fiction books. *Starship Troopers* (G. P. Putnam's Sons, 1959) was Heinlein's first trade hardcover book for adults. Robinson's

What factories make products
—that cut down pollution from cars?
—that go underwater without getting wet?
—that use nothing to do something?

elegant and modern cover design helped position the book as a work for more mature readers. *Starship Troopers* won the Hugo Award for best science-fiction novel in 1960, and was later made into a movie by Paul Verhoeven (1997).

One of Robinson's most pleasurable illustration assignments, creating drawings of Broadway shows for *Playbill*, also called on his skills as a designer. *Playbill* is the magazine that functions as a program for all Broadway plays and musicals, as well as for some off-Broadway productions. The copies of *Playbill* distributed at each theater include the program, credits, creator and actor bios, and background on the play or musical being performed. But all *Playbill*s have other editorial material that changes every month, just like a magazine. In 1980, the editors of *Playbill* invited Jerry Robinson to do a monthly feature on current Broadway productions. For each installment in the series, called *Theatre Life with Robinson*, Jerry attended shows and rehearsals, drew multiple images of the cast, and then combined the best of them into pages that looked like they'd been torn from his sketchbook.

"*Playbill* would give me two seats up front for my wife and I. Then I'd go backstage during the week to sketch the principals. I'd also sketch them during rehearsals. I could see the show several times from backstage."

The late 1970s/early 1980s was a great time for Broadway theater, with shows ranging from the original production of *Evita* (1979–83) with the new sensation Patti LuPone, to *Sugar Babies* (1979–82), a wonderful nostalgia special starring two giants of show business, Mickey Rooney and Ann Miller. In addition to musicals, *Theatre Life with Robinson* also featured well-reviewed dramas such as *The Dresser* (1981), starring Tom Courtenay; *Nine* (1982), starring Raul Julia; and *Gemini* (1981), whose unusual set led to a memorable drawing. "The *Gemini* set was a backyard of a tenement," Robinson recalled.

"So I decided to use the set as a montage, and have all the characters, the principals, as the residents of the building; one of them was Wayne Knight, who later played Newman in *Seinfeld*."

Rehearsals were probably the best time to capture some of the qualities of musicals, especially those with elaborate choreography. For example, one of Robinson's favorite *Playbill* drawings is of Gregg Burge, the immensely talented dancer who starred in the musical *Sophisticated Ladies* (1981), based on the life and music of Duke Ellington.

One of the liveliest musicals Robinson covered was *Ain't Misbehavin'* (1978–82). Like *Sophisticated Ladies,* it was based on the life and music of an African-American artist, in this case the jazz pianist and composer Fats Waller. "It was a fun show," Robinson recalled, and he made one of his most expressive illustrations from his seat in the audience. He drew Luther Henderson playing Waller at the piano onstage, a key image in the musical. "I remember the number he was playing when I drew that," Robinson said: "'(What Did I Do to Be So) Black and Blue.'"

If Robinson wanted to see the stars one-on-one, he would usually make an appointment to meet with them in their dressing rooms. "I don't think I encountered anybody who didn't want to have me draw them. They loved having my illustration as a memento, and they knew it would be in *Playbill*," Robinson said. "I would try to engage them in interesting conversation, so I could keep them riveted while I drew. I looked up their careers and saw what they were interested in so I could talk to them about it. There's nothing actors like to talk about more than themselves." Even so, Robinson had to work quickly, he remembered, often completing his sketch in less than five minutes: "Ten minutes was a lot, fifteen minutes was the most I would do."

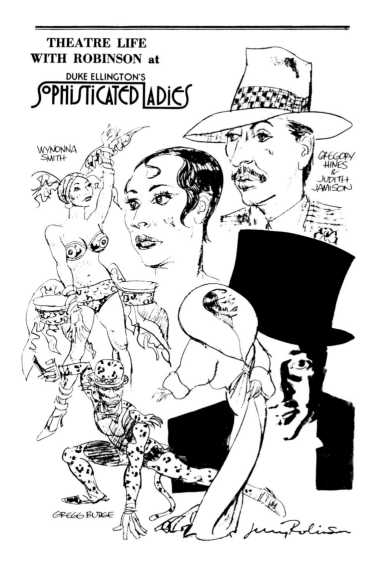

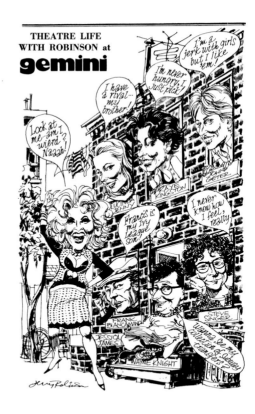

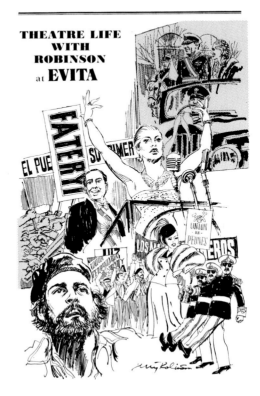

ABOVE AND OPPOSITE: *Jerry Robinson's monthly feature for* Playbill, Theatre Life with Robinson, *covered Broadway hits such as* Sophisticated Ladies *(1981),* Gemini *(1981),* Evita *(1979–83), and* Nine *(1982).*

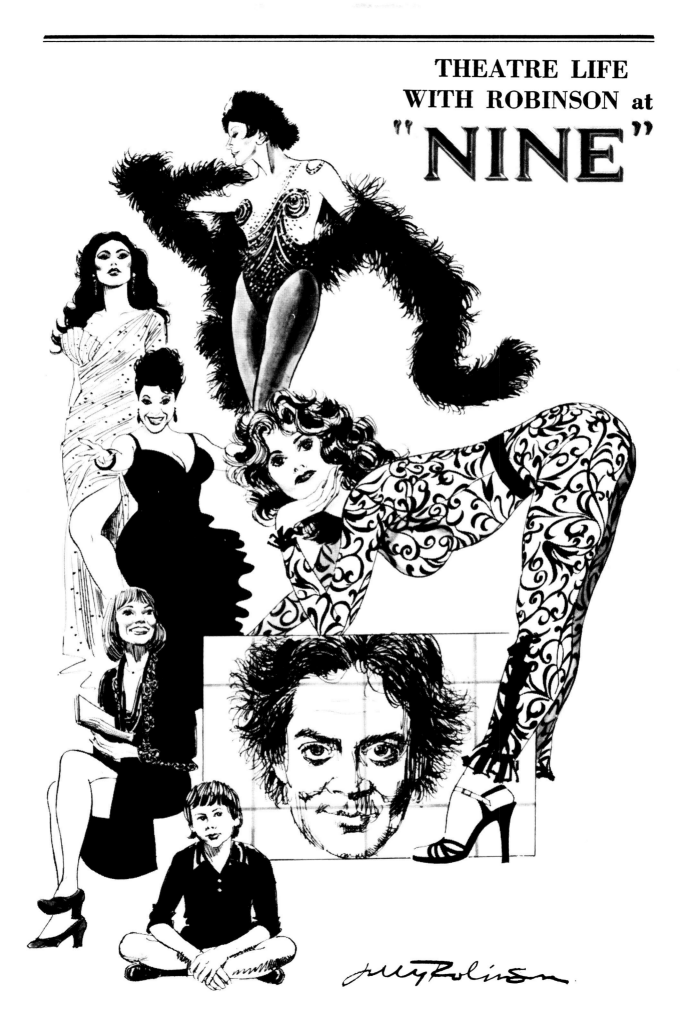

Robinson enjoyed meeting the stars, of course, but sometimes not the ones who were in the play. He was assigned to *Romantic Comedy* (1979), starring Mia Farrow: "I'm in her dressing room, making several sketches, and there's a knock on the door, and it's her mother, Maureen O'Sullivan. That was a big thrill." (Maureen O'Sullivan was Jane in *Tarzan the Ape Man* and several of its sequels.) "I remembered Maureen O'Sullivan from when I was a kid. She was the dream girl of my generation. She was lovely," Robinson said.

Ann Miller, the star of *Sugar Babies,* was another idol to several generations. "That was the second play I covered. *Playbill* ran several pages of my drawings," Robinson recalled about the assignment. "Ann Miller was still gorgeous. She was in her dressing room, just sitting in her chair with her stockinged legs showing to best advantage." Robinson had researched Miller's career, but he noticed something in her dressing room that surprised him. "When I walked in, I saw lions of all kinds: tapestries, toy lions, pictures, and so forth. So I asked, 'How come all the lions? I can't remember you being in a movie with lions.' I had read all her credits and felt sure I would have remembered a jungle picture or something."

Miller answered in her sweet, high-pitched voice: "Oh, no. The lion is my favorite animal because a lion saved my life once."

Robinson, puzzled, asked, "What movie was that?"

Miller nonchalantly answered, "That was in Egypt, 3,020 BC."

As the star went on to tell Robinson the whole story of the lion saving her life in ancient Egypt, Jerry realized Miller believed in past lives. Miller followed with the story of her life during the Spanish Inquisition! "I was speechless!" Robinson said.

Mickey Rooney, Miller's costar in *Sugar Babies*, was an equally interesting character to draw. Rooney was, of course, a Hollywood star, perhaps most famous for his musical turns with Judy Garland in the Andy Hardy films. *Sugar Babies* was his Broadway debut.

OPPOSITE: *This drawing of Gregg Burge, star of* Sophisticated Ladies *(1981), is one of Robinson's favorites. Robinson sketched it while Burge rehearsed.*

ABOVE: *Robinson sketched Mia Farrow as well as Tony Perkins (not shown), the leads in* Romantic Comedy *(1979)*

Rooney was a perfect example of one problem Robinson ran into from time to time: The actor wouldn't sit still in his dressing room long enough to be drawn. Robinson finally figured out a way to make Rooney pose. He handed him a sort of Lord Nelson hat that was there, and sure enough, Rooney posed as if in the spotlight, and in five minutes, Robinson was able to capture a spirited likeness.

OPPOSITE AND ABOVE: *These portraits of Ann Miller and Mickey Rooney, who posed in their dressing rooms, were later released as numbered limited edition prints, each of which was signed by the actors as well as by Robinson.*

JET SCOTT

SHELDON STARK
JERRY ROBINSON

IN A DARING ATTEMPT TO RESCUE A PILOT 250 MILES ABOVE THE EARTH, JET PREPARES TO LAUNCH A THREE-STAGE ROCKET!

I HEARD HIM ANSWER!

NOTHING NOW! TRY HIM AGAIN!

AL! PLEASE, DARLING THIS IS GINGER, YOUR WIFE! THIS IS GINGER

GINGER? GUESS I BLACKED OUT, CAN'T REMEMBER WHERE I--- NO!

CARTOONS, COMICS, AND OP-EDS

As a children's book illustrator, Jerry Robinson had taken his young readers on a voyage to the moon. He had introduced kids to the marvels of atomic energy with his drawings of the nuclear lab at Brookhaven, Long Island. But his most sustained exploration of the scientific future was an all-but-forgotten science-fiction comic strip. This strip, *Jet Scott,* captured the aesthetics of some of the fine art of the day, bringing to the newspaper comics pages the kind of technological expertise found in the work of the best science-fiction artists.

Jet Scott, the eponymous star of the comic strip, was a cool action hero, a James Bond type who appeared in 1953, the same year as the first of Ian Fleming's Bond books. Jet Scott was an investigator for the top secret Office of Scientifact in Washington, D.C. He is sent out to solve cutting-edge science-based mysteries and prevent technological threats from endangering the country and its citizens.

The *New York Herald Tribune,* famed as a writers' newspaper, had its own syndicate, which included comics, but it didn't have the kind of well-known strips that the older syndicates had gathered over the years, such as King Features Syndicate's *Flash Gordon* or the Chicago Tribune–New York Daily News Syndicate's *Dick Tracy.* In the mid-1950s, the *Herald Tribune* was expanding its comics page and adding more action and adventure strips to the humor and kid strips it had been running.

The editors at the Herald Tribune syndicate came up with the idea for a science-fiction strip that would express both the thrill and the threat of atomic power, rockets, experimental jets, and other technologies that were so much in the news in the 1950s.

OPPOSITE: *This* Jet Scott *Sunday comic strip, which appeared on June 5, 1955, reflects the fascination with space and technology in the 1950s.*

The Herald Tribune sought creators. "I began *Jet Scott* when I got a call from the syndicate. They knew my work, and they wanted me to collaborate on the new strip," Robinson recalled. "They forged the partnership with Sheldon Stark and myself." Stark was a prolific scriptwriter who had begun in radio, providing scripts for *The Lone Ranger, Lux Radio Theater,* and *Studio One.* Stark made the transition to TV, writing scripts for some of the anthology series that were hallmarks of the golden age of television drama in the mid-1950s, including *Armstrong Circle Theatre, Matinee Theater,* and *Climax!*

Robinson made every effort to make *Jet Scott* unique: "It wasn't a futuristic strip. It was contemporary science fiction." In literary science fiction, these would be called near-future stories, fiction that pushed the edge of contemporary science and technology. Jerry brought a singular vision to *Jet Scott.* His storytelling mastery had been forged in comic books, especially as he worked with artists like Mort Meskin, developing new techniques for comic narrative and a whole new visual language for telling exciting stories. He was already an accomplished science-fiction artist, having brought to life a variety of otherworldly scenes in the pages of various science fiction comic books. And of course, he had also mastered action and adventure comic art, through drawing *Batman.*

"*Jet Scott* was a real adventure strip, which took a lot of research," Robinson explained. Robinson was meticulous about the technological aspects and details of every strip, whether it was set in New York or New Zealand, undersea or on the edge of space. "If the story required a new radar gun, I would invent one," he explained. One of them turned out to look just like a radio telescope, which was developed years later. "I drew a big dish with a cone in it, because I figured the signals needed some focal point." Robinson's technological depictions ranged from a giant solar concentrator on the sands of Saudi Arabia to rockets flying over the Bering Strait, to spacesuited flyers at the very highest altitudes.

Jet Scott was widely syndicated very quickly. "Within the year, we were in seventy-some papers, mostly top newspapers. We did well, we made our guarantee, and the rest was all gravy," Robinson said, referring to the minimum number of newspapers that had to take the strip for the syndicate to consider it successful. "*Jet Scott* was popular in England and Australia, where it was also syndicated," Robinson added.

"Sheldon, who was in Hollywood, would send out the story ideas to me in New York and we'd discuss them; then he would write the full script. Sheldon's scripts were good, but I had to rewrite them to some extent for our daily strip and Sunday page formats." Although this was his first full-fledged comic strip, Robinson's long experience in comic books and even his college studies in writing and journalism were invaluable now. The pattern of syndication made the writing complicated: "Some papers ran the daily only, some ran the daily and Sunday, and some ran *Jet Scott* only on Sunday. So we had a

PREVIOUS SPREAD: *An original Robinson pencil drawing for a 1955* Jet Scott *strip*

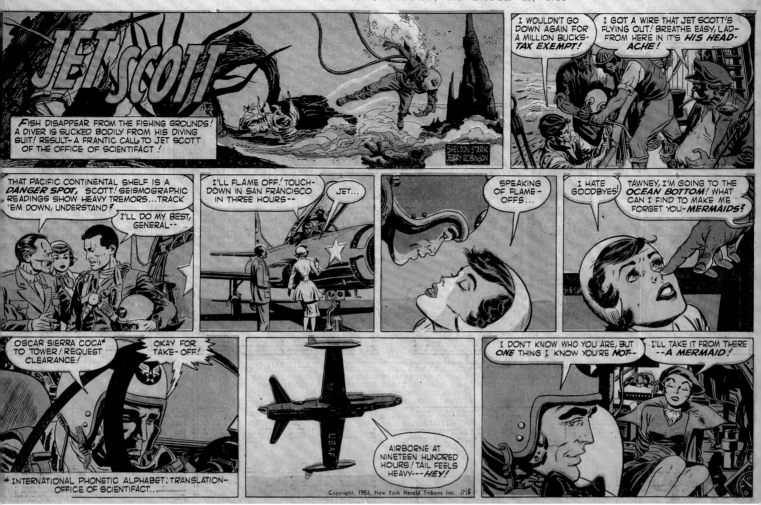

continuity, a story, that had to read from Sunday to Sunday without the dailies, and also make sense in the dailies both with and without the Sundays."

Despite these difficult logistics, Robinson appreciated Stark's inventive ideas for the *Jet Scott* storylines, and they began working together on characters and concepts even before the strip launched. Robinson enjoyed the collaboration and the diversity of storylines in the scripts, but the schedule was grueling. "*Jet Scott* was done in a very realistic style. It was quite a job. I couldn't take a day off, or I'd fall behind. We never had enough in the bank to take any time off," Robinson remembered, referring to the number of strips completed in advance of publication. "We started off with two weeks' worth of strips and after that I could never get ahead. I would pencil all the weekly strips first, then ink them. Then I did all the penciling and inking, and even the color guidelines, for the Sunday page—everything on every comic, except the lettering."

Robinson's *Jet Scott* strip breathes the atmosphere of 1950s art in a way few other comic strips ever did. Robinson's sense of modern design and abstraction makes each strip a powerful composition, particularly in his color strips on Sundays. His pictorial space and the sometimes-stark design of the characters and backgrounds have a rhythm that recalls jazz

ABOVE: Jet Scott *Sunday comic strip,*
November 15, 1953
Pencils, inks, and colors: Jerry Robinson

or Abstract Expressionist painting. The cityscapes of Stuart Davis or the jazz-inflected late compositions of Piet Mondrian are never far from Jerry's artistic awareness.

Working for a relatively small syndicate, Robinson had nearly full creative control over *Jet Scott*. He used this freedom to create his own vision of what a comic strip should be. "The Herald Tribune syndicate would send out promotional materials for each new story," Robinson recalled, an unusually supportive procedure for a strip. "The promos would contain two or three weeks of the new continuity," he explained. The brochures also contained background material on the creators and on the science in the *Jet Scott* stories. These efforts both encouraged the newspapers that were already running the strip to keep promoting it to their readers, and helped sign up new papers for syndication.

"I was determined to do the strip entirely by myself," said Robinson. But in the end, the huge workload just proved too burdensome. "After two years, it seemed we had reached a plateau in the number of papers that were going to run the strip," Robinson noted. So after two years, *Jet Scott* was grounded.

Jet Scott ended in the fall of 1955. Little did anyone realize that the issues of near-future technology, science fiction, and space exploration were just about to play a major role on the world stage. "The irony is, of course, we stopped just before *Sputnik*," Robinson said, referring to the first artificial earth satellite, launched by the Soviet Union in 1957. *Sputnik* led to the space race and the rush to put a man on the moon. "If we had kept going, we could have probably doubled our syndication list. But the strip was not all I wanted to do," Robinson added. "*Jet Scott* could have been the premier science-fiction strip, but it didn't leave me time to do anything else." (*Jet Scott* lives on, however: In 2010, Dark Horse Comics reprinted the full two-year run of the strip.)

In 1964, Robinson created and illustrated a new comic strip that would appeal to an all-ages audience. He called his brainstorm *Flubs & Fluffs*. It featured humorous errors sent in by teachers, parents, and students. Long before blooper reels became popular on TV, Robinson figured out that everyday errors, combined with witty cartoons and comments, could appeal to adults and children. The full name of the strip was *True Classroom Flubs & Fluffs,* and Robinson felt that was the key: The errors and comebacks had to be true.

Flubs & Fluffs was about making a mistake and then trying to put the best face on it. Gro Bagn, Robinson's wife, played a crucial role in naming the cartoon feature. In fact, Robinson credits a story she told him with the genesis of *Flubs & Fluffs*. At the time, Gro was curator of cultural history at the Brooklyn Children's Museum (the first children's museum in the United States). In addition to planning exhibits and lecturing, she spent many hours in the museum with children. One weekday she saw a grade-school boy whom she recognized. She asked him, "What are you doing in the museum at

OPPOSITE: *A Robinson* Flubs & Fluffs *original from 1984*
Script, pencils, and inks: Jerry Robinson

thanks to:
Mrs. William Moose
Box 34432
Bob Jones University
Greenville, S.C.

"After lying in the attic for five years, my grandfather finally fixed the chair."

"Socrates died from an overdose of wedlock."

"W.C. Fields was the man who laid the first Atlantic cable."

"Ionic, Doric, and Corinthian were three brothers in ancient times."

A third grade nature study class: "Lizards and comedians are pretty much the same."

PREVIOUS SPREAD: Flubs & Fluffs *strip,*
April 7, 1968
Script, pencils, inks, and colors: Jerry Robinson

THIS SPREAD: *Individual cartoons
that were used in the* Flubs & Fluffs *feature in
the 1970s and 1980s*

"There are many caterers on the moon."

"Leonardo da Vinci painted the Moaning Lisa."

"Brahms' alibi is considered a masterpiece."

"George Washington was one
of our floundering fathers."

this time? You should be in school!" The boy said that he didn't have to be in school that day because it was a Jewish holiday. "But you're not Jewish, are you?" Gro asked him. "Well, I'm Jewish spiritually," he answered. Robinson thought that was a charming story, and asked Gro to tell him about anything else like this that happened at the museum. Eventually, Jerry used Gro's anecdotes to work up the presentation that led to *Flubs & Fluffs*. The name was the final piece of the puzzle, Robinson recalled: "It was chosen for its alliteration. Once I had that, it was much like with the Joker or [the editorial cartoon] *Still Life;* it all fell into place."

Robinson pitched the idea to the comics editor at the *Daily News,* the New York tabloid newspaper that had one of the best and most extensive comic strip sections in the country. *Flubs & Fluffs* was soon running in the *Daily News*'s Sunday funnies. As *Flubs & Fluffs* gained in popularity, the contributions mailed in by readers from all over the country were at times overwhelming: "I got up to fifteen hundred letters a week. I'd come back from the *Daily News* with a huge canvas mailbag full of them. They said I was getting as much mail as the president of the United States." Robinson's whole family pitched in sometimes to sort through the mail. "I had so many letters to read through to find ones that would work," Robinson said. "The 'flub' had to be something I could illustrate, and I didn't just draw the mistake in and of itself; the whole picture had to have visual humor."

OPPOSITE AND ABOVE: *Individual cartoons that were used in the* Flubs & Fluffs *feature in the 1970s and 1980s*

ABOVE: *Jerry Robinson and his young son, Jens, sorted through thousands of reader contributions for* Flubs & Fluffs *each week. (1960s)*

OPPOSITE: *Original for a* Flubs & Fluffs *"Classic Flubs" page (c. 1980)*

Flubs & Fluffs is still a fond memory for many readers. "Each cartoon had a notice next to it, thanks to so-and-so who sent it in, so they'd get their names printed in the paper," said Robinson. "For years and years after, I'd have people write me, telling me they still had the page with the humorous mistake they'd sent in." And while the strip was for the most part limited to the *Daily News,* at the time it was running, the *News* had a circulation that actually extended far beyond the city. "At that time, the circulation of the *Daily News* was a million copies a day, and the Sunday circulation was even higher," Robinson remembered. "People all over the world got the *News,* because it had such a great comics section. The comics were bigger then— *Terry and the Pirates, Dick Tracy*—people everywhere wanted to read the paper with these strips. I remember getting contributions from Pakistan, South Africa, everywhere."

Flubs & Fluffs was given a half page in the *Daily News*'s Sunday comics section, and Robinson had unusual freedom in designing his cartoon. Most Sunday comic strips are confined to a grid system, so the comic can be printed in different configurations in different newspapers. Robinson noted, however, "I could break it up any way I wanted. It was kind of a first." He could use the entire half page as his design area, and that gave him the freedom to include as many or as few figures, in whatever configuration he

"The couple got married and lived hippily ever after."

You can call yourself Maharishi but I'm still married to Seymour Fenster!

ABOVE: *This* Flubs & Fluffs *cartoon shows the influence of the 1960s counterculture.*

wanted, depending on what was best to convey the idea. "*Calvin and Hobbes,* by Bill Watterson, was really the first strip after *Flubs & Fluffs* not to use that standard grid," Robinson added.

Jerry Robinson became something of a local celebrity: "I was invited to a lot of schools while I was doing the strip. The kids loved to hear all the mistakes." Robinson was even invited to help organize a citywide *Flubs & Fluffs* educational supplement for the paper. Two collections of *Flubs & Fluffs* were published by Scholastic Inc. in 1966 and 1970 and one by Fawcett in 1966.

Like many newspaper strip cartoonists, Robinson would get to do some special, seasonal contributions to the funnies: "The regular, weekly *Flubs & Fluffs* strip was a half a page but several times a year, I would do a full page, particularly around holidays. Once in a while, I'd even do a double page. I did that a couple of times in the *Daily News.* That was unprecedented in the comics pages!" *Flubs & Fluffs* ran for fifteen years, from 1964 to 1979, when Robinson gave it up to concentrate on editorial cartooning.

Long before comic strips appeared in Sunday supplements in the 1890s, newspapers had featured cartoons about politics and social issues. American

political cartooning began with Benjamin Franklin, most famously his drawing of a dismembered snake representing the American colonies with the caption JOIN, OR DIE. (1754).

Jerry Robinson has always been intensely interested in politics. For a cartoonist, editorial cartoons are the most natural form of political expression, but it's an extremely difficult field to break into. But Robinson found a way; he turned a crisis in New York journalism into an opportunity to start a new career.

In 1962, New York City had a dozen major daily newspapers, including three that still exist: the *New York Times,* the *Daily News,* and the *New York Post.* But at 2 A.M. on Saturday, December 8, 1962, the International Typographical Union's New York local went on strike at New York's four largest newspapers. The city's papers had formed their own publishers association to bargain with all the newspaper unions, and even the city papers that had not been struck shut down and locked out the unions. The longest newspaper strike in New York City's history began. For 114 days, until a settlement was finally reached on March 31, 1963, the greatest newspaper town in the country had no newspapers. Various publications appeared to fill in the gap, including a special issue of *Life* magazine, distributed only in New York, and interim newspapers published by several groups of journalists.

For five years prior to the strike, Jerry Robinson had been primarily doing book illustration. It was satisfying work, but he missed doing the kind of inventive, personal drawing that is really the province of comics and cartoons. From early in his career, Robinson's political awareness had had an influence on his work, for example the comic book hero London he created in 1941.

Robinson was an inveterate newspaper reader—after all, he'd begun college as a journalism major—and as a comic book artist and cartoonist, he had developed a deep knowledge of and appreciation for political cartooning. He admired the work of the historical masters such as Thomas Nast, the famous nineteenth-century cartoonist for *Harper's* magazine whose cartoons gave the Republican and Democratic parties their elephant and donkey symbols. He also admired contemporary editorial cartoonists, like Bill Mauldin at the *Chicago Sun-Times* and the *Washington Post*'s Herbert Block, famous under his pen name, Herblock.

Robinson read the interim newspapers during the strike and saw an opportunity to crack the editorial cartooning field. The traditional path for an editorial cartoonist in America usually included a long apprenticeship at a newspaper, often in a small town or city, then getting the attention of an editor in a larger market, and finally becoming the main cartoonist for a medium- or big-city daily. The art of the editorial cartoonist is in decline today, as fewer and fewer papers have their own artists creating original cartoons on local and national issues. But in the 1960s, there were about 150 newspapers across the country that had their own, full-time editorial

ABOVE: *Jerry Robinson in his studio on Cape Cod, Massachusetts (1970s)*

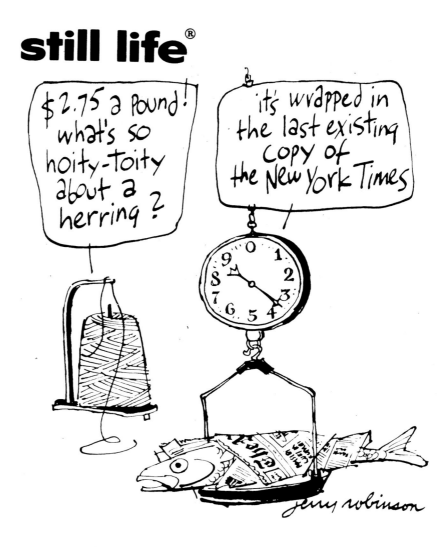

cartoonists. This represented a huge "farm team" from which the New York City papers could select artists, making it tough for newcomers to break in. Robinson wanted to get into the editorial cartoon field, which he thought he might enjoy and be good at, but he didn't want to leave New York, seek a job at another city's paper, and then come back. But there might be a way to break into the market strategically—and the strike, ironically, was the time to do it.

Today, local and nationally syndicated columnists, art and additional editorial cartoons, and even humorous writing appears on the op-ed page, the second editorial page of every newspaper. But in the early 1960s, virtually all newspapers had just a single editorial page. "I knew my cartoon had to be different to break into the editorial page," Robinson said of the challenge. "At that time there was only one editorial cartoon at the top of the page. So I knew, to run on the same page, my cartoon would have to be different from the paper's own editorial cartoon." Robinson decided to

still life®

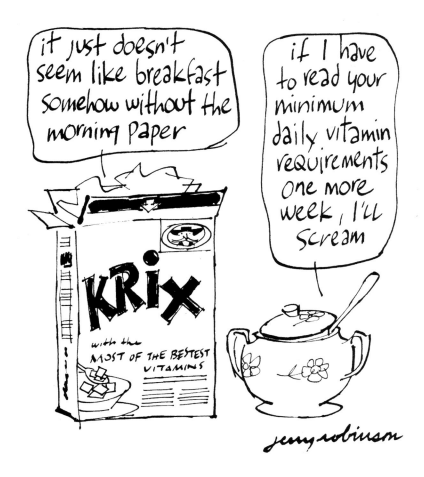

create a whole new feature. "I remember I went out on the balcony of my apartment with a sketch pad and drew my first cartoons for the presentation of the feature," Robinson said. "I had the idea of just using inanimate objects. I didn't have the name yet," Although other cartoonists would sometimes personify symbolic objects in their cartoons—Herblock, for example, created menacing anthropomorphized nuclear missiles—most cartoonists were the descendants of Thomas Nast and his disciples, like Walt McDougall and Frederick Burr Opper, who created unforgettable caricatures of politicians, industrialists, and other public figures. Robinson came up with the idea of using only inanimate objects to create cartoons that commented on politics and society.

Robinson succeeded in getting his cartoon placed in the *Metropolitan Daily*, one of the temporary papers published during the strike. If things worked out the way he hoped, if his new feature was successful, if people liked it, it could lead to a syndicated editorial cartoon.

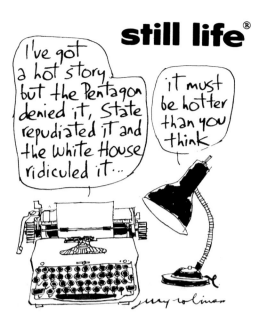

still life ®

I've got a hot story, but the Pentagon denied it, State repudiated it and the white House ridiculed it...

it must be hotter than you think

jerry robinson

ABOVE: *A daily panel from the 1960s; Jerry's wife, Gro Bagn, helped name* Still Life.

OPPOSITE TOP: *New York City, 1963: Jerry Robinson sits on a fire hydrant (an important* Still Life *"character") in front of a* Daily News *delivery truck advertising his popular cartoon.*

OPPOSITE BOTTOM: *Sadly and unknowingly prescient, this cartoon was the lead in Robinson's promotion piece for* Still Life—*which shipped a few days before President John F. Kennedy's assassination on November 22, 1963.*

Robinson scrupulously avoided any anthropomorphic objects: "What I didn't like was objects made into people. If I was going to use an object, I was going to make it palatable to me; that was the first thing I wanted to accomplish. So I tried to endow the drawings with personality. They were symbols, rather than talking chairs or lightbulbs." That emphasis on the symbolic was the key to the uniqueness of Robinson's cartoon—and its uniqueness was the key to Robinson's success.

Editorial cartoons don't usually have continuing titles; they're just identified by the artist's signature. But since Robinson's cartoon was going to be unlike the other editorial cartoon in the newspaper—and he hoped ultimately a syndicated feature—he needed just the right title, something that would signify its singularity. Robinson found the answer close at hand, "I think the thing that tied it together was the name, *Still Life.* That was Gro's solution," he said.

The brief run of Robinson's *Still Life* in the *Metropolitan Daily* during the strike attracted editorial attention. "At first, the *New York Post* wanted *Still Life,* but they wanted me to work on staff. I refused," Robinson recalled. "I wanted to preserve my own independence as a freelance artist." He decided to try to sell his new feature to the *Daily News.* He made an appointment with Richard Clarke, editor of the *Daily News,* and took samples of *Still Life* to show him. Robinson was surprised when Clarke told him that he had already seen it in the interim paper and really admired the feature. Clarke told him, "I would have approached *you* about running the feature, except that I assumed from something I read that you had already been picked up by a syndicate." For Robinson, it was one of the easiest sales of his career: "Before I left the office, I had a signed, one-page contract."

On Monday, June 3, 1963, *Still Life* debuted in the *Daily News,* running six days a week, Monday through Saturday. It became one of the features distributed by the Chicago Tribune–Daily News Syndicate (along with a roster of strips such as *Little Orphan Annie* and *Dick Tracy,* and columns and features by the *News's* writers.) Because *Still Life* was a syndicated feature, Robinson had to prepare his cartoon in advance of *Daily News* deadlines, so it could also be circulated to all the newspapers that subscribed to the syndicate.

Though nationally syndicated, *Still Life's* home was the *Daily News,* "New York's Hometown Paper," as it still calls itself, and the paper went out of its way to welcome the new feature. "The *Daily News* launched *Still Life* with a big promotion, with signs on all their trucks," Robinson remembers. For the first few weeks, the *News* ran the feature near the front of the paper, usually on page six. *Still Life* really stood out in the news pages, and helped get readers used to the idea of reading this unusual cartoon with no people, only objects with pithy, trenchant captions commenting on a variety of issues.

The Chicago Tribune–Daily News Syndicate signed up a number of newspapers across the country to run *Still Life,* but Robinson decided that,

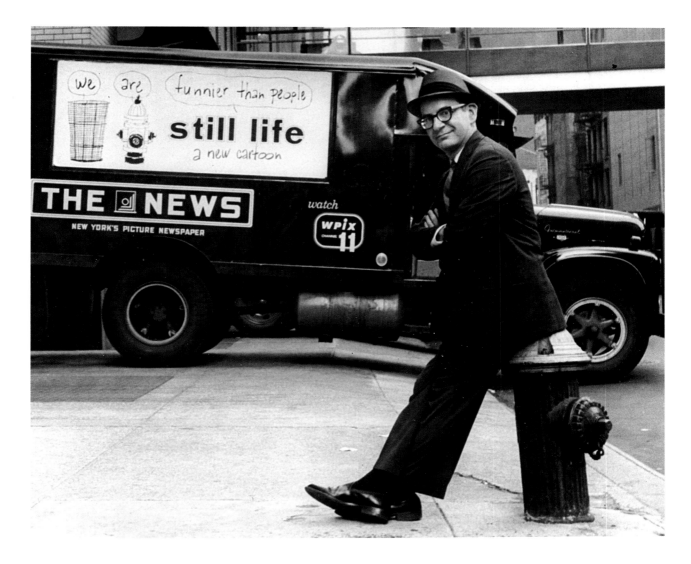

given how unusual the feature was, he would create and mail his own promotional booklet to editors, too. Robinson designed the promotion carefully, so it "gave you the scope and concept of *Still Life*." The booklet had a heavy stock, full-color cover, and crisply printed black-and-white cartoons inside; Robinson chose to lead off with a political cartoon, whose caption mentioned then-president John F. Kennedy. As Robinson described it, "The booklet was the result of weeks and weeks of work and we mailed it out in November 1963." Robinson remembers ruefully, "It arrived on editors' desks throughout the United States the day of the Kennedy assassination." Despite the unfortunate timing of this promotion, *Still Life* gradually attracted more and more subscribing papers.

In 1962, when *Still Life* first appeared, the Pop Art movement was still young. Pop Art took the mass media seriously in a way that "high art" was ill equipped to do. In a world where movies, photographs, and ubiquitous

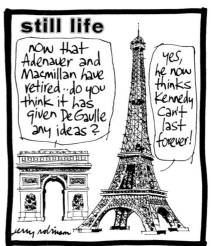

still life®

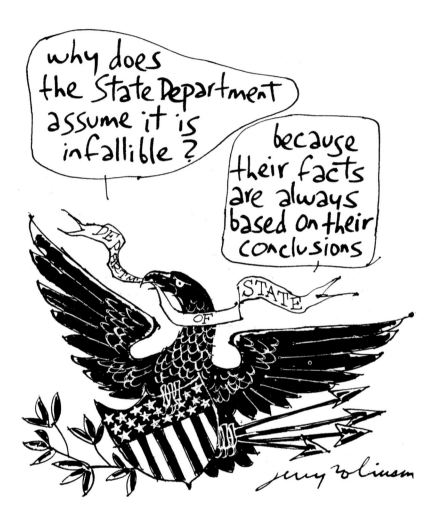

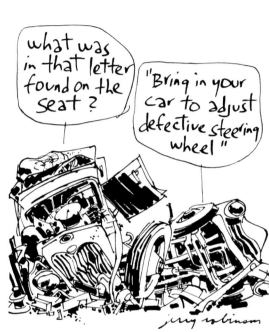

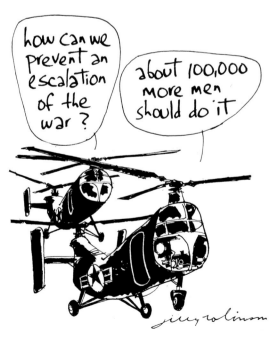

ABOVE AND OPPOSITE: *Robinson's use of stylized, but highly recognizable objects as spokes pieces for the punchlines in* Still Life *broke new ground in editorial cartooning. These* Still Life *cartoons were published between 1963 and 1977.*

still life ®

ABOVE AND OPPOSITE: *A collection of* Still Life *cartoons that shows Robinson's trenchant social and political humor (1960s–1970s)*

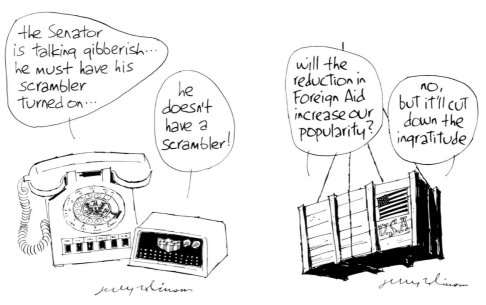

ABOVE, LEFT TO RIGHT: *Jerry's daughter, Kristin Robinson, artist Roy Lichtenstein, and Robinson at a Pop Art exhibition. Behind them is Robinson's assemblage inspired by* Still Life. *(c. 1969)*

advertising had become the dominant visual environment for most people, Pop Art explored a new iconography based on popular media. Technique itself became part of the exploration, from the painterly renderings of mechanically reproduced comic book images in Roy Lichtenstein's paintings, to Andy Warhol's silk-screened multiples using movie and advertising icons.

It was the perfect moment for *Still Life*. If consumer goods and stars were icons, then why not make use of their new signifying power in a political cartoon? Robinson's breakthrough idea—giving phones and tape recorders, hats and baseball gloves, bicycles and typewriters, even wastebaskets and fire hydrants cartoon voices and opinions that tartly commented on the news—responded to the restive currents in gallery art, and the quotidian images that surrounded *Still Life* cartoons on the inky, pulpy pages of the newspapers in which they appeared.

Robinson not only had to make his cartoons different from the "other" editorial cartoon in the newspaper, he had to give *Still Life* some aesthetic quality that would both confirm and deny its link to the advertising,

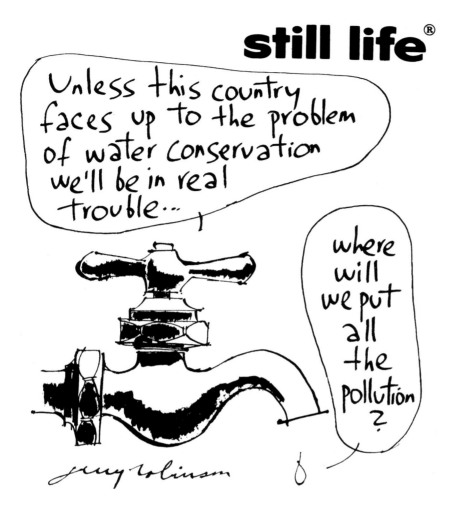

promotional, and instructional images of objects that surrounded his work. Technique was one avenue that he chose: "I used a particular kind of ink line that gave the objects a certain look of reality but not reality," he recalled. *Still Life*'s objects were clear, accurate, easily identified, convincingly placed in space and made three-dimensional by minimal but effective use of perspective and overlapping. They were drawn in an active, sometimes discontinuous line, accented by shading in thick, contour brushstrokes that might recall a Franz Kline painting. "I tried to create a whole look in the concept, in the technique. I created my own style of lettering for the cartoon, so it would look different than another editorial cartoon, or even a comic strip," Robinson explained. Borders are important in the ruled environment of newspaper pages. So Robinson innovated here, too: "I didn't use the standard border for the cartoon," he noted. The *Still Life* border was often a brush line, slightly uneven, marking the handmade quality of the panel as a work by an artist. In print, *Still Life* cartoons, such as the one shown on page 153, stood out from the bordering news stories or drawing-filled ads.

ABOVE: *Some of the feature's ideas are still relevant, Robinson observed, in commenting on his favorite* Still Life *cartoons: "I like the ones that are not necessarily about the moment, but that have legs, the ones that could be published today, the timeless ones that were meant to stimulate thought, rather than be polemics." (c. 1973)*

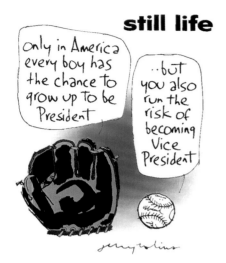

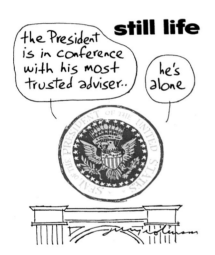

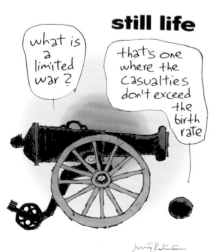

During the 1964 presidential election campaign, which eventually pitted Republican candidate Barry Goldwater against incumbent president Democrat Lyndon Johnson, Robinson featured commentary on the candidates while the primaries were still going on. In the spring of 1964, he wrote a *Still Life* with the caption ALL THAT GLITTERS IS NOT GOLDWATER.

His cartoon happened to appear in the *Daily News* the same day its board of directors met in New York. The chairman of the board was an important Republican Goldwater supporter. He saw Robinson's cartoon and exploded. Editor Richard Clarke was ordered to remove the cartoon from the paper. Clarke was apologetic when he told Robinson the bad news. *Still Life* ended its run in the paper with an even stronger cartoon commenting on Goldwater. This wasn't the end of *Still Life*, however; it was still syndicated by the Chicago Tribune–Daily News Syndicate and remained one of their popular national features. However, *Still Life* never again appeared in the *Daily News*.

Traditionally, when a president sees a cartoon he likes, and requests the original from the editorial cartoonist, the quid pro quo for the cartoon is an invitation to the White House. *Still Life* brought invitations from presidents Lyndon Johnson, Richard Nixon, Gerald Ford, and Jimmy Carter. In 1963, the first year that the strip appeared in the *Daily News*, *Still Life* won the Reuben Award from the National Cartoonists Society for the best panel of the year (as *Flubs & Fluffs* later did). It's very unusual for any sort of cartoon or strip to win a Reuben in its first year. One more honor for the strip, which was particularly meaningful for a comic book veteran like Robinson, was an appearance in *MAD* Magazine. *MAD* rarely ran a cartoon feature by anyone other than its regular artists, but in September 1970, the magazine featured an unprecedented three-page selection of *Still Life* cartoons.

After *Still Life* was dropped from the *Daily News* in 1964, Robinson felt that it never achieved its full sales potential, although the cartoon continued to be carried by the Chicago Tribune–Daily News Syndicate. The editorial pages were also changing by the late sixties and early seventies and most newspapers had added an op-ed page to their editorial spread. These op-ed pages included cartoons, so it was no longer really necessary to distinguish a cartoon like *Still Life* from a regular editorial cartoon; there was room now for more than one political cartoon. That fact, in combination with the problems he'd had at the *Daily News*, led to Robinson's next endeavor. Jerry decided to create a new editorial feature *and* his own syndicate to carry it. In 1977, he launched "Life with Robinson," handled by his own new Cartoonists & Writers Syndicate (CWS). Later, as Robinson became more involved in the world of international cartooning, he syndicated clients from all over the world.

OPPOSITE: *Some of Robinson's* Still Life *cartoons from the 1970s were published in full color.*

TOP: *Jerry Robinson meets President Lyndon B. Johnson at the White House in 1968.*

BOTTOM: *President Jimmy Carter (left) and political cartoonist Tom Curtis enjoy remarks by Jerry Robinson in the Oval Office (1979).*

(GEORGE PRIMPTON)

(AND THE MIGHTY BUCHWARD KABUKI PRAYERS...)

(JIMMY BRESRIN)

(ARU-Ri'r Abner-CAPP)

ABOVE: *Robinson pokes fun at writers George Plimpton and Jimmy Breslin and fellow comics artist Al Capp in this original pencil drawing for the National Cartoonists Society. (1968)*

"Like *Still Life,* my new work was going to be a syndicated feature, six days a week," Robinson explained. "Because of that, it needed a title." Robinson was now known as an editorial cartoonist and he thought it was a good idea to include his name in the title, similar to the way many editorial cartoonists signed their cartoons with a big signature. "It wasn't about ego," Jerry reflected. "It was about positioning the cartoon for syndication. I wanted to make sure that it was understood as a personal statement, my take on the issues of the day."

As with *Still Life*, Robinson designed a distinctive look for *Life with Robinson*. Instead of the tall rectangle of a traditional editorial cartoon, Robinson made the strip a horizontal panel. This created a subtle link to comic strips, a good connection for a panel that often got its punch from combining cartoony and realistic styles in the same image. As Robinson put it, "I tried to do a whole package that identified *Life with Robinson*; when you looked at it, you wouldn't mistake it for another feature."

Life with Robinson was successful: "At the height of the feature, it

appeared in seventy-five or one hundred papers," Robinson recalled. "Unlike *Still Life, Life with Robinson* wasn't used as a daily panel. It was sold as an editorial cartoon. I did six a week. It was never in the *Daily News*, because we had that flap. I never had a New York paper for *Life with Robinson*." But Robinson's latest cartoon appeared in major markets and had influential readers: "The paper that was the most important for me was the *Washington Star*, the competition to the *Washington Post*," said Robinson. "The *Star* was a very important paper at the time. I also ran in papers in Denver, San Francisco, Houston, a lot of big cities. They were scattered all over. And then I had papers abroad. The White House got it. I was invited to a lot of things there. Even Herblock read it."

Since he syndicated *Life with Robinson* through his own Cartoonists & Writers Syndicate, Robinson was in effect editor as well as artist. "As editor, I liked my own work," he joked. He controlled the entire process and therefore could work a little closer to deadline. "For *Life with Robinson*, I got it down to two weeks in advance," Jerry recalled. "I'd mail it out a week at a time. If I had any changes or additions or some news story broke, I'd have the option to make changes at the last minute. The system worked very well."

All of Robinson's diverse experience in his long career as an artist went into *Life with Robinson*. "The style was a combination of my illustrative style and also *Flubs & Fluffs*. I had created a kind of cartoony style for that, which worked well in the comics pages. *Life with Robinson* was a little more illustrative than cartoony, but I had also done illustration. So I could move back and forth across the spectrum. In *Flubs & Fluffs*, the figures would be more caricatures, while in *Life with Robinson*, if I drew a picture of the Oval Office for example, things would be more realistic. It was a blend of realism as well as cartoon art."

TOP: *This original for the December 31, 1980,* Life with Robinson *cartoon features political figures in the news: Richard Nixon, Gerald Ford, Henry Kissinger, Ted Kennedy, Yassir Arafat, Leonid Brezhnev, Fidel Castro, Ronald Reagan, Anwar Sadat, and Menachem Begin, among others.*

BOTTOM, LEFT TO RIGHT: *George Plimpton, Jerry Robinson, and Al Capp at a National Cartoonists Society event in the 1960s*

life with robinson

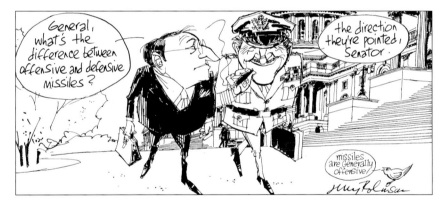

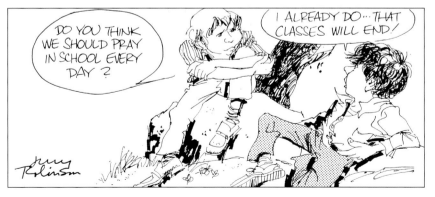

OPPOSITE AND ABOVE: Life with Robinson *cartoons ran from 1977 through the 1990s and spanned the op-ed spectrum from international conflicts, to national politicking, to social issues such as homelessness and the death penalty.*

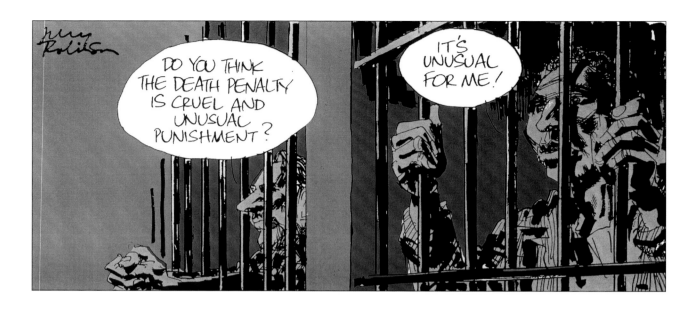

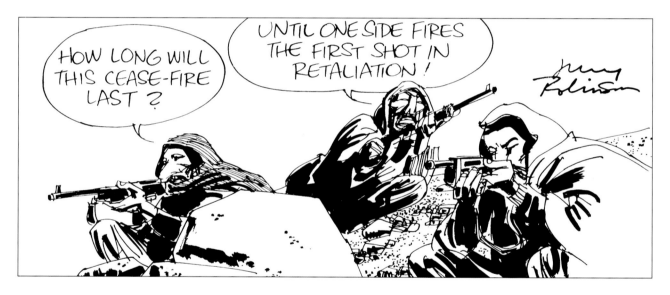

OPPOSITE AND ABOVE: *Robinson illustrated both the despots and the disenfranchised in* Life with Robinson *cartoons such as these from the 1970s–1990s.*

Robinson set out to do something new, something much more influenced by international cartooning, something that foreshadowed a role he would later play in bringing international cartooning into much greater prominence. He had always been open to different cultural influences and the style he adopted for *Life with Robinson* was much more European than almost any other editorial cartoonist's work in American journalism at the time, except perhaps for some of the underground press. While *Life with Robinson* superficially resembled more traditional editorial cartoons, in some respects its sophisticated style preserved the advantage offered by *Still Life*.

Robinson retired *Life with Robinson* after an eighteen-year run (1977–95), though many of the cartoons are still available through the Cartoonists & Writers Syndicate. Some of the *Life with Robinson* cartoons have been widely reprinted since their original publication, because they so pointedly and economically capture current issues and ideas. Perhaps the most frequently reprinted is a cartoon captioned DADDY, WHAT'S A CLONE?, which shows a mustachioed adult and a room full of identical, also mustachioed, children.

Robinson's editorial cartoons *Still Life* and *Life with Robinson* spanned thirty-two years and are still widely remembered and admired. Stephen Hess and Milton Kaplan in their history of editorial cartoons, *The Ungentlemanly Art: A History of American Political Cartoons* (1975) single out *Still Life* as one of the best strips from a "period of unrivaled experimentation" in the 1960s and 1970s. Graphic novelist Eddie Campbell, the creator of *Alec* and *The Amazing Remarkable Monsieur Leotard* (and artist for Alan Moore's *From Hell*) has written admiringly of Robinson's work in his blog, *The Fate of the Artist*, singling out *Life with Robinson* for its "angular, humorous style." Robinson's editorial cartoons were also honored by the National Cartoonists Society with Reuben Awards for outstanding achievements in the medium in three different categories: best comic book artist (1956); best syndicated panel (*Still Life*, 1963) and best special feature (*Flubs & Fluffs*, 1965).

TOP LEFT: *Jerry Robinson (at the podium) was inaugurated as president of the National Cartoonists Society in 1967; cartoonist Bob Dunn is to his right, New York City mayor John V. Lindsay to his far right.*

TOP CENTER: *Milton Caniff presents Robinson with the 1963 NCS Reuben Award for Best Syndicated Panel,* Still Life. *Robinson was also a previous winner in 1956 for Best Comic Book Artist.*

TOP RIGHT: *Art Buchwald (left) and Jerry Robinson at an NCS meeting (c. 1969)*

BOTTOM: *Walt Kelly (left) and Jerry Robinson. Robinson holds his 1965 NCS Award for Best Special Feature,* Flubs & Fluffs.

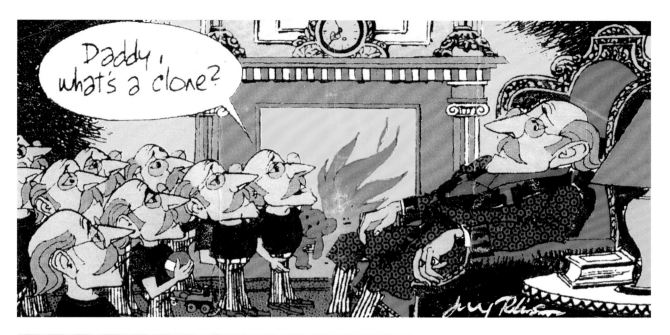

TOP: *A widely reproduced* Life with Robinson *cartoon from the late 1970s*

BOTTOM: *A 1969 proclamation thanking Robinson for his service as president of the National Cartoonists Society*

CARTOONS FOR INTERNATIONAL UNDERSTANDING

Jerry Robinson had been active in the Association of American Editorial Cartoonists (AAEC), serving as president and working on industry issues and lobbying. The AAEC also published an annual volume of work by its members, *Best Editorial Cartoons of the Year*. However, Robinson began to envision a different kind of "best of" book: an *international* collection.

Robinson pitched the idea of a cartoon anthology that would cover the 1970s, year-by-year, to the publisher McGraw-Hill in 1979. The 1970s had been turbulent, and as Robinson noted in the introduction to the published volume, "The decade of crisis became the catalyst for a renaissance in the art of the political cartoon." McGraw-Hill liked the idea, but asked Robinson to drop the international cartoonists; they thought that would kill sales of the book. "They didn't know the international cartoonists because they weren't published here. But they were the Herblocks of their countries," Robinson recalled. He insisted that at least half the cartoons be international.

The book, *1970s: Best Political Cartoons of the Decade* (McGraw-Hill, 1981), was a surprising success. The print run sold out, and the reviews were uniformly positive, particularly praising the inclusion of international cartoons. Robinson was deeply gratified, and it gave him the idea that would become the basis for the success of his syndicate: "I felt it was more important than ever to know about world opinion—and who better than the top political cartoonists in each country to interpret the issues concisely and with drama and humor. No one else is syndicating these international cartoonists to American newspapers. Exceptional talents such as Jean Plantu of *Le Monde* and Louis Mitelberg (TIM) of *l'Express*, both in Paris, EWK from *Aftonbladet* in Stockholm, or Fritz Behrendt from *Het Parool* in Amsterdam, Yaakov Farkas (ZE'EV) from *Ma'ariv* in Tel Aviv, and Roy Peterson from the

OPPOSITE: *Robinson's minimalist cover design for the catalogue for the Human Rights exhibit at the 1993 World Conference of Human Rights in Vienna, Austria, consists solely of two words handscrawled in bloodred on a white background.*

ABOVE: *A photo of Robinson from the 1990s*

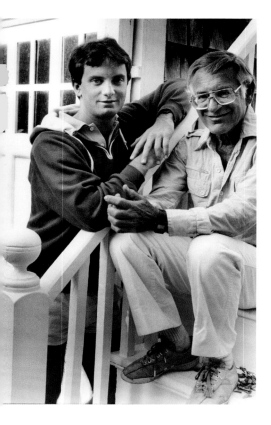

ABOVE: *Jerry Robinson and his son, Jens, on Cape Cod in the 1980s. Jens has played an important role in the development of Robinson's Cartoonists & Writers Syndicate.*

Vancouver Sun are famous in their own countries, but few knew them here," he observed. Robinson began contacting international cartoonists to syndicate their work in the United States by Cartoonists & Writers Syndicate.

This presented two major problems: signing up cartoonists all over the world and deciding on a format to make it feasible for the subscribing newspapers to justify running international cartoons. Taking CWS international was going to be a huge job—one Robinson couldn't do alone. He was fortunate that he already had an assistant at the syndicate, the talented Steve Flanagan, a former student of his from New York's New School for Social Research. Another person unexpectedly joined in the enterprise: Jerry's son, Jens Robinson, then an undergraduate at Dartmouth College. From an early age, Jens knew what made a good cartoon. He had traveled to comics conventions with Jerry; now he helped conceptualize the new syndicate, working with his father and Steve Flanagan, who became CWS's editor, to identify artists and design promotional material.

The anthology format of *1970s: Best Political Cartoons of the Decade* had been successful, so Robinson and his team sought a way to include the same variety in a feature for subscribing newspapers. An anthology feature seemed like a natural way to circulate the international cartoons. They settled on a weekly feature, *Views of the World*. It would contain five cartoons and be designed to run on op-ed pages. In the *1970s* book, each cartoon had been clearly identified with an artist's name, city, country, and originating paper, and that continued in *Views of the World*, as well as in all subsequent CWS features. "About half the papers used the entire feature weekly," Robinson notes. "Others used the individual cartoons. Sometimes they featured our cartoons as the paper's main editorial cartoon. It's always really gratifying when I'm traveling and I see one of our artists featured in a paper's editorial pages."

Identifying, contacting, and signing contracts with international cartoonists was a daunting job, especially since Robinson wanted to include opposing viewpoints whenever possible. In the planning stages of *Views of the World*, Jens Robinson and Steve Flanagan visited the United Nations, foreign consulates, and cultural centers. In the spring of 1982, Jens spent the semester in Washington, D.C., as an intern for Paul Tsongas, the Democratic senator from Massachusetts. While there, he visited national embassies, the Library of Congress, and international nongovernmental organizations (NGOs) to identify the world's top international political cartoonists.

It took two years of preparation to launch *Views of the World*. After identifying artists, each one had to be contacted, and then contracts had to be translated into a variety of languages and signed. In some cases, the agreements were made directly with artists, but in others, representation had to be secured through their newspapers. In the case of the Soviet Union, the government agency VAAP controlled all the cartoonists' creations, and all royalties were paid through them.

Views of the World was a resounding success. The *Los Angeles Times* called the day after the launch to subscribe. "The *St. Louis Post-Dispatch* said they got more reader reaction to *Views* than to any other feature they ever added to their editorial page," Robinson recalls. "It was the right time. Editors were less parochial and television news was devoting more time to international news coverage," he added. Americans were traveling abroad more than ever, business was growing more and more international, and American culture was visually more diverse. *Views of the World* fit perfectly with these developments.

In 1985, Jens Robinson went to England to study international relations at the London School of Economics and Political Science. He visited the *International Herald Tribune* in Paris with tear sheets of *Views of the World*. As a result, the *International Herald Tribune* became CWS's first overseas client. Because of the newspaper's worldwide reach, readers and editors around the world became aware of CWS's global content and more sales followed. In subsequent years, Jerry and Jens personally visited and signed up publications around the world, including ones in London, Istanbul, Tokyo, Beijing, Hong Kong, Shanghai, Rio de Janeiro, and São Paulo.

Travel had opened the doors to creating an international cartoon syndicate, and Robinson continued to globetrot and meet more cartoonists. By this time, international interest in comic books and cartoon art had grown around the world. Comic conventions and festivals were being held not just in the United States, as in the San Diego Comic-Con, but around the world, from Lucca, Italy; to Angoulême, France; to Tokyo, Japan. On his trips to Europe, Africa, and Asia to entertain the troops, Robinson had met with leading cartoonists, a practice he continued when attending international comic

TOP LEFT: *Robinson met the influential Japanese comics and manga artist Shotaro Ishinomori in 1995.*

TOP RIGHT: *Robinson meets with the top editorial staff of "Satire & Humor," China's largest magazine of its genre in Beijing, China (1995).*

BOTTOM: *Jerry Robinson (center, right) meets with Cuban cartoonists and journalists in Havana, Cuba (1999).*

festivals and conventions. His travels took him to Moscow, Kiev, Athens, Prague, Warsaw, Budapest, Rome, Hamburg, Copenhagen, Cairo, Tel Aviv, Buenos Aires, Beijing, and dozens of other cities oten five continents. All over the world, the media covered the Joker creator's visit with Batman-infused excitement mixed with respect for a comics legend. The CWS newspaper deals were closed on the merits of the innovative and international features. However, *Batman* probably opened a few doors for CWS political cartoons.

Although Jerry Robinson initially intended his syndicate to introduce international cartoonists to the United States, his approach—meeting with artists wherever he traveled and introducing cartoonists to each other—had another effect. John Lent, a professor at Temple University in Philadelphia, Pennsylvania, and an international authority on cartoons, credits Robinson both with bringing cartoonists to international attention, and with creating links among cartoonists in their own regions. "Before the Internet, one of the main connections of Southern Hemisphere cartoonists throughout the world was through Jerry and his syndicate," says Lent.

After earning a law degree from Northwestern University, Jens Robinson joined CWS as editor in 1991. In the 1990s, CWS took on the corporate name CartoonArts International. Although it's still commonly called CWS, the new name better describes its multiple endeavors, including book projects, exhibitions, and other non-syndicate activities, such as its cartoon archive. This archive, now a database of tens of thousands of cartoons searchable by subject, date, or artist, is utilized by the world media.

OPPOSITE: *Jerry Robinson with a group of young Batman fans in a favela, Rio de Janeiro, Brazil (1984)*

ABOVE: *NCS cartoonists on tour entertaining troops in Europe and North Africa; left to right: Mac Miller, Carmine Infantino, David Pascal, artists' model Pixie Burroughs, Bill Holman, and Jerry Robinson (c. 1955)*

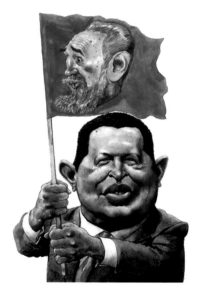

TOP: *"Obama's Inauguration." Artists counterclockwise from top left:* TOM, *Amsterdam;* KAL, *London;* CORAX, *Belgrade; Peterson, Vancouver;* HENG, *Singapore,* Views of the World *(January 20, 2009)*

BOTTOM: *"Castro & Chavez," by Vladimir Motchalov, Moscow,* Comment & Caricature *(2005)*

Some of CartoonArts International /Cartoonists & Writers Syndicate features include:

Views of the World: A daily and weekly selection of international editorial cartoons on the top issues of the day.

Regional Views: Weekly focused selections on regional issues include Views America, ViewsAsia, ViewsLatinAmerica, ViewsAfrica, and ViewsEurope.

Business Views: A weekly selection of political cartoons on business and economic issues.

Caricatures of the World: Monthly portfolios of newsmakers' portraits by a group of the world's great caricaturists.

Comment & Caricature: A weekly op-ed illustration and caricature service, featuring topical, symbolic imagery and newsmakers' portraits by the world's great caricaturists.

Wit of the World: A daily panel and Sunday page of humor in color by artists appearing in top international humor magazines, including *Punch* in England and the *New Yorker* and *MAD* Magazine in the United States.

Translations: The New York Times Syndicate/CartoonArts distributes ViewsLatinAmerica and Spanish-language versions of *Views of the World* (*Visiones del Mundo*) and *Wit of the World* (*Espejitos del Mundo*) to the Spanish-language press in the United States; and *ViewsMideast* to the Jewish press and Middle East–oriented media.

Soon Robinson's syndicate branched out to represent editorial cartoonists from the United States as well. CWS's American political cartoonists

include some of the country's most distinguished: Jeff Danziger, Kevin (KAL) Kallaugher, Jim Morin (*The Miami Herald*), Joel Pett (*Lexington Herald-Leader*), and Ann Telnaes. Morin, Pett, and Telnaes each have won Pulitzer Prizes. In addition to three Pulitzer Prizes and two prestigious Herblock Prizes (Danziger and Morin) CWS artists have won every other major American award—the Headliner, the Fischetti, and the Thomas Nast (Overseas Press Club).

Robinson's expertise and connections in the world of international cartooning led to his curating several important cartoon exhibitions, including a series of shows for the United Nations, coordinated with conferences on major social issues.

TOP: Wit of the World *cartoon, by Marco de Angelis, Rome (2007)*

BOTTOM LEFT: Wit of the World *cartoon by Sergei Tunin, Moscow (2009)*

BOTTOM RIGHT: *"Disney Buys Marvel," by Brian Gable, Toronto;* Business Views *(2009)*

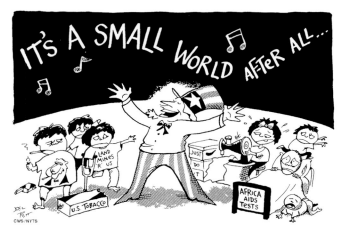

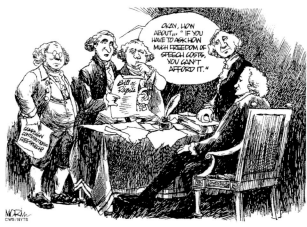

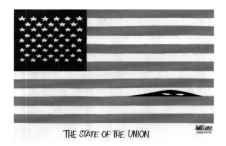

In 1992, the UN Conference on Environment and Development, better known as the Earth Summit, was held in Rio de Janeiro, Brazil. Attended by an unprecedented 108 heads of state, including President George H. W. Bush; representatives from 172 governments; environmentalists and scientists from all over the world, and covered by more than ten thousand international journalists, the Earth Summit marked a new level of environmental awareness. Robinson attended a strategy session held by Senator Al Gore, who led the American delegation. The CWS exhibition, "Our Endangered Planet," was at the center of the conference. "Our Endangered Planet" featured cartoons with environmental themes from more than forty countries and included works by some sixty artists. In addition to curating the show, Robinson also covered the conference for its daily newspaper, *TerraViva*, including a report on a notable address by oceanographer, Jacques Cousteau, who sounded a warning that global environmental degradation would become irreversible within ten years. The Earth Summit inspired CWS to distribute a weekly feature of international cartoons devoted to the environment, called *Ecotoon*.

In 1993, Robinson curated a second CWS exhibition for the UN, one that had a great deal of personal meaning. As a cartoonist of Jewish heritage, and someone who has fought for the rights of artists and cartoonists, including some in prison, Jerry was particularly moved to organize the "Human Rights" exhibition at the World Conference on Human Rights, held in Vienna, Austria. "Human Rights" featured cartoons by more than eighty-four artists from forty-two countries on topics such as freedom of speech, women's rights, torture, imprisonment, and economic deprivation. In cooperation with the UN, and supported by the government of Austria, Cartoonists & Writers Syndicate published a catalogue of the exhibition with a striking cover Robinson designed: a graffiti-inspired image of the words "Human Rights" scrawled in blood red on a background that looked like a wall. "Human Rights" was subsequently sponsored by the New York City Department of

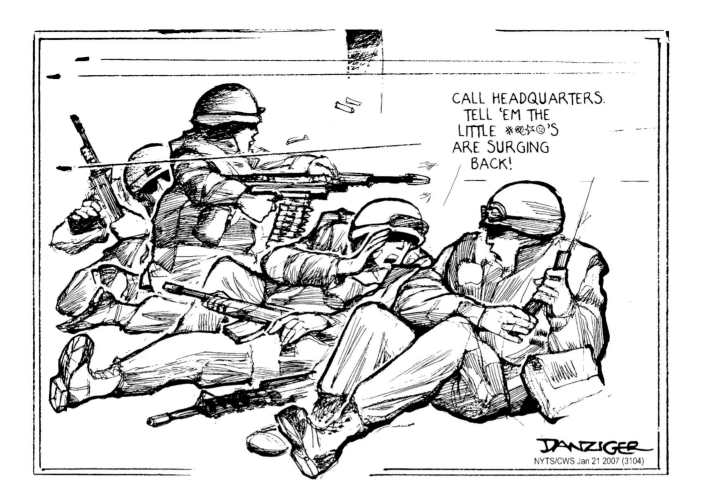

Cultural Affairs, and in Washington D.C., by the Austrian government and Amnesty International.

The following year, CWS produced and Robinson curated an exhibition and catalogue, "Inhabiting the Earth," with a foreword by Ted Turner and Jane Fonda, for the UN Conference on Population and Development in Cairo, Egypt. The noted magazine *Rose El Youssef* hosted a meeting for Jerry to meet the leading Egyptian cartoonists.

In 2007, the UN asked Robinson and CWS to mount another exhibition, this time in its headquarters in Manhattan and again on the topic of human rights. "Sketching Human Rights," co-curated by Jerry Robinson and his son Jens, marked the sixtieth anniversary of the Universal Declaration of Human Rights (1948–2008). The exhibit of sixty images by internationally renowned artists was opened by the Deputy Secretary-General Asha-Rose Migiro and Jerry Robinson at the UN headquarters in New York before going on a world tour.

Connections with Middle Eastern and African cartoonists were further cemented by international conferences attended by the Robinsons in Malta and Istanbul, cosponsored by CWS and the NGO Search for Common Ground. U.S. State Department–sponsored annual visits by foreign cartoonists are

ABOVE: *"Iraq Surge," by Jeff Danziger, U.S. (2007)*

also hosted in New York by CWS where Jerry and Jens arrange meetings with the publishers and editors of the *New York Times*, DC Comics, *MAD* Magazine, and the *Onion* newspaper.

Views of the World remains the core feature syndicated by Cartoonists & Writers Syndicate. Starting with twenty cartoonists from fifteen different countries, CWS now has more than two hundred and fifty artists from more than fifty countries. *Views of the World* also spawned a variety of specialized features, including regional and topical collections. Several award-winning contributors from the first years are still creating cartoons for syndication by CWS, including: Francisco "Pancho" Graells (*Le Monde* and *Le Canard Enchaîné*, Paris), Martyn Turner (*Irish Times*, Dublin, Ireland), Marco de Angelis (*La Repubblica*, Rome, Italy), Sean Leahy (*Courier-Mail*, Brisbane, Australia), and Dale Cummings (*Winnipeg Free Press*, Canada).

In 2003, CartoonArts International/Cartoonists & Writers Syndicate forged an alliance with the New York Times Syndicate. Because of the resources and reputation of the *New York Times,* the New York Times Syndicate (NYTS) plays a major role in international journalism and is an ideal partner for CWS. All CartoonArts International/Cartoonists & Writers Syndicate artists, as well as the vast CartoonArts Archive are represented on the NYTS web site, and the Times Syndicate places the cartoons in major newspapers all over the world. CWS pioneered the searchable archive as a new way of marketing the cartoons, which has led to growing sales of individual cartoons, or "one shots." CartoonArts International and NYTS collaborate on a number of journalistic projects including Turning Points, an annual service combining cartoons on the year's top issues with text by world figures such as Richard Branson, Mikhail Gorbachev, Madeleine Albright, and Jimmy Carter.

Today, many of the finest cartoonists around the world are represented by CWS, including Brian Gable (*The Globe and Mail*, Toronto, Canada), Oliver Schopf (*Der Standard*, Vienna, Austria), Tom Janssen (*Trouw*, Amsterdam, Netherlands), Finn Graff (*Dagbladet*, Oslo, Norway), António Antunes (*Expresso*, Lisbon, Portugal), Peter Schrank (*The Independent*, London), Vladimir Motchalov (*Moscow News*, Russia), Heng Kim Song (*Lianhe Zaobao*, Singapore), P. Venkata "Keshav" Raghavan (*The Hindu*, New Delhi), Alan Moir (*The Sydney Morning Herald*, Australia), Rod Emmerson (*New Zealand Herald*, New Zealand), Helioflores (*El Universal*, Mexico City), Godfrey "Gado" Mwampembwa (*Daily Nation*, Nairobi, Kenya), and Jonathan "Zapiro" Shapiro (*Mail and Guardian*, South Africa). In addition to editorial cartoons, CWS artists specialize in humor, from the bitingly satirical to the more gentle and lyrical. Humor cartoonists represented include Clive Collins, Roland Fiddy, and Mike Williams (UK); Carlos (CALOI) Loiseau (Argentina); and Giuseppe Coco (Italy). They also work for the *New Yorker*, *MAD* Magazine, *Punch*, *Private Eye*, and the world's other notable humor magazines.

TOP: *Catalogue cover for the 1994 exhibit Inhabiting the Earth at the UN Conference on Population and Development, Cairo Design: Jerry Robinson, art Walter Hanel, Frankfurt*

BOTTOM: Ecotoon *panel by Javad, Tehran (2009)*

Cartoonists & Writers Syndicate began when the only contact between artists and syndicate, and syndicate and newspapers, was through the mail. Today almost all CWS art travels via the Internet; cartoons can be sent out the same day they are received from the artist, often just hours after they're drawn. "As an artist, I'm really proud to represent other artists," Robinson said. "I find it a lot easier to sell their work than my own. I feel privileged to promote so many great artists." Robinson passionately believes the end user should pay appropriate rates for the cartoon material. Jerry considers fair compensation and credit for their work a matter of artists' rights. It's a lesson Robinson learned in the early days of comic books, and he's made it a cornerstone of his career.

As an artist starting his own syndicate, Robinson was in his own quiet way holding up the banner of artists' rights. He would do so more publicly, in the campaign to restore credit to the creators of Superman, Jerry Siegel and Joe Shuster.

ABOVE: *"From the People in Marketing,"* *by Kevin (*KAL*) Kallaugher, London (2009)*

AMBASSADOR OF COMICS

One night in 1975, Robinson was working late in his studio. Late nights weren't unusual, since he was producing six *Still Life* cartoons and the Sunday *Flubs & Fluffs* every week, as well as the occasional advertising or other freelance work. His assistant, Bob Forgione, who had been his student at the School of Visual Arts, was working alongside him. Like many cartoonists, Robinson usually worked with the TV droning in the background. Suddenly he heard the name "Jerry Siegel." His friend Jerry was on the idiosyncratic Tom Snyder's late-night talk show, *The Tomorrow Show*. Siegel was telling the story of losing the rights to Superman.

Jerry Robinson had grown close to Joe Shuster and Jerry Siegel, the creators of Superman, back in the glory days of the 1940s. Robinson worked with them in the bullpen at DC Comics, and they all became friends. Siegel was married, but Shuster wasn't, and he and Jerry would go out in New York City on double dates. Robinson and Siegel had a lot in common. They both read widely. Siegel was a huge science-fiction fan and read everything in the field. Robinson also loved science fiction, though he had probably read more broadly in literature. Siegel was a writer, and Robinson had begun his college career studying creative writing and would later become one of comics' most influential historians. And Robinson just liked Shuster and Siegel. "They were both good people. They had a lot of integrity. They've been depicted in comics histories sometimes as socially awkward or geeky, and I think that's really an unfair characterization," says Robinson. "That's not the Jerry and Joe I knew."

As everyone knew, Jerry Siegel and Joe Shuster had created Superman in Cleveland, Ohio, in 1933. The first Superman comic book story appeared in *Action Comics* no. 1 (June 1938), and for a decade after that, Jerry and Joe

OPPOSITE: *Jerry Robinson at the William Breman Jewish Heritage Museum in Atlanta, Georgia, for the exhibit Zap! Pow! Bam! The Superhero: The Golden Age of Comic Books, 1938–1950, which he curated (2005)*

ABOVE: *Jerry Robinson (left) with comics writer and editor Dennis (Denny) O'Neil at an NCS dinner in Jerry's honor held at the Society of Illustrators in New York City, July 10, 2002.*

were the people who kept Superman going, either writing and drawing the stories or overseeing their own studio where Superman comics and strips were created. Siegel and Shuster had tried to sell Superman as a syndicated comic strip. When the syndicates rejected it, they went to comic books. Like almost everyone else in the early days of comics, they signed away all rights. They were paid 130 dollars for that original story about the Man of Steel.

Siegel and Shuster were the first comic book creators to try to get back the rights they had sold away for so little. They filed a lawsuit to regain Superman in the late 1940s; they lost that and several subsequent cases. Eventually, word began to circulate in the comic book community that Siegel and Shuster had reached some kind of settlement with DC Comics, which had been purchased by Warner Communications in 1969.

Superman was the first successful super hero to appear in comic books; indeed, comic books probably would not exist without him. Appropriately, he was also the first super hero to appear in a big-budget Hollywood film, created by and starring A-list talent. Before this, super heroes had been limited to low-budget serials, such as *Atom Man vs. Superman,* and the George Reeves television show. As news of a Superman film began to appear in the press— Richard Donner would direct; *The Godfather* author Mario Puzo was writing a script—Jerry Siegel realized that this was the best chance he would ever have to restate his and Joe Shuster's claim to the Man of Steel. When Robinson heard Siegel on TV that night in 1975 he realized there had been no settlement, and that one of Superman's creators was trying to take his story public.

He called Siegel the next day and offered to help. Siegel said that comic book artist Neal Adams had also offered his support, and soon they were all working together.

"Neal and I decided to target the arts community, especially in New York. That's where we had our best connections," Robinson recalled. "Fortuitously, Jerry and Joe were coming to town the next week, and there was a meeting of the board of the National Cartoonists Society. As a past president of NCS, I was able to arrange for the board to address the issue," he said. "I called Bill Gallo, my friend and immediate successor at NCS, and with his help, the board unanimously passed a resolution of support." Adams rounded up support in the comic book field, and Robinson used his connections to get the support of the Association of American Editorial Cartoonists, of which he was also past president; the Cartoonists' Guild, which included many of the *New Yorker* cartoonists; and friends in many fields, such as cartoonist Will Eisner, comics writer and editor Denny O'Neil, journalists Mike Wallace and Pete Hamill, even writers Norman Mailer and Kurt Vonnegut, whom Robinson knew from summers in Cape Cod. Jerry also contacted international artists, his friends and clients who were represented through Cartoonists & Writers Syndicate, to spread the word around the world.

The campaign began to have an effect; Jerry Siegel and Joe Shuster appeared on the *Today* show; items appeared on the *CBS Evening News* and

in the *Washington Star* and other papers. Superman's creators were tired and frail at this point in their lives; they placed the upcoming negotiations with Warner Communications in the hands of Jerry Robinson and Neal Adams. "Publicity was our most effective tool," Robinson recalls. "The movie was in production, millions of dollars were at stake. We had to act quickly to take advantage of the pressure that the media coverage brought to bear."

He and Adams brought all the resolutions and letters of support and newspaper articles to Warner Communications. Jerry enlisted the help of his friend Jules Feiffer, who connected Robinson with a lawyer who would advise them pro bono. At the time, Joe Shuster had no income, and Jerry Siegel was a clerk for the state of California who couldn't even afford to own a car; he'd had one heart attack and feared another. What they were asking for—a pension, health insurance, enough money to unburden them of the debt from their legal challenges—was not a lot for a huge corporation, but would make a big difference in Siegel's and Shuster's lives. But the most important thing, and the one that proved to be the sticking point in negotiations, was credit. Siegel's and Shuster's names had disappeared from everything Superman after they brought their first legal challenge in the 1940s. They—and Robinson and Adams, and all the artists and writers who supported them—wanted Siegel's and Shuster's names restored to their creation.

"That was the only way to restore their dignity, after all they'd been through," said Robinson. "It's every artist's moral right to be credited for his or her work. That's unquestioned in Europe, but not here." Siegel and Shuster left New York for California; they couldn't take the strain. Robinson called and updated them every day. At one point Siegel told Robinson, "This

ABOVE LEFT, LEFT TO RIGHT: *Joe Shuster, Neal Adams, Jerry Siegel, and Jerry Robinson at the signing of the agreement with Warner Communications on December 23, 1975*

ABOVE RIGHT: *Robinson with his friend and colleague Neal Adams at a screening in New York City for* The Spirit *(December 2008)*

Dear Jerry:

Now that the deal with Warners has been satisfactorily concluded, I am writing special thank-you letters to certain people who played an important role in helping to make this possible.

Jerry, I want to thank you on behalf of Joanne, Laura and me for the wonders you accomplished on our behalf. Right from the start, you felt a really adequate figure should be achieved, together with other important issues such as protection of the families and the credit line. Also, you were instrumental in our receiving support from the nation's cartoonists and their organizations.

I believe that a precedent has been set and hope that the spotlight on our predicament and its successful resolvement will help other cartoonists and their protective organizations in being treated more justly in their business dealings.

Again, Jerry, thank you for being what is truly priceless: a good friend.

Gratefully,

Jerry

Jerry Siegel

cc: Joe Shuster

ABOVE: *The thank-you letter Jerry Siegel wrote to Jerry Robinson, December 1975*

is it. We have to settle by tomorrow." His reasons were personal. "He had a wife and young daughter," Robinson says. "He was literally afraid he would die of the stress and end up leaving them nothing." Warner had no legal obligation; that had been established repeatedly in court. Public pressure was all Siegel, Shuster, and their supporters had to rely on.

It was the last act of the negotiations, and Robinson was alone; Neal Adams was at a comic book convention in Florida and couldn't be reached. Robinson called Warner's negotiator, Jay Emmett, at home. Warner had agreed to most financial points and, while Robinson couldn't let on that he had to close the negotiations by the next day, he knew he had to make one last push for Jerry's and Joe's credits on Superman. Warner and its lawyers had balked at this, primarily because they thought it might leave open the question of Siegel and Shuster's legal claim. Robinson and Emmett had managed to maintain a cordial tone throughout the negotiations, and now Robinson aimed for the high ground, while appealing to corporate self-interest. "Warner is a multimedia company; you depend on actors and directors for movies, writers and artists. How is it going to look to all these people if you don't restore the credits?" Robinson argued. He pointed out that every credit is jealously guarded in Hollywood, and that it would leave bad feelings in many different parts of the artistic community if these two artists were left destitute.

Robinson argued that credit and legal control were different: "Just because Shakespeare isn't copyrighted, you don't take his name off the plays. Sherlock Holmes is out of copyright, but you don't take off Arthur Conan Doyle's name."

The call began a series of back-and-forth negotiations. Warner's financial offer improved enough to be acceptable, but the tug-of-war over the credits continued. Emmett said Warner couldn't credit Siegel and Shuster on licensed products because the licenses had already been signed for toys and merchandise; and Warner couldn't give the artist/writer team credit on the upcoming *Superman* movie with Christopher Reeve because the film was completed. Warner offered to restore Siegel's and Shuster's credits to the comics.

Robinson told Emmett, "We can let you have the toys. But Jerry and Joe's names have to be on all print materials and films." After another call to the lawyers, Emmett agreed to the print credits, but again he told Robinson it was too late for the *Superman* movie because the movie's credits were already done. Robinson recalled: "I told him that I'd had professional experience in film, and I knew credits were the last part of the film to be completed, that they could be changed even the day before the premiere." One last round of calls—by this time it was after two A.M.—and the agreement was reached. Siegel's and Shuster's names would also be on films and television productions. The negotiations were over.

Siegel and Shuster flew to New York to sign the agreement, and Robinson and his wife, Gro, hosted a party for them that night in their Riverside Drive apartment. Will Eisner, *New Yorker* cartoonist Sam Gross, and other supporters including Jules Feiffer, Norman Mailer, and Kurt Vonnegut were there. The *New York Times* sent a reporter and a photographer. As Robinson was leaving Warner headquarters in Midtown, he shared a cab in the pouring rain with the actress Anne Jackson, wife of Eli Wallach, who lived in Robinson's neighborhood, and the couple came, too.

Jerry Robinson and Neal Adams had promised the producer of the *CBS Evening News* an exclusive. They gathered around the television to watch Walter Cronkite, waiting to see how the story would be covered. As the half-hour newscast rolled on, everyone began to think the settlement had been bumped for another story. But Cronkite had saved it for the closing segment.

Cronkite told Jerry and Joe's story as one of hope and loss and redemption, finally announcing the signing of the agreement. He closed the broadcast, over a shot of Superman flying, saying, "Today, at least, truth, justice, and the American way have triumphed."

"Everyone raised their champagne glasses in a toast to Jerry and Joe," Robinson recalls, "and many of us had tears running down our faces." Later, in a letter to Robinson, Siegel thanked him, and then sought a larger meaning in the settlement: "I believe that a precedent has been set and hope that the spotlight on our predicament . . . will help other cartoonists . . . in being treated more justly in their business dealings."

ABOVE, LEFT TO RIGHT: *Sam Gross, Anne Jackson, Jerry Robinson, Will Eisner, and Joe Shuster (front) gathered in the Robinsons' apartment on the Upper West Side of Manhattan to celebrate the successful negotiations with Warner Communications (1975)*

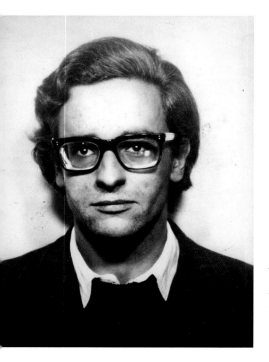

TOP: *Uruguayan editorial cartoonist Francisco Laurenzo Pons (c. 1972)*

BOTTOM: *Robinson in one of the activist T-shirts (c. 1980)*

Jules Feiffer was instrumental in bringing Robinson into another struggle to help a cartoonist in trouble. "I had no idea when Jules called me what he was getting me into for the next several years," Robinson recalls. "He knew I had an interest in human rights, and he'd been contacted by Amnesty International about a cartoonist who was jailed in Uruguay." The cartoonist, Francisco Laurenzo Pons, had been the editorial cartoonist for *Marcha* (*Progress*), a weekly political and cultural magazine. *Marcha* was shut down in the wake of the 1973 coup that overthrew Uruguay's government and installed a right-wing, repressive military regime. Laurenzo went underground to support resistance to the dictatorship because he didn't want to go into exile and leave his wife and small son. He was arrested and imprisoned in July 1978, and sentenced to a six-and-a-half-year term.

Amnesty International had identified Laurenzo as a "prisoner of conscience," and contacted Feiffer, whose powerful political cartoons in New York's *Village Voice* had secured him an international reputation. An Amnesty group in California had accepted Laurenzo's case, and Feiffer wanted to know if the Association of American Editorial Cartoonists would be willing to become involved in the campaign to free him. Robinson was past president of the AAEC and was currently chair of its international committee; he decided they could definitely try to do something.

"As I looked into it, I learned that Uruguay's was a brutally repressive regime," Robinson recalls. "They tortured anyone they imprisoned, and they 'disappeared' people. It was like the Costa-Gavras film *Missing*." Robinson learned that Laurenzo's family was in difficulty. "Any member of an opponent's family was prevented from working and earning money. Laurenzo's wife, Claudia, and his son, Tomás, were really suffering," Robinson discovered. "The first thing we did was set out to raise some money for them."

After briefing the AAEC board, a group of cartoonists donated original art to be auctioned in cooperation with the California Amnesty International committee. This was the first of several auctions to support Laurenzo's family. "We couldn't send the money directly to Claudia. The government would have seized it," Robinson recalls. "We had to work with Amnesty and our other contacts to find people going to Uruguay who could hand-carry it. That was dangerous for everybody," he observed.

The cartoonists' goal was to free Laurenzo, but that proved ultimately to be impossible. "The Reagan administration had restored military aid to the junta, which had been cut off by President Carter," Robinson said. "We did all kinds of things. We had meetings at the White House, and sat down with Ed Meese, the attorney general. We talked to Elliott Abrams, who was supposedly in charge of human rights," Robinson said. "But it was clear that they were going to do nothing—in fact, Abrams impeded our efforts."

Laurenzo had been tortured in prison, causing severe health problems, which went untreated. "Prisoners on either side of Laurenzo had committed

suicide," Robinson had learned. "In some ways, the most fatal thing for a prisoner is to give up hope." The best way to help Laurenzo fight his health problems was to help keep up his hope. Each month when Claudia was allowed to visit her husband briefly, she updated him on the efforts of the cartoonists in America to free him. "When she first told him about our efforts, he was amazed, and asked, 'Why would they do that for me?'" Robinson related.

"One day I had a brainstorm, an idea that I thought might help get Laurenzo out of there," Robinson recalled. "I created a new award for the AAEC to bestow, the Distinguished Foreign Cartoonist Award. We'd present it to Laurenzo as an honor for Uruguay, and invite him to come receive it, without letting on we knew he was in prison." To make the award less pointed and controversial, it would go to two cartoonists. As Robinson explained, "We thought we'd balance an award to a cartoonist from a fascist country with one to a cartoonist from the opposite side of the political spectrum." The other cartoonist, Eric Lipinski, was from Poland, which was then a Communist country. Lipinski was founder of the satirical magazine *Szpilki* and his country's foremost cartoonist. He was twice imprisoned in Auschwitz; although he was not Jewish, Lipinski had used his artistic skills to forge passes for non-Jews to enter the Warsaw Ghetto.

ABOVE: *Robinson treasures this gift, a drawing from Laurenzo. Although imprisoned and with no access to artists' materials, the Uruguayan artist still found a way to draw. He created this picture of his hands using colors made from vegetables from his prison meals and his own blood.*

The Distinguished Foreign Cartoonist awards were going to be presented at the AAEC's annual meeting in Nashville, Tennessee, in June 1981. The Association's press release quoted Robinson's successor as AAEC president, Sandy Campbell, who worked closely with Jerry on the campaign to free Laurenzo, as saying "The selection was based on the artists' professional skill and influence within their own countries, without regard to their political views." Despite meetings and letters to the Uruguayan embassy, the cartoonists received no reply as to whether Laurenzo would be released to accept the award. Finally, a week before the AAEC convention, they were notified that Laurenzo's wife and son would be given a one-week visa to attend. "This was unheard of," Robinson said. "They never let the families of prisoners out of the country."

There were other unexpected surprises that weekend. Country musician Tom T. Hall, composer of the hit "Harper Valley P.T.A.," took an interest in Laurenzo's cause. Hall hosted a benefit party at his estate, and personally paid to print up thousands of FREE FRANCISCO LAURENZO PONS! T-shirts.

The cartoonists' campaign hadn't freed Laurenzo, but it had at least made him somewhat safer. "After we started our campaign, at least they stopped torturing him, although they still wouldn't give him any medical treatment," Robinson noted. The campaign continued, and the next year they succeeded in getting letters from members of the U.S. House and the Senate in support of Laurenzo's case.

At the time, Jens Robinson was a college student at Dartmouth, and he had gotten an internship with Senator Paul Tsongas. Tsongas didn't need much encouragement to take up Laurenzo's case, especially after he asked Elliott Abrams for information and got newspaper clippings from Uruguay's right-wing, government-controlled press. Tsongas was furious and generated a letter of support for the Laurenzo cause and routed it to his colleagues. Twelve senators, Democrats and Republicans, signed the letter, including Howard Baker, the GOP majority leader, and Ted Kennedy. More than forty House members signed a similar letter sponsored by Congressman Barney Frank of Massachusetts.

Francisco Laurenzo Pons was finally released in 1984, six months before his sentence was up. Two decades later, when Laurenzo's son, Tomás, visited Jerry Robinson in New York, he said he still had the drawing of Batman that Robinson had given him, framed and hung up.

Robinson also helped a number of artists in Russia when it was still the Soviet Union. The artists he represented there were required to receive all their payments from the Cartoonists & Writers Syndicate through a government arts agency. This Soviet agency was allowed to keep 90 percent of the artists' income—and usually just kept it all. Several times, while on business trips, Robinson personally smuggled in the payments to the artists, in U.S. dollars, which were worth the most in Russia. "One time, I was bringing five thousand dollars in a money belt," Robinson remembers. "Luckily, I was

never searched. The money was to be divided among five or six artists, one of whom received one thousand dollars. He literally fell on the floor when I gave him his share."

On another trip to Moscow, Robinson brought money from the sales of several cartoons to an artist, Vyacheslav Sysoyev, who had been imprisoned in a Soviet Gulag labor camp. A friend of the imprisoned cartoonist contacted Robinson because of his efforts on behalf of Laurenzo Pons and gave him several of Sysoyev's cartoons to see if he could place them. Robinson sold one almost immediately to the *New York Times,* which published it on the paper's op-ed page. Sysoyev had been an underground or *samizdat* artist, but by the time Robinson visited him in Moscow, society was changing under Gorbachev; Sysoyev was free, and he and his wife met Robinson at an exhibition of former underground artists. "It was worth the entire trip to see the looks on their faces when I showed them the *New York Times* issue featuring his work," Robinson recalled.

Jerry Robinson's humanitarian work on behalf of comics artists has not gone unrecognized. The people who love comics care deeply about the medium, and the people who create it, and when they get together, they

OPPOSITE: *An original animation cell from* Stereotypes, *an hour-long film that Robinson co–art directed (Moscow, 1990–91)*

ABOVE: *Robinson (second from right) and Vladimir Pozner, noted Russian journalist, (right) at the Soviet-American Citizens Summit II in Moscow, 1990*

thank and honor those who've served the field. The largest event of this kind in the world of comics is Comic-Con International, held every summer in San Diego, California. The Eisner Awards are an annual event at this conference. The Eisners recognize outstanding achievements in comic books, cartoons, and graphic novels. One of the awards presented in conjunction with the Eisners is the Bob Clampett Humanitarian Award, named for the animator who brought to life many Warner Bros. cartoon characters and who created the much-loved cartoon series *Beany and Cecil*. In 1999, Jerry Robinson was presented with the Clampett Award in recognition of his work on behalf of Jerry Siegel and Joe Shuster, Francisco Laurenzo Pons, and other cartoonists whose freedom and rights have been threatened.

Robinson has also been active in establishing awards in memory of his friends and colleagues who helped to make comic books a viable medium. Since Joe Shuster is a native of Toronto, Robinson supported the proposal that the annual Canadian comic book convention, Paradise Comicon in Toronto, name an award after Superman's co-creator. In 2005, Robinson traveled to Canada for the first Joe Shuster Canadian Comic Book Creator Awards, which honor outstanding contributors to Canadian comics, and Jerry's speech there paid tribute to Shuster as a person and artist.

Robinson felt the contributions to comics by his close friend Bill Finger— including Finger's role in co-creating Batman—should be more widely recognized and honored. In 2005, after several years of lobbying for the award,

ABOVE: *Comics legends Will Eisner and Jerry Robinson. Robinson holds his 2004 Eisner Hall of Fame Award; the award was named after Jerry's longtime friend Will.*

Jerry presented the first annual Bill Finger Award for Excellence in Comic Book Writing. The award continues to be presented each year at Comic-Con in San Diego.

Robinson himself has worked throughout his career to bring recognition to comics and cartoons as media worthy of study and respect. From his earliest days in the field, when he saved original art because he thought it was worthwhile, to his years of teaching at the School of Visual Arts, to his lecture series on comics, planned in collaboration with Will Eisner, Jerry always tried to share with others his appreciation for the art of comics. One of his most successful avenues for doing this has been the exhibitions he's curated for galleries and museums.

In 1975, Robinson curated Cartoon & Comic Strip Art at the Graham Gallery on Madison Avenue in New York City. "All the major categories of cartoon art: comic book, comic strip, political cartoons, magazine cartoons, editorial cartoons, and caricature were represented in the exhibit," Robinson recalled. "It was the first major show of its kind in a fine-arts gallery, so it was a landmark in that respect." The exhibition was successful enough that the gallery followed with two more. Later that year, Robinson was consulting director for a much larger public show, Cartoon, an exhibition mounted at the Kennedy Center in Washington, D.C. The Kennedy Center exhibition was divided into eight categories, each with its own extensive exhibition space. In addition to comics art, Cartoon included works by Pop artists who used comics imagery, and a painting of the Joker by Mel Ramos, as an example of the influence of the comics on contemporary art. Robinson hung Ramos's painting across from the original art that had inspired the painting, one of his own Joker covers. "When the Ramos painting came in with an appraised value of one hundred and sixty-five thousand dollars, that gave me a little regret, to say the least—I had been paid one hundred dollars to do the original," Robinson noted. "I think we should have been painters."

Robinson has curated many exhibitions of political cartoons, including the aforementioned for the United Nations conferences in the 1990s. In 1992, he curated a traveling exhibition of cartoons from Russia, documenting the cultural opening as the Soviet system cracked. The exhibition, Glasnost in Cartoons, opened at the National Press Club in Washington, D.C. But Robinson's most extensive and widely traveled exhibition is one that opened in 2004 and is still traveling as of this writing.

ZAP! POW! BAM! The Superhero: The Golden Age of Comic Books, 1938–1950 originated at the William Breman Jewish Heritage Museum in Atlanta, Georgia, in 2004. The exhibition concentrates on the young Jewish artists who helped create America's comic book culture. Intellectually, the exhibition links the dreams of Jewish immigrants about succeeding in America, with the optimism and social conscience that were part of Jewish culture. It looks at the Jewish community in the New York area that informed the idealism of the first super-hero comics. The exhibition's design embodies

ABOVE: *The Breman Museum's exhibition catalogue for Zap! Pow! Bam! The Superhero: The Golden Age of Comic Books, 1938–1950.*

THE COMICS

AN ILLUSTRATED HISTORY OF COMIC STRIP ART 1895-2010

by JERRY ROBINSON

a sense of the modern, a feeling of yesterday's tomorrows, while including interactive features designed for children's play, a drawing area, and a costume change station. It was the first exhibition to examine the Jewish contribution to comic books. After its opening in Atlanta, the show traveled to Detroit, Miami Beach, Cleveland, and Los Angeles' Skirball Center. Robinson's exhibition at the Jewish Museum in New York in 2007 was essentially a smaller version of Zap! Pow! Bam!

When Robinson was illustrating children's books and magazines, he also wrote two brief articles for kids on the history of comics. This was the modest beginning of his career as a comics historian. He went on to write the first definitive history of American comic strips, as well as one of the first studies of a single comic strip, *Skippy and Percy Crosby* (Holt, Rinehart and Winston, 1978).

In the early 1970s, comics were being discovered as "art," but there was a dearth of books about the medium. There were early histories such as Coulton Waugh's *The Comics* (Macmillan, 1947) and the nostalgia craze of the 1960s had included some publishing on comics, including one extraordinarily fine book, *The Great Comic Book Heroes* by Jules Feiffer (Dial Press, 1965), an anthology of classic super-hero stories with an insightful introduction framed as memoir. Robinson's own book, *The Comics: An Illustrated History of Comic Strip Art* (G. P. Putnam's Sons, 1974), began as a commission from a newspaper trade group that wanted to promote comic strips. Robinson expanded the assignment to create a serious work about comics that combined a history of the medium with biographies of the great cartoonists. Robinson's *The Comics* contextualizes the changes in comics in American society, analyzes artistic change over time, and considers the aesthetics of the comic strip. Robinson's years of teaching comics at the School of Visual Arts are evident in his pointed characterizations of artists' individual styles. Like Giorgio Vasari, the Renaissance painter and architect credited with founding art-historical writing, Robinson brought an artist's eye and an insider's insight to his own artistic field, the comics, and helped establish a critical vocabulary for understanding comic strips.

Robinson's research for *The Comics* interested him in the cartoonist and social commentator Percy Crosby. Crosby created the first mature and complex comic strip about children, *Skippy*, in 1923. His strip was a huge success, but he ended up unjustly committed to a mental institution. Robinson was attracted to Crosby's story because he was "a cartoonist's cartoonist and I really admired his style and flair. He had such an intriguing career and such a tragic one, from the heights to losing everything." The name of the strip lives on in Skippy peanut butter, another blow to Crosby. Though the name was obviously chosen to associate Crosby's popular strip with a child-oriented product, Rosefield Packing Company, the original Skippy peanut butter manufacturers, trademarked the name and paid Crosby nothing. (Various courts have turned down subsequent lawsuits brought by a Crosby heir.)

OPPOSITE: *The new cover for Jerry Robinson's book* The Comics: An Illustrated History of Comic Strip Art, *originally published by G. P. Putnam's Sons in 1974; updated for Dark Horse Comics in 2010 Cover design by Jerry Robinson*

TOP: *Robinson's seminal biography on the neglected artist Percy Crosby (Holt, Rinehart and Winston, 1978)*

BOTTOM: *Jerry Robinson has been recognized internationally for his contributions to comics and comics history. Here he receives the Presidente Senato della Repubblica award in Italy (1987).*

ABOVE: *Robinson sat on the jury for the 24th International Salon of Caricature in Montreal in 1987. Left to right: Henri Barras, Switzerland; Rinalto Traini, Italy; Hans-Georg Rauch, Germany; Jerry Robinson, U.S.; Guy Badeaux, Canada*

Robinson spent several years researching Crosby's story, and he finally published *Skippy and Percy Crosby*, combining a biography of the cartoonist with an analysis of the strip. Forgotten by all except a few aficionados, *Skippy* was a sharply observed portrait of a little boy that went far beyond previous strips about children. Discarding the mischievous, boys-will-be-boys tropes of earlier strips from *Buster Brown* to the *Katzenjammer Kids,* Crosby's strip created characters who spoke like real children, had genuine relationships with family and friends, and the kind of psychological veracity and insight later developed by Charles Schulz in *Peanuts* and Bill Watterson in *Calvin and Hobbes. Skippy and Percy Crosby* was favorably reviewed in the *New York Times Book Review*, and is generally considered to be the first and still one of the best books about an artist and his comic strip.

Following the publication of his books on the history of comics, Robinson has been called upon time and again to write and talk about the history of comics. For several years, he created beautiful calendars for the Italian art publisher Rizzoli that combined classic comics images with monthly pages filled with comics history for every date. These are still valued references for those lucky enough to have them. And he has spoken on comics history at conventions, academic conferences, and professional meetings of artists, animators, and cartoonists around the world. Robinson perhaps finds his most appreciative audience at Comic-Con International in San Diego, where he appears on several panels every year, often with other comics pioneers,

and gives out the Bill Finger Award. At a recent awards speech at Comic-Con, Robinson was trying to bring the audience back to the days when comics were young. It's one of the rare experiences that people who love comics come to conventions for. That particular night, actor Samuel L. Jackson was scheduled to give an award after Robinson and, graciously but insistently, sent word to the organizers of the ceremony that he would have to leave if the proceedings weren't speeded up. Comic book artist Batton Lash was asked to talk to Jackson, and he went backstage. "Do you know who that is?" he asked the actor. "That's the *Batman* artist who created the Joker." Jackson replied, "Well, in that case, let him talk as long as he likes."

The great thing about American comic book super heroes, one of the secrets of their success, is that they're part of the community. They live in Metropolis, or Gotham, or Central City; they walk the same streets you do, whether they're wearing capes or carrying reporters' notebooks, and they know their cities like the backs of their hands. The people who love and create comics form a community too, no matter what language they speak or where they live. And in that comics community, Jerry Robinson is a super hero.

ABOVE: *Robinson drawing* Batman *sketches for fans at Comic-Con International in San Diego (1990s)*

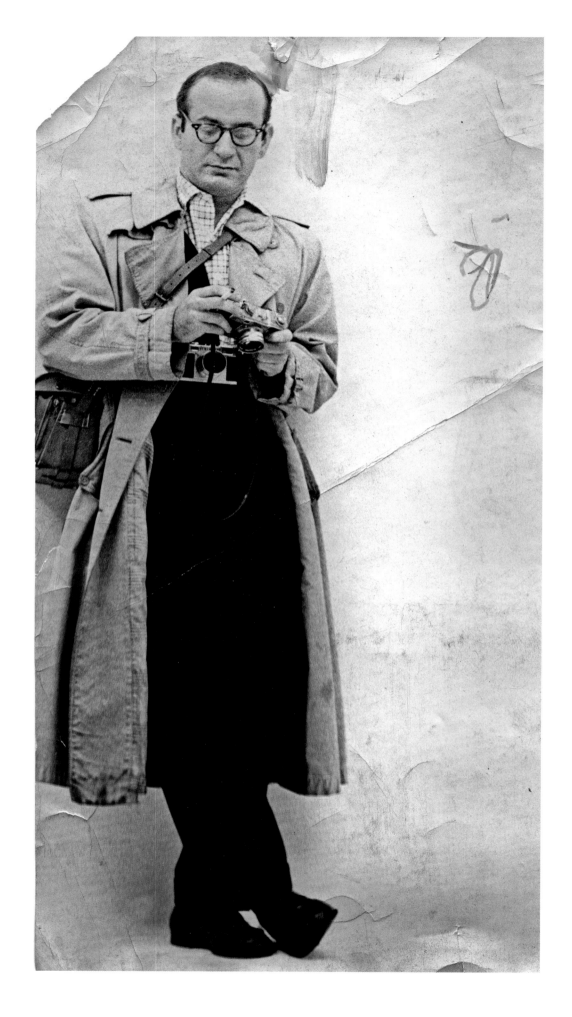

PORTFOLIOS

Jerry Robinson's art and writing credits are well-documented in the previous chapters, and he has always loved and made time for all the arts: drawing, painting in various media, photography, and writing. Robinson has exhibited his art and photography in galleries and group shows; he draws wherever he goes, filling countless sketchbooks with the sights from his world travels; and he is a remarkably versatile writer.

As a photographer, Robinson became enthralled with the work of Henri Cartier Bresson at the 1947 exhibition of Bresson's photography at MoMA. Like Bresson, Robinson composes entirely through the lens, disdaining cropping or other manipulation of his negatives or prints. Robinson also admires the work of photojournalists Robert Capra and Paul Strand; Jacob Riis, who used the art for social reform; and the portraits of place by Andreas Feininger, Eugène Atget, and Edward Steichen.

Robinson's trips in the 1950s to Europe, Africa, and the Far East, further excited his passion for photography. A 35mm Canon and Rollei reflex have been his constant companions ever since. Robinson's first exhibition, "Color Photographs from Seven Countries," was held at the SVA Gallery in 1946. His articles and photographs have appeared in major photography journals.

Along with his cameras, Jerry's shoulder bag always holds sketchpads, pencils, and markers. People are his favorite subject. He enjoys the challenge of capturing a candid moment at a café, museum, in a park, at the beach, on shipboard or on the street. In addition to his important writing credits in comics, cartoons, and books, already in print, Robinson continues to produce outstanding work, such as the short story included here on pages 217–20. "The Writer" evokes his Russian heritage in a short tale of dark humor, resignation, and eternal hope.

OPPOSITE: *Jerry Robinson on a photo shoot abroad (1960s)*

PHOTOGRAPHY

Robinson is always looking for the Bressonian moment—the candid, fleeting revelation of a story or an emotion. "I think my experience as a cartoonist and storyteller is to convey a sense of what went just before, and perhaps what might be coming next," said Robinson. "That is what I try capture in a frozen image on film."

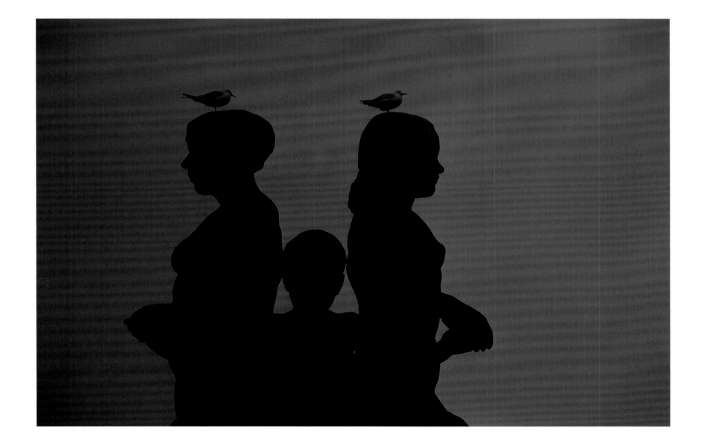

PAINTINGS AND SKETCHES

Robinson works in all mediums, but especially likes watercolor, pastel, and casein. Most of his paintings were done over summers in Kennebunkport, Maine, or Cape Cod, Massachusetts, from 1960 to 1985. Since then he has painted at his studio in Lost Lake, New York.

Prague 1998

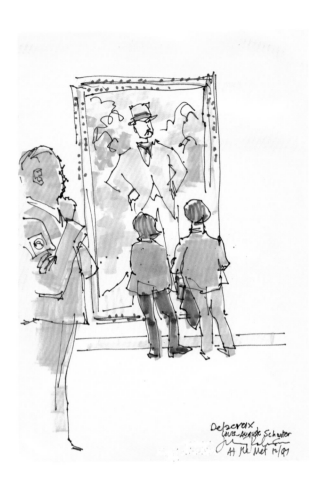

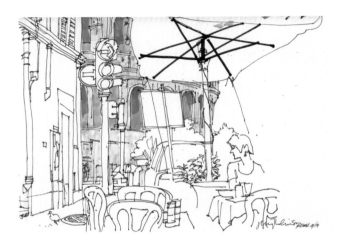

Hamlet at
Circle Rep

Ⓐ

"I finally get a speaking part ... 3 words ...
Two in the opening scene and one just before
the final curtain!"

WRITING

The Writer

Rashkovitch pulled the oars slowly through the heavy waters of the lake. Early morning mist rose from its surface as if from a hot bath. The quiet was broken only by the oars slicing mechanically in and out of the placid waters, and by an occasional grunt from Rashkovitch. His head and shoulders were bowed. Alongside him rested a worn, black portfolio tied by a string at both ends. A corner of a once-white parchment showed between the stiff covers.

Rashkovitch coughed and shook his head. It will be no different this time, he muttered through his beard, now decorated with spittle. But then, he reasoned, what have I got to lose? As he neared shore he could make out a few carts that had already arrived at the clearing. Some of the early ones. He knew who they would be, always the same ones, seeking the best places. "As if it mattered," Rashkovitch snorted. "They never give up. What ambition! What dedication! What fools!"

Rashkovitch docked the boat, stored the oars under the seat, and with his portfolio carefully tucked under his arm, lifted himself heavily onto the shaky pier. "Rashkovitch!" someone called out. "You're early! I thought you were not coming again!"

"Oh, I couldn't sleep. Besides I had nothing else to do."

Rashkovitch began his search at the bank of the lake. Bent over close to the ground he resembled a huge turtle lumbering along the water's edge. He paused now and then to dislodge a suitable stone with his boot. When he had collected a pocketful, he took them to a long wooden table. He untied the portfolio and began to neatly lay out his parchment pages, one after the other in long rows; securing each sheet with two of the stones.

Artists continued to arrive by cart and on horseback. They started covering the walls of a nearby shed with their paintings. Some brought ladders to hang their work at the very top of the shed, way above the others. This was considered the most advantageous position, although you had to strain your neck to see those paintings up under the eaves—and even then you couldn't see them very well. *My God,* mused Rashkovitch, *what lengths man will go to in search of self-delusion!*

The paintings were all shapes and sizes: squares, rectangles, extremely tall and narrow, or very wide and only a foot or so high, and even one large round painting, which belonged to Anton, of course. A carpenter by trade, Anton was the only one with the skill to fashion a round frame for his canvas. *How he must have worked to make it,* thought Rashkovitch. *I must ask him how he did it.* But then he realized Anton would certainly tell him in excruciating detail and decided satisfying his curiosity wasn't worth it.

The wall of the shed now looked like a crazy quilt of every subject and color imaginable. The paintings were all crowded together, fighting for a bit of attention: religious motifs hung solemnly amid still lifes of flowers and fruit in great

OPPOSITE: *Robinson shot the photos at left in a Moscow park in winter 1989. The ground was covered by several feet of snow, but still hundreds of Muscovites strolled along, looking at rows of paintings in a bewildering array of styles, colors and subjects. Some paintings stood on easels stuck in the snow, some perched on the limbs of bare trees. Their creators stood proudly next to their masterpieces, trying to keep warm—and searching each passing face for a sign of approval . . . and a possible sale.*

These photographs inspired Robinson's story "The Writer."

profusion; several wooden bridges and waterfalls abutted landscapes of farmlands and snow-capped mountains. Portraits of family groups standing stiffly in front of their houses, with the inevitable dog, cat, or both playing in the foreground mixed with formal portraits of local officials and historical figures (Greeks and Romans seemed to be the favorites). Many farmyard animals were immortalized—horses, cows, sheep, roosters, and even a very pink, plump pig. There was an assortment of other odd subjects too wearying to recount, except for one surprisingly tasteful and rather erotic painting, apparently of the artist's wife performing her toilette.

The latecomers tried to squeeze in their frames, moving other paintings in the process and causing much unpleasant pushing and name-calling. Two fights broke out before order was restored—one between a tall, bearded man in a tattered gray coat, his canvas of two wild roses in a nauseous yellow vase, and a rather wild-looking farmer who, despite the cold morning air, wore only a thin, striped shirt. The latter was responsible for an oil of a mountain goat perched on the edge of a cliff at sunset. Fortunately no one had much stomach for receiving any blow of substance. The other fight, somewhat more aesthetic, was over the incompatibility of adjacent paintings, but neither party would agree to move their treasure. *Ah!* Rashkovitch thought, *at least they argue, they have passion about something! It certainly isn't evident from their paintings.* Rashkovitch finished laying out his parchments. One of the artists moved over and looked at them intently.

"What are they?" he asked.

"What are they?!" Rashkovitch repeated. "Don't you know? What are you, new here? Yes, of course you're new or you wouldn't ask. What's your name? Don't answer! It doesn't matter!"

The poor fellow had no intention of answering, he was much too confused by the sudden outburst.

"They're a story," Rashkovitch continued without a pause. "I suppose you don't read. No, of course not. No one reads anymore."

The fellow looked again at the parchments with disbelief. "A story? What is the story?"

"If I told you, you wouldn't buy it, would you? No, of course not. And even if you did, you couldn't read it. And besides, if you could read," shouted Rashkovitch, warming to the dialectic, "you wouldn't buy it because you don't have any money! You don't, do you?"

"No, I don't have any money."

"So don't bother me, artist," said Rashkovitch as he walked over to the trees to relieve himself.

"Don't worry, artist," someone called out. "He'll tell you the story. He always does. After all, what else can he do? We don't read and we don't have money. The story is no good unless he reads it, so he must read it. We've heard it many times. It's very good."

"But he doesn't have to read it if we don't pay him," the first artist said in wonder.

"No, but he looks at our paintings," another fellow replied, "and, as he says himself, he doesn't pay for them . . . Of course, he doesn't *like* our paintings." Rashkovitch ignored them all, sat down on a log, took a paper bag from his jacket, and unwrapped a huge onion sandwich.

"What do you think, Rashkovitch, will he come today?" asked an artist named Gordorski, as he, too, sat down on the log.

"Of course he will," responded Rashkovitch listlessly. "It would be no pleasure for him unless he deprived us of some."

"Today will be different."

"Yes, yes, today will be different. Just as the sun will set in the east."

"You have no faith, Rashkovitch!"

"I do have faith. I faithfully believe there is nothing to have faith in."

"There is nothing for us to do until he comes. Read us another story!" shouted Anders, who always managed to hang his painting of *Cybele with Cymbals and Pine Tree* at the top center of the shed.

"I don't have another story."

"Well, then, write one!"

"Why should I?"

"Well, ah . . . because you should. We have heard the one many times. We don't paint the same picture again and again. We do different ones . . . from time to time."

"Why?" asked Rashkovitch dryly.

"Because . . . because we want to," stammered Anders.

"That's your problem," Rashkovitch answered with some disdain. "If you did it right the first time, you wouldn't have to do another!"

"Rashkovitch, you're crazy!" Anders shouted, flushed with anger and frustration. "I don't even believe a story is written on those papers! You are a fraud!"

"Well, you don't know if I can really write, because you can't read," Rashkovitch countered with obvious relish, "but I can *see* that you can't paint!"

"He comes! He comes!" an artist suddenly called out. *"I hear Him!"*

Everyone stood rooted to the ground, straining to hear the all-too-familiar sound. Then, sure enough, two belled horses and a carriage appeared briefly silhouetted at the top of the cliff before disappearing behind the trees as the road curved down to the lakeside clearing.

Moments later the snorting horses came to a stop before the shed, splattering mud on those who dared venture too close. The carriage door swung open and He stepped out, one shining boot after the other, landing nimbly on the box set out for Him. Everyone rushed to the nearest spot possible next to his work, except Rashkovitch who, ignoring the entire event, proceeded to finish his onion sandwich.

The artists remained frozen, their silence deafening, as He strode along the length of the shed, his long black coat flaring in the light breeze; the rhythmic pounding of his boots on the wooden planks resounding across the water. One artist audibly sucked in air as He passed. He barely glanced at

the paintings. One artist hurriedly tried to straighten his picture, a green and blue parrot with two oranges, and stumbled in the mud, squirting one small blob of mud onto the middle of His left boot. He stared at the offending spot and slowly hissed, through clenched teeth, "Fool! You know I hate parrots!"

Pausing at the end of the shed, He stared across the lake, turned and strode back. This time he stopped, smoothed his moustache, and squinted intently at a painting. As several works were crowded together, no one was sure which one was the focus of his attention. (This proved to be the cause of a continuing debate and at least several fights during the ensuing months.) After an unbearable thirty seconds of suspense, He passed on without a word. Suddenly He stopped and looked over at Rashkovitch. "Still writing, Rashkovitch?"

"Yes," Rashkovitch answered wearily.

"The same story, Rashkovitch?"

"Of course. Would you care to buy it?"

"Why should I? I have already read it."

"But you never bought it."

"I had to read it before I knew if I liked it enough to buy it."

"Of course. But did you like it?"

"Yes, it was extremely good, Rashkovitch."

"Then why not buy it?"

"Because I've already read it, you fool. Why don't you write a new one? I might buy it."

"But you would have to read it first, of course."

"Of course."

"I like writing this one too much."

"As you please, Rashkovitch."

With that, He briskly stepped back into the carriage. The wheels dug deep ruts into the mud as the carriage circled the shed and made its way back up the hill. Everyone watched in silence until, once again, the carriage came into view briefly at the crest of the hill and then disappeared, leaving only the faint sound of bells to mark its passing. A collective sigh rose from the artists. Silently they packed up their paintings. Rashkovitch methodically stacked his parchments and returned them to the portfolio. He freed the boat from the rotting piling and began to row back across the lake, now gleaming in the mid-morning sun.

"Good-bye, Rashkovitch! See you next year!" yelled Godorski.

Rashkovitch pretended not to hear.

"Next year!" he muttered to himself. "If he thinks I'll come again, he's a bigger fool than I thought." But Rashkovitch knew he would come. He might even fool everyone one day and write another story.

"Why not?"

SOURCES

Allen, Douglas, and Douglas Allen, Jr. *N. C. Wyeth: The Collected Paintings, Illustrations and Murals*. New York: Crown, 1972.

Amash, Jim. "Jerry Robinson [Interview]," *Alter Ego* vol. 3, no. 39 (2004): 3–38, 2–33.

Andelman, Bob. *Will Eisner, a Spirited Life*. Milwaukee, OR: M Press, 2006.

Andrae, Thomas. *Creators of the Superheroes*. Philadelphia: Hermes Press, 2010.

———. "From Menace to Messiah: The Prehistory of the Superman in Science Fiction Literature," *Discourse* no. 2 (1980): 85–111.

Astor, David. "Efforts Go on to Free Jailed Cartoonist," *Editor & Publisher* (August 20, 1983): 14.

Batman Archives vols. 1–5. New York: DC Comics, 1997–2001.

Batman Chronicles vols. 1–7. New York: DC Comics, 2005–2009.

Batman: The Dark Knight Archives vols. 1–6. New York: DC Comics, 1992–2009.

Batman: The Sunday Classics. Princeton, WI: Kitchen Sink Press, 1987.

Batman: The World's Finest Archives vols. 1–2. New York: DC Comics, 2002–2005.

Beatty, Scott. *Batman: The Ultimate Guide to the Dark Knight*. London and New York: Dorling Kindersly, 2001.

Bell, Blake. *Strange and Stranger: The World of Steve Ditko*. Portland, OR: Fantagraphics Books, 2008.

"Blizzard Hits City, Covers Wide Area," *New York Times*, March 8, 1941.

Bowe, Nicola Gordon. *The Life and Work of Harry Clarke*. Dublin: Irish Academic Press, 1989.

Breasted, Mary. "Superman's Creators, Nearly Destitute, Invoke His Spirit." *New York Times*, November 22, 1975.

Certeau, Michel de. *The Practice of Everyday Life*. Berkeley: University of California Press, 1984.

Chabon, Michael. *The Amazing Adventures of Kavalier & Clay*. New York: Random House, 2000.

Couch, N. C. Christopher. "The Brandywine School and Comic Art," in *Parole, texts et images, Formes et pouvoirs de l'imaginaire*, edited by Jean-Francoise Chassay and Bertrand Gervais, 193–217. Montreal, Figura, Centre de recherché sur le texte et l'imaginaire, 2008.

Creswick, Paul. *Robin Hood*. Illustrated by N. C. Wyeth. Philadelphia: David McKay, 1917.

Cronin, Brian. *Was Superman a Spy?* New York: Plume, 2009.

Daniels, Les. *Comix: A History of Comic Books in America*. New York: Bonanza Books, 1971.

———. *DC Comics, Sixty Years of the World's Favorite Comic Book Heroes*. Boston: Little, Brown and Company, 1995.

———. *Superman: The Complete History*. San Francisco: Chronicle Books, 1998.

———. *Batman The Complete History: The Life and Times of the Dark Knight*. San Francisco: Chronicle Books, 1999.

Denby, David *Great Books: My Adventures with Homer, Rousseau, Woolf, and Other Indestructible Writers of the Western World*. New York: Simon & Shuster, 1996.

Desris, Joe. *The Golden Age of Batman: The Greatest Covers of Detective Comics from the '30s to the '50s*. New York: Artabras, 1994.

Dewey, Donald. *The Art of Ill Will: The Story of American Political Cartoons*. New York: New York University Press, 2008.

Eisner, Will. *Comics and Sequential Art*. New York: W. W. Norton, 1985.

Eliot, Maj. George Fielding. Drawings by Jerry Robinson. "Is the Jap Army a Hollow Shell?" *Look* (May 29, 1945): 48–51.

Ellis, Doug and John Gunnison. *The Adventure House Guide to Pulps*. Silver Spring, MD: Adventure House, 2007.

Feiffer, Jules. *The Great Comic Book Heroes*. New York: Dial Press, 1965.

Forman, Maury and David Horsey, eds. *Cartooning AIDS Around the World*. Dubuque, IA: Kendall/Hunt Publishing Company, 1992.

Goulart, Ron. *Cheap Thrills*. New Castle, PA: Hermes Press, 1972.

Harris, Neil. "Who Owns Our Myths? Heroism and Copyright in the Age of Mass Culture," *Cultural Excursions: Marketing Appetites and Cultural Tastes in Modern America*. University of Chicago Press (1990): 233–49.

Hess, Stephen and Sandy Northrop. *Drawn and Quartered: The History of American Political Cartoons*. Montgomery, AL: River City, 1996.

Hulse, Ed. *Blood 'n' Thunder Guide to Collecting Pulps*. Morris Plains, NJ: Murania Press, 2007.

Inge, M. Thomas. *Comics as Culture*. Jackson, MS: The University Press of Mississippi, 1990.

Jones, Gerard. *Men of Tomorrow: Geeks, Gangsters, and the Birth of the Comic Book*. New York: Basic Books, 2004.

Kane, Bob with Tom Andrae. *Batman and Me*. Forestville, CA: Eclipse Books, 1989.

Kluger, Richard. *The Paper: The Life and Death of the New York Herald Tribune*. New York: Alfred A. Knopf, 1986.

Lamb, Chris. *Drawn to Extremes: The Use and Abuse of Editorial Cartoons in the United States*. New York: Columbia University Press, 2004.

Leaning, John R. "'Quiet Diplomacy' Not Helping Uruguayan Cartoonists in Jail," *The Cape Codder* (August 13, 1982): 7.

Liebling, A. J. *The Press*. New York: Ballantine Books, 1975.

Lesser, Robert. *Pulp Art*. New York: Gramercy, 1997.

McCarthy, Colman. "Imprisoned Uruguayan Cartoonist Wins a Prestigious Award Here," *Washington Post*, May 23, 1981.

Muir, John Kenneth. *The Encyclopedia of Superheroes on Film and Television*. Jefferson, NC: McFarland & Co., 2004.

Murray, Will. "The Shadowy Origins of Batman," in Maxwell Grant, *The Shadow* v. 9 (2007): 70–71. San Antonio: Sanctum Books.

Nasaw, David. *Children of the City: At Work and at Play*. New York: Oxford University Press, 1986.

———. *Going Out: The Rise and Fall of Public Amusements*. New York: Basic Books, 1993.

Nemerov, Alexander. "N. C. Wyeth's Theater of Illustration," *American Art* v.62 (1992): 36–57.

Outcault, Richard F. *The Yellow Kid*. Northampton, MA: Kitchen Sink Press, 1995.

Prawer, S. S. *Caligari's Children: The Film as Tale of Terror*. Oxford: Oxford University Press, 1981.

Ringgenberg, Steve. "Jerry Robinson [Interview]," *Comics Interview* no. 56 (1988): 28–47.

———. "Jerry Robinson [Interview]," *Comics Interview* no. 57 (1988): 17–33.

Ro, Ronin. *Tales to Astonish: Jack Kirby, Stan Lee, and the American Comic Book Revolution*. New York: Bloomsbury, 1994.

Robinson, Jerry. *The Comics: An Illustrated History of Comic Strip Art*. New York: Putnam's, 1974.

———. "Foreword," *Batman Archives* v. 3. New York: DC Comics, 1994.

———. *OD'ed on OJ*. New York: Universe Books, 1995.

———. "Cartoonists & Writers Syndicate Spins a Worldwide Cartoonweb," *Cartoonist Profiles*, no. 116 (1997): 24–35.

———. et al. *Zap! Bam! Pow! The Superhero 1938–1950, The Golden Age of Comic Books*. Atlanta: The William Bremen Jewish Heritage Museum, 2004.

Rovin, Jeff. *The Encyclopedia of Superheroes*. New York: Facts on File Publications, 1985.

———. *The Encyclopedia of Super Villains*. New York: Facts on File Publications, 1987.

Sabin, Roger. *Comics, Comix & Graphic Novels: A History of Comic Art*. London: Phaidon, 1996.

Silverman, Kenneth. *Edgar A. Poe: Mournful and Never-Ending Remembrance*. New York: HarperCollins, 1991.

Steranko, James. *The Steranko History of Comics*. 2 vols. Reading, PA: Supergraphics, 1972.

Szasz, Ferenc M. "Atomic Comics: The Comic Book Industry Confronts the Nuclear Age," in *Atomic Culture, How We Learned to Stop Worrying and Love the Bomb*, edited by Scott C. Zeman and Michael A. Amundson, 11–31. Boulder: University Press of Colorado, 2004.

"Traffic Disrupted by 11.6-Inch Snow; Storm Continuing," *New York Times*, March 9, 1941.

Tollin, Anthony. "Spotlight on the Shadow: Foreshadowing Batman," in Maxwell Grant, *The Shadow* 9 (2007): 132–133. San Antonio: Sanctum Books.

Vassallo, Michael J. "The History of Atlas Horror-Fantasy Pre-Code 1952," *Marvel Masterworks Atlas Era Journey into Mystery* v. 1 (2008): vi–xii. New York: Marvel Enterprises.

———. "The History of Atlas Horror-Fantasy Pre-Code 1953," *Marvel Masterworks Atlas Era Strange Tales* v. 2 (2009): vi–xii. New York: Marvel Enterprises.

Vaz, Mark Cotta. *Tales of the Dark Knight: Batman's First Fifty Years, 1939–1989*. New York: Ballantine Books, 1989.

Vidal, David. "Mild-Mannered Cartoonists Go to Aid of Superman's Creators," *New York Times*, December 10, 1975.

———. "Superman's Creators Get Lifetime Pay," *New York Times*, December 24, 1975.

Walker, Brian. *The Comics: The Complete Collection*. New York: Abrams, 2008.

Williamson, Lenora. "Foreign Cartoonists Invited to U.S." *Editor & Publisher* (1981): 55.

INDEX

All page numbers in *italics* refer to illustrations.